UNCOMMON VALOR, COMMON VIRTUE

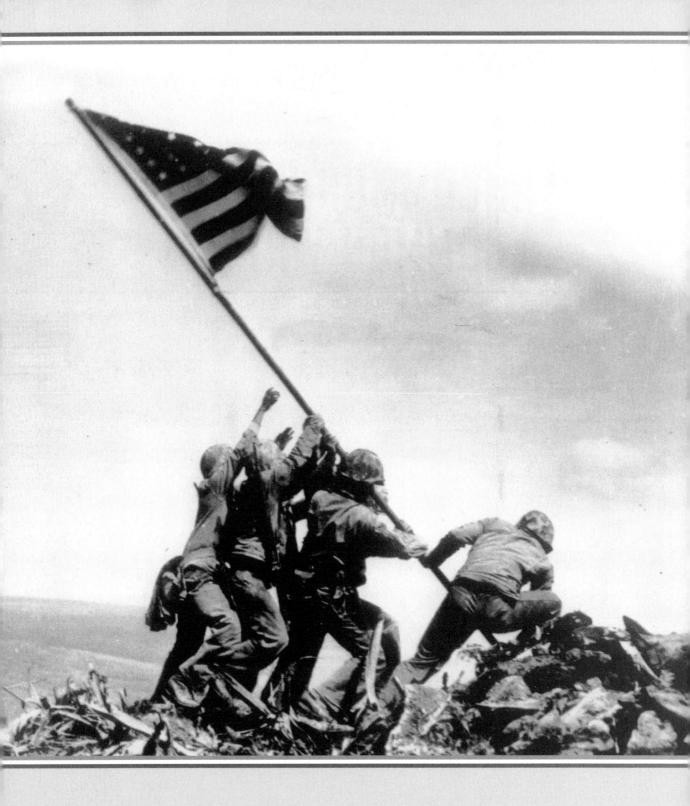

UNCOMMON VALOR,
COMMON VIRTUE

IWO JIMA AND THE PHOTOGRAPH
THAT CAPTURED AMERICA

HAL BUELL

BERKLEY CALIBER
NEW YORK

THE BERKLEY PUBLISHING GROUP
Published by the Penguin Group
Penguin Group (USA) Inc.
375 Hudson Street, New York, New York 10014, USA
Penguin Group (Canada), 90 Elington Avenue East, Suite 700, Toronto, Ontario M4P 2Y3, Canada
(a division of Pearson Penguin Canada Inc.)
Penguin Books Ltd., 80 Strand, London WC2R 0RL, England
Penguin Group Ireland, 25 St. Stephen's Green, Dublin 2, Ireland (a division of Penguin Books Ltd.)
Penguin Group (Australia), 250 Camberwell Road, Camberwell, Victoria 3124, Australia
(a division of Pearson Australia Group Pty. Ltd.)
Penguin Books India Pvt. Ltd., 11 Community Centre, Panchsheel Park, New Delhi—110 017, India
Penguin Group (NZ), 67 Apollo Drive, Rosedale, North Shore 0632, New Zealand
(a division of Pearson New Zealand Ltd.)
Penguin Books (South Africa) (Pty.) Ltd., 24 Sturdee Avenue, Rosebank, Johannesburg 2196, South Africa

Penguin Books Ltd., Registered Offices: 80 Strand, London WC2R 0RL, England

UNCOMMON VALOR, COMMON VIRTUE

The publisher does not have any control over and does not assume any responsibilty for author or third-party websites or their content.

PRINTING HISTORY
Berkley Caliber hardcover edition / May 2006
Berkley Caliber trade paperback edition / November 2007

Berkley trade paperback ISBN: 978-0-425-21517-3

PRINTED IN THE UNITED STATES OF AMERICA

10 9 8 7 6 5 4 3 2 1

FOR
Joe Rosenthal
A GREAT AMERICAN

The title of this book is taken from the final report by Admiral Chester Nimitz
on the Iwo Jima campaign. He wrote, in part:

For those who fought on Iwo Jima,
Uncommon Valor was a Common Virtue.

ACKNOWLEDGMENTS

FEW BOOKS ARE the work of a single person. Many have helped with this volume:

Claudia DiMartino, invaluable first editor, helped keep the story in line. Jorge Jaramillo of AP Wide World Photos found many pictures in AP files. Richard Horwitz found still more in the National Archives and helped keep the digital files organized. Chuck Zoeller, director of the AP Photo Library, likewise contributed research, time, and effort. Norman Hatch, who headed up photo operations on Iwo, contributed valuable detail. Daniel Schwartz researched newspaper files to find daily reports from 1945.

Lou Reda of Lou Reda Productions, Inc., Easton, PA, stayed with the book over many years, certain it would find a place and contributed the enclosed DVD. Frank Weiman of Literary Group International likewise helped put the book in the proper pipeline.

Naval Institute Press permitted liberal use of Marine quotes from their book, *Never in Doubt: Remembering Iwo Jima*, edited by Lynn Kessler.

Natalee Rosenstein of Berkley Publishing Group guided the story to the printed page.

Thank you, each and every one.

AUTHOR'S NOTE

MY **INTEREST IN** the Iwo Jima flag-raising photograph taken by Joe Rosenthal has a long history.

I was a recent elementary school graduate focused on my coming high school adventure when the photo was first published in February of 1945. I have no memory of its appearance at that time. In college, my interest drifted toward photojournalism, and that brought the picture to my attention. Its power and influence underscored the power of photography, a consideration that became one of several to turn my head more directly toward picture journalism as a career.

Transferred by Associated Press (AP) from Chicago to New York in 1957, I worked on the photo desk with Jack Bodkin, who, as an editor with the Wartime Still Picture Pool in Guam, was the first to see Rosenthal's picture as it was taken out of the developing tanks at pool headquarters. George Sweers, AP photographer who covered the Korean War, and who was my predecessor as AP's Asia photo editor, worked as a wirephoto operator in Kansas City the Saturday that the picture was transmitted on the AP network.

In 1960, as AP photo editor in Asia, I visited Iwo Jima, then under U.S. jurisdiction. I walked the black sands of the invasion beach, saw the rusting hulks of military equipment along the shore and inland, visited Japanese fortifications, and traveled a paved road up Mt. Suribachi to the spot Rosenthal chose to take his picture a generation earlier. Keyes Beech, then a much-respected Asia correspondent

for the *Chicago Daily News*, a paper I had grown up with and admired, was on the same junket. Beech was a Marine Corps journalist and covered the Iwo battle. He was one of five Marine journalists who contributed to *The U.S. Marines on Iwo Jima*, one of the first accounts of the battle from beginning to end. Over drinks in Tokyo, our mutual home base, I asked about the flag picture and its impact, and was rewarded with many insightful tales. Beech also accompanied the flag raisers on their War Bond tour. I also developed a friendship with Bob Trumbull, *New York Times* correspondent who covered Iwo, and who by 1960 worked in an office adjacent to AP in Japan's major national newspaper, *Asahi Shimbun*.

Reassigned to New York and named head of AP photos, I met Richard Newcomb, who wrote *Iwo Jima*, another "must read" book for anyone interested in the battle. I attended Joe Rosenthal's party when he retired from the *San Francisco Chronicle*. We met frequently thereafter at one or another photo or AP function, including one marathon lunch in the Italian section of San Francisco that lasted from noon to 5:00 P.M. Gradually, bit by bit, the Iwo story—flag picture and the battle—emerged in all its texture. I was captivated and dug deeper into AP files and into picture archives. I searched eBay for Iwo memorabilia. I explored the Iwo story from the Japanese perspective. Norman Hatch, Marine Corps photo officer on Iwo, filled in empty spaces about military coverage of the conflict.

It seemed that too much of what I read contained some error of fact, many of which are corrected in this volume. I was struck over and over again at how this picture had become such a significant thread in the American experience, including its connection to the terrorist attack on the World Trade Center. I was struck by the attempts to trivialize the picture, the many attacks upon its credibility and the misinformation about the picture that survived even to contemporary times.

Much of what was written concentrated either on the battle or on the picture. Somehow that missed the point; you cannot separate wet from the water.

This book is the result of this lifelong interest. Unlike other books on the subject, this book contains many photographs reproduced in large size. Some of the pictures are old standbys; some have been seen only rarely, others not at all. Some are Rosenthal's photos, some were made by military combat photographers, others are news pictures of the continuing, six-decade-long saga of that ferocious battle and the picture that memorializes it.

CONTENTS

	HISTORY OF IWO JIMA	1
	INTRODUCTION	5
	PROLOGUE	9
1	THE WAR	13
2	THE BATTLEFIELD	21
3	THE ENEMY	29
4	D-DAY	41
5	D+1, D+2, D+3	71
6	D+4: The Flags of Suribachi	95
7	D+5	127
8	D+6 TO D+14: An Icon Is Born, A Battle Continues	155
9	REALITY, MYTHS, AND THE FOG OF WAR	179
10	A PICTURE FOR ALL TIME	189
	ANOTHER PICTURE	215
	IWO JIMA AND 9/11	217
	LOOSE ENDS	219
	MEDAL OF HONOR CITATIONS	225
	INDEX	253

UNCOMMON VALOR, COMMON VIRTUE

HISTORY OF IWO JIMA

THREE GROUPS OF islands string out to the south from Tokyo for some 750 miles, reaching to within 300 miles of the Marianas. Japanese history refers to these islands as Nanpo Shoto (*shoto* means island group). They are, from north to south:

The Izu group, known to Japanese fisherman as early as 1500.

The Ogasawara group, first noted by Prince Sadayori Ogasawara in 1593. He named them *munin*, (no men) and a corruption of that word, Bonin, became their international identification.

Kazan Retto, or Volcano Islands (literally in Japanese, volcano islands in a line). Iwo Jima (*Iwo* means sulphur, *Jima* means island) was the largest of the Volcano Islands, which also includes Chichi Jima and Haha Jima. Iwo is distinguished by its volcano, Suribachi Yama, and by a central plateau that in modern times was suited for use as aircraft runways.

Several Westerners visited these islands, among them the American whaler, Captain Reuben Coffin, out of Nantucket, who landed at Haha Jima in 1823 and claimed the island for the United States. Another whaler claimed Chichi Jima for King George IV, and a group including Englishmen, Portuguese, Italians, Hawaiians, and an American named Nathaniel Savory took up residence there in 1827.

Commodore Mathew Perry of the U.S. Navy stopped at Chichi Jima in 1853 en route to Japan to negotiate the opening of that country to the world. He

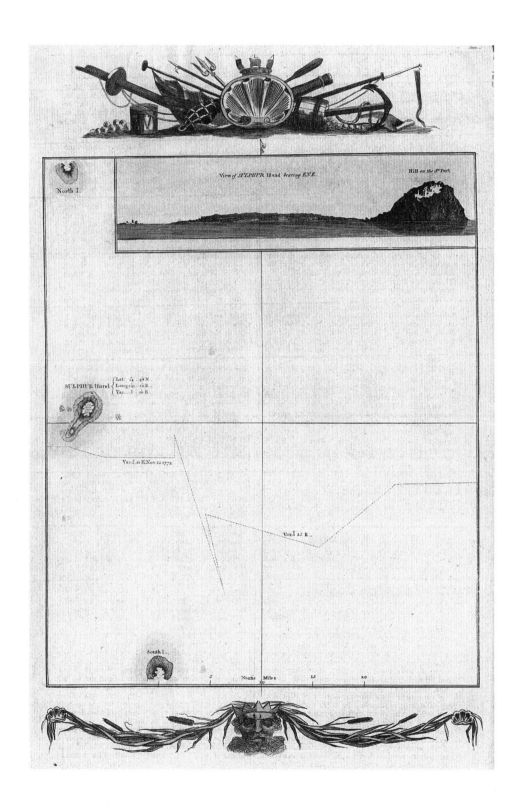

recommended that a strip of land on Chichi Jima be purchased and used as a coaling station for American ships in the area.

Scholars believe that Iwo Jima was named Sulphur Island, for obvious reasons, by an Englishman named Gore; an odor of sulphur prevailed throughout the island. Later in its history, sulphur mining, and the growing of sugar cane, became island industries, providing residents with a meager living.

Others visited the area, including the expedition of the famous English explorer Capt. William Cook. Although he was slain by that time, one of his officers drew a map of Iwo Jima in 1786 that offered both a classic overview and a profile view of the island.

After the visit of Perry to Japan, Japanese officials thought it best to take claim to the islands of the Nanpo Shoto, and colonists were dispatched. In 1861, Japan made a formal claim that went uncontested by other nations, and the islands became part of Japan, administered by the Tokyo government. The first colonists arrived at Iwo Jima in 1887, and foreign settlement was banned throughout the island chain in the early 1900s. American and European influence disappeared.

Sulphur mining, the growing of cane, and sugar refining became the livelihood of 1,100 Japanese residents until 1943.

INTRODUCTION

THIN CLOUDS CREATED a bright but softly filtered light. The rush of ocean winds limited conversation with anyone more than a few yards away.

Five U.S. Marines and a Navy corpsman raised an American flag on the summit of Mt. Suribachi, a 556-foot volcano in the Pacific Ocean. Joe Rosenthal, an Associated Press war photographer, made a photograph of the scene that became an icon for all time. In less than twenty-four hours, his picture was seen worldwide and the tiny, volcanic island, a place nobody knew, became a place nobody would forget.

This book tells the story of that picture, made on February 23, 1945, the fifth day of the U.S. Marine invasion of Iwo Jima, one of World War II's most ferocious battles and the bloodiest in Marine Corps history.

The battle continued on Iwo for weeks after Rosenthal's shutter froze the flag-raising scene and memorialized American valor and victory. The picture represents more than a brief instant on a faraway island; it symbolizes the nation's belief in its mission at mid-twentieth century. It is the most famous photo of World War II and the most published photo of all time.

The stories of the Iwo Jima battle, of the man who made the photo, how he made it, and how the photo changed his life and the lives of many others are part of the picture's story and are as interwoven as the threads of a fine fabric. It is a story told over six decades of the American experience.

It is not always a pretty story. The photo as a symbol of American valor fell victim to those who trivialized it, to others who attempted to discredit it, to those who called it a lie and a fabrication. But the picture survived trials and tribulations, its message everlasting.

Other books have been written about this most violent of Pacific War battles, but none combine words and as many pictures in a personal, eyewitness, belly-to-belly report of those days in February and March 1945. Many of the pictures in this book were made by Rosenthal, who won a Pulitzer Prize for his photo of the flag raising. It also includes photos by Marine, Coast Guard, and Navy photographers, made as Americans literally inched their way across a four-and-a-half-mile-long island in thirty-six days of fiery hell and thirty-six nights of constant vigilance against infiltrators, surprise attacks, and hand grenades thrown from the shadows.

Other photographers were on Suribachi when the flag went up, and their pictures are in this book, too, including pictures of the first flag raised on the volcano summit. The Rosenthal photo was actually the second flag used, and that is part of the continuing controversy. Each of all the photos adds its small sliver of insight to the whole.

No single person's experience captures the full dimension of the Iwo Jima story, and so included in this book are quotes gathered from interviews, oral histories, battle reports, and citations from several archives.

Dispatches of war correspondents are also included that, in the spare, documentary style of the mid-1940s, reported the war in newspapers, magazines, and radio broadcasts. They are printed as exact language of the original to capture the flavor of the times and provide insight into how the home front came to know the battle.

The telling is unencumbered by statistics, military designations, and the record of daily advances and losses, all of which are kept to a minimum. Words and pictures offer a mosaic of the conflict lived by the individuals caught in the battle's fury. It is the stuff of midnight terrors but not without the bizarre humor of warriors who laugh at death so that they will not be fearful of death.

All together Rosenthal made sixty-five pictures on Iwo Jima, but only four of them were pictures of the flag raising. "You had to conserve film," he says. "You never knew when your next shipment of supplies would catch up." He used a film pack, a device that held twelve 4×5–inch sheets of film in a single film holder. Frame Number 10 captured the flag-raising picture, followed by a second picture of Marines holding the flag pole in place and a final photo that he calls his Gung Ho picture—a shot of Marines cheering and waving beneath the newly raised flag.

Joe Rosenthal is a man of small stature and an unassuming bearing. He is painfully modest and will tell you that he is no hero. He rarely mentions—and then only when questioned—that he also covered the Marine assaults on Guam, Peleliu, and Anguar. Iwo Jima was the fourth deadly beach he faced.

Marines who crawled through Iwo's black sands with Rosenthal will also tell you they are not heroes. All the heroes, they say, died on Iwo Jima, many sacrificing their lives to save their fellow Marines. So great was the valor, that twenty-seven Medals of Honor, the nation's highest award for bravery, were awarded to those, living and dead, who fought on the island. Medal of Honor stories, taken from the official citations, are included in this book and document in great specificity the selfless courage of so many who fought on Iwo.

Some 100,000 men—Americans and Japanese—crowded Iwo's eight square miles; the battle could be nothing but personal and the most vicious kind of hand-to-hand fighting.

Iwo Jima today is as it was before the war, an ocean outpost on the fringes of Japan. The tiny island is remembered as the site of a remote battle during a war a long time ago. Rosenthal's picture is widely recognized, though few know his name. A high school freshman in 1945 who read about Iwo in his newspaper would, in the twentieth century, be well into his seventies; Rosenthal is in his nineties.

Iwo Jima was mostly unknown before the 1940s. History, however, takes twists and turns, and by late 1944, World War II moved relentlessly toward the tiny volcanic island. Iwo became a critically strategic site needed by both Japanese and American forces; the Allies needed an air base, the Japanese needed to deny them an air base and protect Tokyo, the ultimate target. It was clear that the Americans would soon invade the small island.

Japanese strategy was to annihilate attacking U.S. forces and retain control of Iwo's vital airfields, but in his heart the Japanese general in command knew he would never leave the island alive.

Tens of thousands died or were wounded after the flag was raised and the fight concluded. Three of the flag raisers fell to enemy fire and never saw the picture; a fourth was seriously wounded. Bill Genaust, who made a motion picture of the flag raising, was also killed; he never saw his famous film. Four Marines from the forty man platoon that climbed and secured Mt. Suribachi that February morning left Iwo unhurt.

This book recounts, in words and pictures, a story that put a Japanese enemy who knew he was destined to die against a U.S. Marine invader who knew he was

destined to prevail. Destiny, as always, had its way; the enemy perished and the Marines prevailed. The cost in blood was staggering, claiming nearly 7,000 American lives and 21,000 wounded. More than 20,000 Japanese perished. Iwo was and remains the costliest battle in Marine Corps history and ranks with Gettysburg and Normandy in terms of bloodshed.

Why Iwo Jima? Why did two armies comprised of 100,000 warriors collide on this eight square miles of volcanic rock nearly unseen on the world's largest ocean, a miniscule speck of land that the Japanese themselves described as "an island of sulphur springs, with no water, no sparrows, no swallows." Why did Iwo Jima figure so prominently in the closing days of the world's greatest conflict? Why did 29,000 die and 21,000 suffer wounds in five weeks of the most violent kind of battle?

Both sides perceived Iwo Jima as vital to their strategies. For the Americans, it was a key stepping-stone on the road to Tokyo. For the Japanese, it was a key defensive outpost on the edge of the inner circle of the homeland defense. Iwo Jima was two sides of the same coin.

Japan took a special interest in Iwo immediately after the fall of Saipan in June 1944. Iwo became a base for Japanese fighters and bombers that harassed American naval forces, and attacked the airfield homes of U.S. bombers that rained devastating destruction on the Japanese industrial machine. Iwo, actually a part of Tokyo, would be the first Japanese soil to face foreign invasion. It was the early warning system that alerted the home islands to oncoming bombers that passed far overhead en route to Tokyo and Osaka and other major centers. Allied forces had to be stopped at Iwo.

The Americans needed Iwo's airfields for its fighter aircraft that would protect bombers over Japan, fighters that could not make the round trip from other island airfields to the Japanese home islands. Iwo would become a safe house for U.S. bombers crippled on their missions, bombers and crew otherwise lost at sea. More than two thousand actually landed at Iwo once it was secure. The Japanese early warning system would be eliminated, giving bombers a greater element of surprise. Conquest of Iwo would be a major morale blow against the enemy because it was a home island of Japan, a nation that had never known a foreign conqueror.

PROLOGUE

MANY PEOPLE ASK Joe Rosenthal the same question: When did you get your first camera? They must believe that it's the first camera that leads a person into the world of photography. That may be true in some cases, but it wasn't the case with Rosenthal. He won his first camera in a contest, a prize for selling magazines as a young lad in Washington, D.C. In those days kids won prizes if they sold twenty of this magazine, or thirty of that magazine. He sold enough to win a camera, but it wasn't that camera that led him into photography.

In the days when he peddled magazines off a bag on his shoulder his family lived in the nation's capital, where he was born in 1911, the youngest of three brothers. His father was a businessman, a reasonably successful businessman. He and Rosenthal's mother came to the United States from Poland and Russia. He remembers his boyhood life as comfortable.

Rosenthal graduated from high school in Washington and, as a young graduate, he entered the real world—in time for the crash of 1929.

He recalls: "I was a kid without any real knowledge of what to do yet in life, but it was certain that higher education was not in the cards. Everyone, even today, knows that many people were out of work in those days. I was lucky. I got a couple of small jobs. I worked in a laundry for a while, and then in a grocery store where I delivered packages from six in the morning until seven o'clock at night. Saturday was a longer work day, we kept at it until eleven P.M. or so, but we caught

a break on Sunday morning. I usually got off and could play a little football. It was sandlot league, the hundred pound class, of which I was pretty good at a hundred and five pounds."

The economic situation took a heavy toll on the Rosenthal family. His father lost practically all of his business, and his brothers went to California to work for an uncle who ran an ironwork and eventually went on to make a fortune.

"I was unhappy in Washington because there was no future that I could see," Rosenthal says. "So I decided to join my brothers in San Francisco. I saved up enough money for the train ride across the country."

The beautiful city of San Francisco won his heart, but the reality was that he had to make a living, and he was quickly down to his last dollar. His brothers supported him for several weeks until he got a job—the first available job he could find—as an office boy in a newspaper syndicate—Scripps Howard's Newspaper Enterprise Association (NEA) in the old *San Francisco News* building.

Rosenthal's duties at NEA included being the "boy" who took care of photo prints. Pictures made by NEA photographers in northern California were distributed by mail and train throughout the West and across the country. Rosenthal was one of the office boys who handled routine chores like print sorting and making mail runs. The boys washed prints in huge tubs of water and dried them on hot tins heated by electricity or sometimes low gas flames. Then they used a big squeegee to press them down tight on the tins and squeeze out the excess water. The prints dried and popped off the tins with a shiny, glossy finish on the image. Once the prints were dry, editors wrote captions and the boys glued them on the back side of the prints. The prints then went out to newspapers in California and the West. It was a typical apprenticeship for beginners learning photography in those days.

"If a beginner showed aptitude, the photographers would, a little at a time, show them the difference between the front end of the camera and the back end of the camera," Rosenthal recalls. "They would show how to set a lens, and load film and focus. And some of them would encourage a youngster like me to consider being a cameraman. We would also learn how to make photo prints from negatives.

"I know it would make a better story if I could say that I used that old magazine camera to make a great picture and was to make still more pictures. But that old camera was long since forgotten—broken or lost, I don't remember which. I learned photography the way most of my generation learned it—the hard way, mistake by mistake under the tutelage of work-a-day photographers who took the time to teach it to youngsters a spoonful at a time."

He was soon out shooting pictures that ended up in the NEA service. Some were printed in newspapers. He liked the work and found it fun going from place to place.

"I felt kind of important carrying that big camera around just like the hotshots on the newspapers that photographed crime figures and celebrities and sports and all the grist that appeared in newspapers and magazines of the day.

"It's different today. The young photographers are much better educated, and they know a lot more about photography when they enter the profession than the youngsters in my time. The camera systems now are different, and everything is shot in color with high-speed cameras, and computers are used to process photos. Even film and photo print making have disappeared.

"No, that was a different time back in the thirties."

The first camera Rosenthal used was a Graflex. It looked like an eight-inch cube with a lens in front that the photographer racked back and forth to keep the subject in focus. The picture was reflected by a mirror arrangement onto a glass and looked down a hood, and you saw your picture on the glass and focused.

It would be several years before the Speed Graphic came along—the camera so many people associated with press photographers, and the camera Rosenthal and most other photographers used in the war.

Rosenthal, like his young contemporaries, received instruction in the simplest, direct way of that time—he was told to just go out and shoot a lot of pictures, bring them back, process them, and be told what was wrong with the pictures.

"I clearly remember my first assignment for Scripps Howard. It was to shoot rhododendrons in Cape Park. They were huge blossoms and apparently quite popular everywhere."

More assignments came, the usual subjects that photographers in the 1930s covered. Some of it was silly, like the Onion Queen in Salinas. And there was sports—San Francisco was home to many first-class collegiate sports teams, what with Stanford just down the road and Santa Clara and St. Mary's. They were all in the big leagues of the national collegiate scene. Track and field was a major sport in California, and there were disasters and other top general news.

Rosenthal had a piece of the action and eventually ended up working for Wide World Photos, a picture agency owned by the *New York Times*. Wide World was purchased by Associated Press, and that made Rosenthal an AP photographer about the time America became involved in World War II.

U.S. troops rest in their bunks on one of the long voyages from training camps to the beaches of Pacific islands during World War II.

National Archive photo

1
THE WAR

SAN FRANCISCANS, WHO considered their city the gateway to the Far East, shared a special sympathy, even a kinship, with those killed and wounded in the December 7, 1941, attack that thrust the United States into World War II. The thousands of miles that separated the Golden Gate from Pearl Harbor did not lessen those feelings.

Joe Rosenthal remembers the time well.

"So much was happening then. Of course, everybody wanted to get into it any way that they could. All my acquaintances were going into the services, one service or another. Others, who couldn't go overseas, volunteered for one thing or another . . . everybody wanted to do something. The general aura of the times was that this was everybody's war, and we all had to pitch in to win it. The atmosphere was really different than it was during Korea, and certainly different than Vietnam. There was no debate over the war, at least in those early days. It was all for one.

"At the time, I had no personal responsibilities, unlike my brothers who had their families to worry about. I could do anything I wanted to do. I felt that I should be in the fight in some way.

"Part of my desire to get into it came from reflecting on the fact that my parents came to this country at the turn of the century. They came from places in Poland and Russia where the treatment had not been very good. They were like many immigrants in the early 1900s; they came here seeking freedom, seeking the chance to marry, to raise a family, to work at whatever they wished to work at, and to progress. Part of that, even now as I tell it, sounds a little bit corny. But even today, more than a century later, I believe it to be true.

"Of course, the war was the biggest story of the time. It was a *world* war. It was the biggest story you can imagine.

"That was the mix that was in my mind as I attempted to get into the war in some meaningful way. I wouldn't have minded being drafted. That would have been okay. I tried to volunteer in several of the services, but I always ran into eyesight problems. My eyes have been poor my whole life. I had vision . . . I still have vision . . . but my eyes are extremely poor, always have been. Even glasses cannot correct my eyesight completely. It's funny, I suppose, a photographer having poor eyesight, but that's what kept me out of the service."

After several attempts at joining up, and being declared 4–F by the draft board, Rosenthal turned his attention to his work, and there was plenty of it connected to the war. As an Associated Press photographer, he covered training and the preparation of defenses, sandbagging of telephone company offices, the dimouts or blackouts.

Rosenthal's friend, Stan Delaplane, had gone to Washington to be assistant to the director of the War Shipping Administration, writing stories about the war effort of the Merchant Marine, the idea being to recruit seamen for the dangerous job of transporting matériel to war zones. He wrote to Rosenthal—would he be interested in working for the same group if Delaplane could get a waiver on the eye test . . . and would he come to work in Washington?

"Stan and his people were organizing an overseas correspondent section for the War Shipping Administration. The offer was that I would come in as an officer of the Merchant Marine and then go out with a writer, travel around, and do war stories about the Merchant Marine's contribution to the war effort," Rosenthal recalls. "It sounded good to me, so in about a minute and a half I made up my mind."

He applied for a military leave of absence from AP, was sworn in as a second class seaman and went to the upper floor of the building in San Francisco, where four hours later he was made a chief. Then he hopped a plane to Washington, where, in about a week, he was made a warrant officer.

"I think that was the fastest, highest rise in the history of the military—or at least the quasi-military."

Once equipped, Rosenthal was off to New York to board a cargo ship, part of a convoy of sixty-four ships spread about a thousand yards apart. His assignment was to make photos of the seafaring activities on board . . . Merchant Mariners moving cargo and war matériel, climbing masts, the stuff of international war transportation.

"Our ship carried a cargo of bombs destined for British and American airports in England and to be dropped at other places as needed. Originally, we thought

we were headed for Murmansk where there was a very heavy war situation. But just before departure, that run was discontinued and we headed for Liverpool.

"That was some trip. We encountered heavy seas most of the way, with the decks awash much of the time. We interviewed the crew, most of them veterans of several crossings. Many had ships shot out from under them and were fished out of the water, lucky to be alive. They came back to the Merchant Marine because they had such strong feelings about the war, especially those who had families mistreated by the Nazis.

"Several times during our voyage, we had to scatter and run when German subs were in the area, and don't think I wasn't nervous sitting on top of all those bombs. Destroyers came up and dropped depth charges around us whenever they thought a sub attack was possible. Once the subs were chased off, we reorganized our formation and continued on.

"Our convoy lost three or four ships during the trip, but I never saw an actual strike by a sub. The hits would come at night, and the sky would redden on the horizon. The red glow told us that one of the ships was in trouble, probably sinking, and I knew there were people just like the people on my ship, floundering in the water, praying that they would be saved. I would say a prayer right then for their rescue.

"The sky would change a lighter red, maybe pink, and then disappear altogether. I wondered what happened, but it was weeks before we knew that any ships had been lost. I really felt helpless."

The convoy swung off Newfoundland and, after fourteen days at sea, arrived in Liverpool. More pictures were made, many in the hospitals where members of the Merchant Marines were treated for their wounds.

Rosenthal was out about seven months, visited several hospitals all over England, then flew to Marrakech and then on to Oran and Casablanca. At each stop, he photographed Merchant Marine ship activities; the stories and pictures flowed. Algiers was home base for about a month, where he did stories on the people that moved the weapons of war around the world. It was in Algiers that word came through—proceed to New Guinea and meet up with another reporter to do stories from the Pacific.

"Well, the only way I could do that was to retrace my steps, fly back through New York, then to San Francisco, where I'd search for transportation to New Guinea. Who knows, maybe I'd have to go through Australia before I got there.

"I finally reached San Francisco and, naturally, I went to visit my pals at Asso-

ciated Press to catch up on things, to hear where others had ended up in the crazy roads that people travel during a war. The AP bureau manager said, 'Joe, we need another photographer to go out to the Pacific. How about it? You interested?'

"Mind you, I was on leave from AP when I joined with the Maritime Service. So at the point that he asked me if I were in a position to go back to AP because they needed someone, I said, 'Hold the phone.' It was arranged that I would come off leave and go back onto the AP staff.

"I can't tell you how excited I was at the prospect of becoming an AP photographer in the big war-photographer's pool. Photographers from AP, International News Photos, Acme, *Life* magazine, and the military, were assigned to the pool and

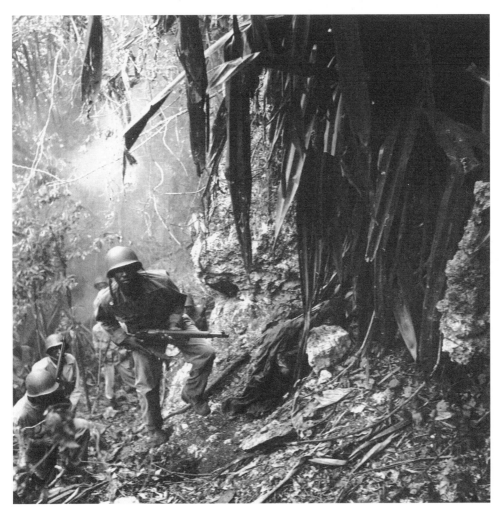

Marines move forward cautiously on Guam many months after the primary struggle for the island was completed. Japanese holdouts continued to harass U.S. forces even as the battle of Iwo Jima was fought.

By Charles Gorry, AP/World Photos

shared the pictures they made on the battlefields of the war. It was the pool and the pool's pictures that told the story of war to the readers of newspapers and magazines on the home front."

In late January 1944, Rosenthal left San Francisco bound for the Pacific war. His first assignment was to meet AP staff photographer Frank Filan, who months earlier covered the battle of Tarawa, a brief but fierce assault on a tiny Pacific atoll. Tarawa was the first place a new Japanese tactic emerged in the island fighting— let the American troops get bunched up on the beach and then open fire on them with weapons aimed precisely on every possible spot along the shore. Filan would win a Pulitzer Prize for his picture coverage of the Tarawa battle, and Rosenthal felt fortunate to receive his indoctrination from an experienced AP combat photographer.

In due course, Rosenthal was on own. He started out in Hollandia covering action in New Guinea. But the action wasn't hot enough.

"I picked up enough about combat photography, and I wanted to get into the assault phase. Actually, the July invasion of Guam was my first frontline operation— I went into the boats with the first assault wave of Marines, made the initial landing that began the recapture of the island.

"To me, the most appealing part about it was that Guam was the first U.S. possession to be retaken from the Japanese, and so I covered the landing and then followed the Marines—and the Army, too, of course—we moved into the interior of the island doing more pictures of the fighting. That went on for about thirty days."

A Navy corpsman offers water to a wounded U.S. Marine on Guam during the battle for the island in August, 1944.
U.S. Navy photo

Once the island was secured, Rosenthal made arrangements to go to Hawaii
to prepare for the next operation on the Navy's list—Peleliu. Correspondents had
considerable freedom of movement in the war zone. They could request—usually
granted—to join an invasion and to pick the unit they wanted to accompany on
the attack.

"The Peleliu beach was very, very humid . . . the surface was hard coral ground,
not so much sand. The coral scuffed and cut the hard boots we wore as we moved
inland. About the third day of the operation, I heard that there would be another
assault on the nearby island of Anguar, and so I requested permission to join that
attack, which was an Army operation. After several days there, I went back to
Peleliu. I must have spent twelve days or two weeks on the island."

Assignments for photographers were usually monitored by AP editors who man-
aged the coverage from editorial desks on the command ships at each action. It was
during a visit to the command ship off the coast of Peleliu that Rosenthal heard
about the forthcoming invasion of the Philippines by General Douglas MacArthur,
and he wanted to move with a group of correspondents heading in that direction
for what would obviously be a major encounter. Now a senior member of the

Pacific correspondent corps, he thought his request would be approved. But instead, he was assigned to the carrier, *Essex*. He complained, saying the Philippine invasion was a bigger story for the AP, but in the end complied and went aboard the *Essex*, where he spent almost two months.

"At least I got a change of clothing and fairly decent meals . . . and every day there was action of some sort. Every day that a flight took off, somebody didn't come back . . . or there was a crash landing on the deck . . . or some plane had to drop into the sea close by and the pilot rescued. In the end, it was a fairly fortunate assignment."

By December, Rosenthal was back in Honolulu, where he took vacation for several weeks, then hooked up with a large Marine force for another island assault. He did not know the island was Iwo Jima.

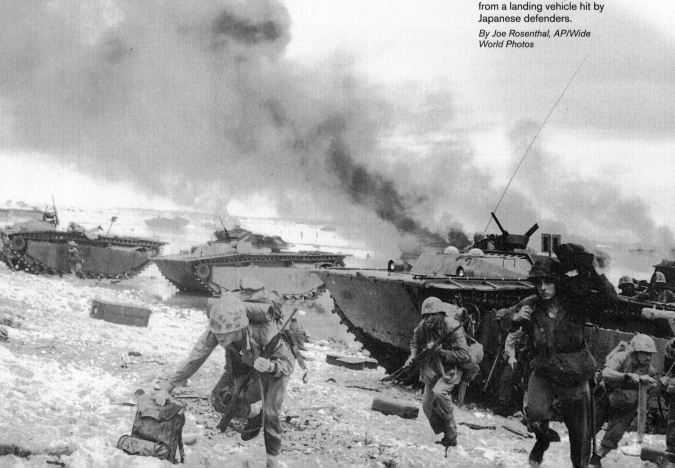

U.S. Marines dash ashore during the battle for Peleliu island in September, 1944. Smoke in the background is from a landing vehicle hit by Japanese defenders.

By Joe Rosenthal, AP/Wide World Photos

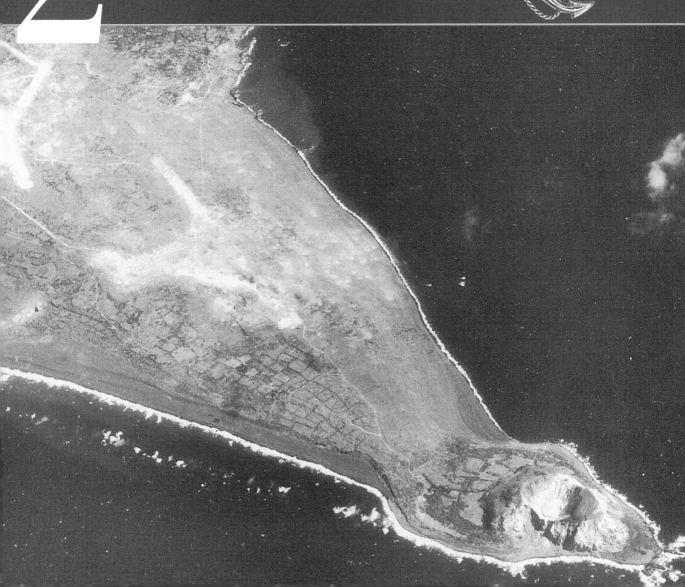

2 THE BATTLEFIELD

Volcano Islands: a group of islands on the north Pacific Ocean,
SW of the Bonin Islands, in about Lat 24 degrees, 48 minutes N;
Lon 141 degrees, 13 minutes E. They are claimed by Japan and
yield much sulphur.

—A Complete Pronouncing Gazetteer of the World, 1922

DURING **THE OCEAN** voyage from Saipan to Iwo Jima, officers and men of the Marine invading force absorbed information about the island. Maps and huge photographs were available. Large, rubber, relief models of the island, created with information collected from aerial reconnaissance, were used in briefings. Pillboxes and fortifications were indicated even though it was known that they were moved on a regular basis and that there were others cleverly hidden by careful, detailed camouflage. Though Americans and other Westerners visited the island in the distant past, little firsthand information described this isolated speck of volcanic ash surrounded by the Pacific Ocean. The island, in fact, was known not primarily as Iwo Jima, but as the largest of an island group called Volcano Islands. Many of the battle stories written and transmitted by war correspondents were datelined, Volcano Islands.

Iwo Jima was said to be shaped like a pear ... or a pork chop ... narrow at the southern portion, wide in the middle and then rounding off in the north. The

PREVIOUS PAGE: An aerial view of Iwo Jima made just prior to D-Day, February, 1945. Mt. Suribachi is the lower right of the photo, with the invasion beach running along the top of the island. Airfield No. 1 is in the center of the photo. *U.S. Navy photo*

volcano—Mt. Suribachi—was the highest point on the island at 556 feet, attached like an ugly, forbidding knob to Iwo's southernmost tip. The volcano's slopes ascended gradually, but soon turned steep and challenging.

At Suribachi's base, Iwo Jima was at its narrowest, less than one mile across.

Beaches of black, volcanic sand stretched northward along both coasts for about 3,500 yards. The area between the beaches was cluttered with rocks and stunted, twisted banyan trees and was largely without green growth. The earth was soft, volcanic ash.

The beaches were formidable—much more so than the invading planners foresaw. Black sand rose steeply from the shoreline in a series of terraces that formed natural bunkers up to fifteen feet high. The beach sand was not sand in the usual sense, but consisted of small pellets like buckshot, durable but light enough to be blown in the wind, and loose enough to frustrate the digging of foxholes. Advancing Marines would sink a foot or more into the sand, and vehicles would struggle for traction in the terraces, slowing both men and equipment and exposing them to deadly fire directed from the Suribachi watchtower.

Troops destined to invade Iwo Jima are briefed on the topography and the Japanese installations they will encounter on the island during their voyage from training camps in Hawaii.

National Archive

Beyond the beaches, the ground sloped gradually upward until it reached the first airfield built by the Japanese atop a broad plateau.

The entire area from the base of the mountain to the airfield could be seen clearly from Suribachi. Protection for the Marines, as a general put it, consisted of "nothing except their tunics."

Still farther north was the second airfield, and just north of that was the island's only town, Motoyama, where 1,200 civilians lived until sent home in anticipation of the coming attack. Near the town was a sulphur mine and a sugar refinery that supported the civilian population.

Continuing north, the landscape changed dramatically from an open plateau to a series of nearly impenetrable, craggy ridges that ran the width of the island.

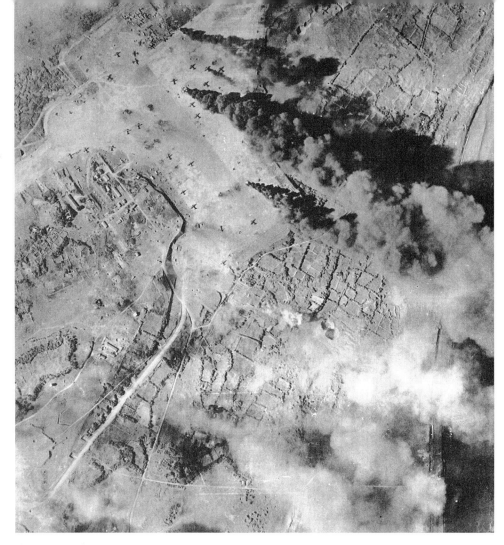

Many of the higher points rose to more than 350 feet, challenging Suribachi's 556 feet. Bizarre rock formations, twisted volcanic deposits, sudden small valleys, and equally sudden outcroppings dotted the northern zone. It was ideal ground for defensive action, consisting of hidden caves linked by tunnels, with gun emplacements that looked down the throats of the oncoming attackers.

Hot sulphur springs emitted stinking fumes, oppressive and depressing. Steam erupted from cracks in the ground, prompting some to observe that the place did not need a war to be hell. In a small clearing among these rocks and ridges, the Japanese started construction of a third airfield.

Rocky outcroppings, crags, and hills in the northernmost section dropped down precipitously to a beachless ocean, four and a half miles north of Suribachi.

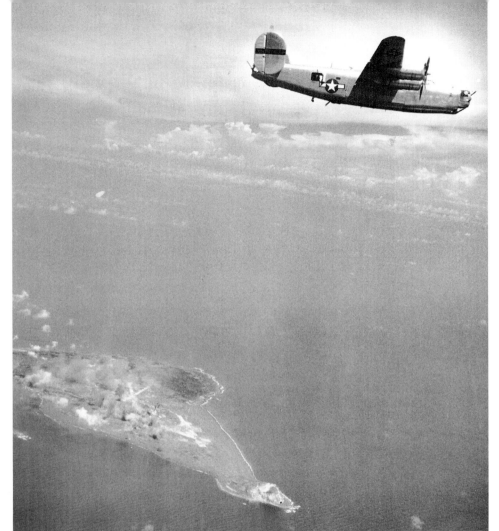

A U.S. Liberator bomber flies over Iwo Jima during an air attack in September, 1944, many months prior the actual invasion of the Japanese island. Mt. Suribachi is in far right end of the island.

U.S. Air Force photo

Nature designed Iwo Jima to be a defensive fortress, and the Japanese incorporated what nature provided into their plan to halt the Americans. Some 100,000 men would clash on this battlefield; 29,000 would die; another 21,000 would suffer wounds.

When Saipan fell to the Americans, it was clear to Japanese planners that Iwo was next and that Suribachi would be a key part of the island's defense. In 1944, work was started to make the volcano well fortified. Caves interlinked by tunnels and trenches were skillfully camouflaged. Weapons trained on the ground below ranged from rifles to machine guns to artillery to hand grenades. Strategically located observations posts called in artillery and mortar attacks from sites hidden in the northern reaches of the island.

Historians would argue later whether Iwo Jima was worth the cost. In the winter of 1944–45, however, the two sides independently came to the same decision—the island was vital to offense and defense. Iwo, once unknown and unseen, would come to center stage in the Pacific war.

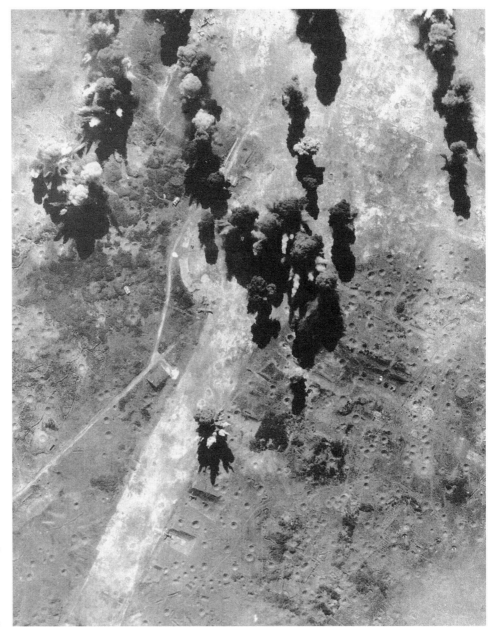

Bombs from American Liberator aircraft explode across the runways of airfield No. 1 on Iwo Jima in December, 1944. Bombing of the Japanese fortress went on for weeks prior the invasion. Area around the field is pock marked from previous attacks.

U.S. Air Force photo

Streamers from phosphorous bombs fall close to American aircraft that had just released their bombs over Iwo Jima. The phosphorous shell was dropped by enemy aircraft just before attacking the American bombers. *AP/Wide World photo from U.S. Air Force*

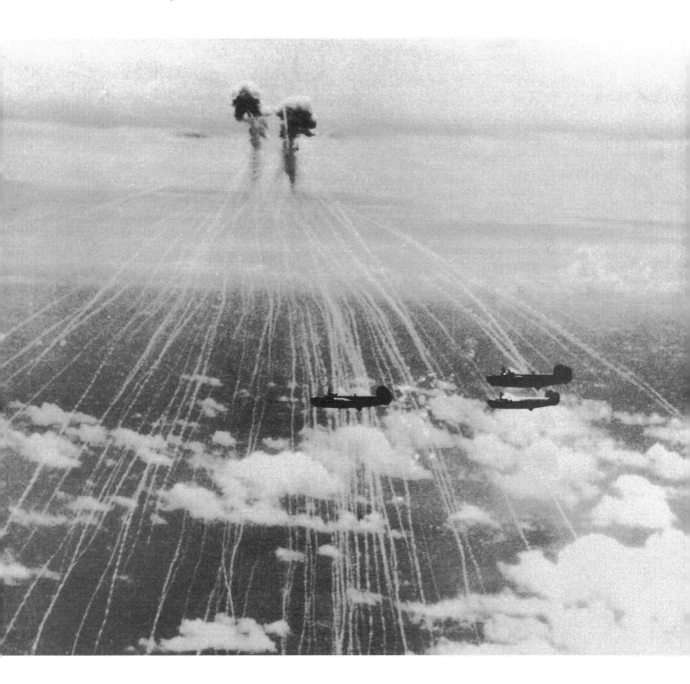

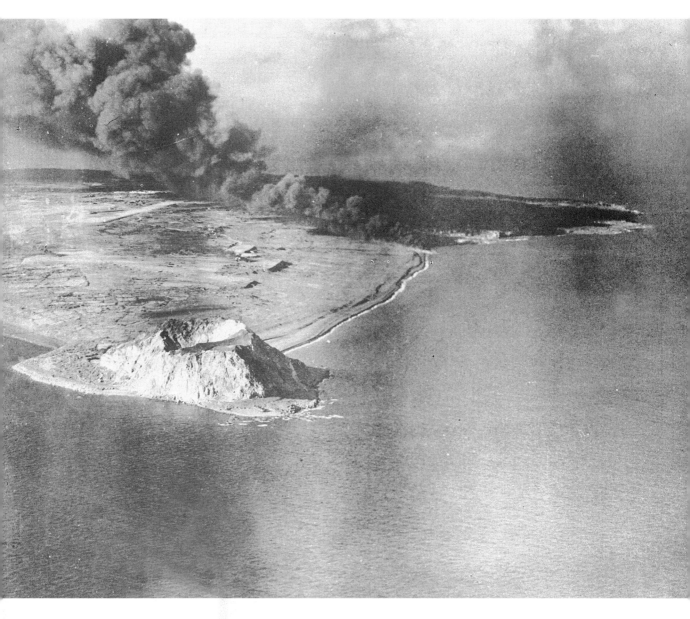

Mt. Suribachi is the foreground in this picture of Iwo Jima. Smoke comes from Japanese installations hit by bombers during the softening up attacks prior to the invasion of the island. The invasion beach runs upward in the picture from the right side of Suribachi.

AP/Wide World photo from the U.S. Navy

3 THE ENEMY

MARINES ON IWO Jima seldom saw live Japanese soldiers. As one Marine put it, "They were not on Iwo, they were in Iwo." Operating from pillboxes, caves, trenches, and tunnels, the Japanese were largely hidden, disappearing from their positions after firing from caves, moving underground through the tunnel network, only to show up at another cave off to the right or left, sometimes even behind the advancing Marines.

While the Marines struggled on D-Day with the loose sand of the terraced beaches and moved across and up the island, the Japanese greeted them with deadly rifle and machine gun fire, and artillery and mortars poured on them from hidden positions. Hundreds of Marines died, and hundreds more were wounded in a rainstorm of firepower the likes of which none had experienced before.

Dead Japanese soldiers were numerous, most of them burned to a charred mass by flamethrowers or demolition charges that blew apart their pillboxes. They were buried in shattered concrete blockhouses hit by shells from the Navy and bombs from the Air Force or burned out by Marines with flamethrowers.

Later, at night, hunkered down in their foxholes, the Marines could sometimes hear Japanese voices underground as enemy troops made their way through the tunnels from cave to cave. It was downright spooky. Small groups of Japanese soldiers attempted to infiltrate Marine positions at night, but that usually resulted in their death.

The masterful plan that created this scenario was the work of General Tadamichi Kuribayashi, commander of the 21,000 or 22,000 Japanese troops on Iwo.

PREVIOUS PAGE: A Japanese casualty of the ridge fighting in the northern area of Iwo Jima is helped by U.S. Marines in the waning days of the battle. Toward the end of the fighting the number of prisoners who surrendered increased but only 1,200 of 22,000 Japanese troops were taken alive. *National Archive*

Kuribayashi, who had spent several years in the United States and Canada and spoke English, was a cavalry officer who fought in China and was then transferred to the Imperial headquarters in Tokyo. His next assignment was Iwo Jima, which the Japanese knew would be the first home island on the American invasion list.

Kuribayashi was a typical Japanese in spirit, determination, and loyalty to his country. Descriptions of him taken from Japanese reports said that he was tall for a Japanese, perhaps five-foot-eight, and had a bit of a Buddha-like paunch with, Japanese press reports said, the heart of a tiger. The few available pictures of Kuribayashi show him wearing the britches and riding boots of a cavalry officer and carrying a stick or a pointer or a riding crop. He looked neat, starched, and precise with a neat, starched, and precise mustache.

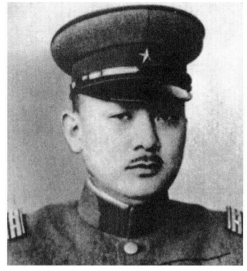

General Tadamichi Kuribayashi, commander of Japanese troops on Iwo Jima.
AP Wide World photo

Kuribayashi knew his assignment to Iwo Jima was a death sentence. Maps told the general the same story they told the Americans: Iwo Jima was isolated in the Pacific Ocean and, once invaded, there would be no escape; the Japanese navy, crippled by severe losses, could not evacuate him or his troops; what was left of the navy had its hands full preparing a defense of the main home islands; battle experience at Tarawa, Peleliu, Saipan, Guam, and the other islands confirmed that escape was not contemplated, and the Japanese warrior's code forbids surrender, a disgrace worse than death. Kuribayashi's fate was sealed.

None of this instilled fear in his heart. Quite the contrary, he believed fighting to the death in the defense of his homeland was an honor of the highest order.

There is a twist in the Japanese language that provides insight into this national concept of honor and duty. The Japanese navy—navy pilots based on Iwo Jima and other places roamed the Pacific striking Allied ships—had a no-surrender policy. A pilot completed his mission and came home. Surrender or capture was not an option for the wounded flyer, or for the pilot whose plane was damaged or was otherwise unable to make it back to base. Eight distinct words were used to report the death of a pilot to his family. Five described self-destruction of some kind—either a purposeful suicide, ramming a plane into U.S. warship or plane, or crashing or exploding the plane to escape capture. The language intricacies set the level of honor.

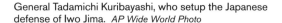

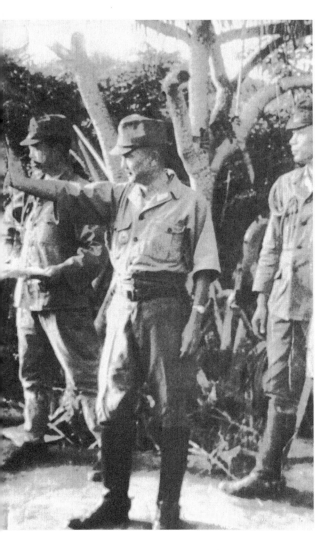

This philosophy accounts in great measure for what Americans perceived as the fanatical defense of the Pacific islands, but what Japanese saw as duty. The differences in the American and Japanese mentality toward battle were striking: Americans were aware they might die, but their effort was aimed at survival and the survival of their comrades, whereas the Japanese saw death as their duty and the ultimate honor.

Over and above all of this, the Japanese believed that their emperor was literally a god, that he was divine in every way. Martyrdom in the service of this heavenly being was a desirable form of worship.

The Japanese army shared these beliefs, which undoubtedly motivated Kuribayashi in his mission to slow down the Americans, and to hurt the American forces as much and for as long a time as possible before realizing his ultimate duty. But he had no illusions about his fate. At one point, Kuribayashi, during the many months of preparation on Iwo, included a telling sentence in one of his letters to his wife, "Do not count on my return to Tokyo." He wrote that his troops understood that death was inevitable, and he commented only ". . . I am sorry to end my life here, fighting the United States of America, but I want to defend this island as long as possible." In his letters, he described the harsh aspects of life for the Japanese on Iwo, fighting dust and flies, cockroaches that crawled on the sleeping troops, and the lack of water. Still, he exhorted his troops to fight to an honorable end.

As part of those preparations, a note was sent to Japanese forces. It was discovered by Marines posted in the caves on Iwo and typified Kuribayashi's instructions to his garrison:

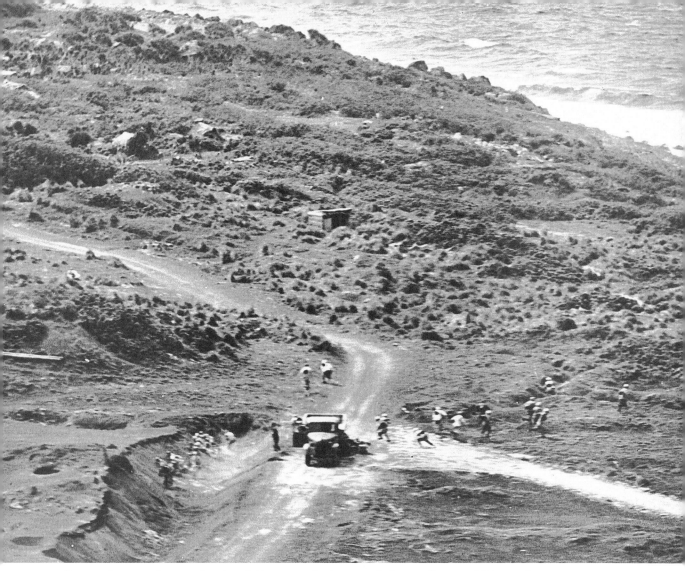

Japanese troops scatter as an American fighter swoops in close on a strafing run. Some run left for a gully; others head for the protection of a ravine on the right. Still others duck beneath the truck for cover.

AP Wide World photo from the U.S. Navy

> *Above all else we shall dedicate ourselves and our entire strength to the defense of this Island.*
>
> *We shall grasp bombs, charge the enemy tanks and destroy them.*
>
> *We shall infiltrate into the midst of the enemy and annihilate them.*
>
> *With every salvo we will, without fail, kill the enemy.*
>
> *Each man will make it his duty to kill ten of the enemy before dying.*
>
> *Until we are destroyed to the last man, we shall harass the enemy by guerrilla tactics.*

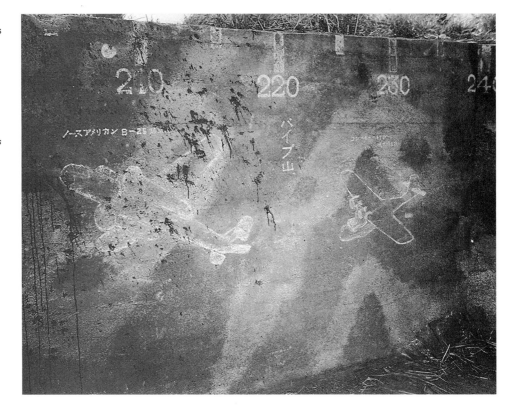

Drawings of American planes were scratched on the walls of Japanese gun emplacements. These drawings are of B-25 bombers and PBY-1 aircraft.

U.S. Marine Corps photo by Cpl Burgess

Kuribayashi's note had the ring of the kamikaze, who were not just pilots, as is popularly believed, but any combatant who swore he would die fighting the enemy. Pilots were the most notorious of the kamikazes because of their successful attacks against American warships: at Iwo, they sent the USS *Saratoga* limping home and sunk the *Bismarck Sea.* At Okinawa, kamikazes sunk several American ships, put others out of commission, and killed thousands of sailors by ramming their bomb-planes into U.S. warships.

Kuribayashi encouraged the spirit of the kamikaze among his troops, many of whom took the kamikaze oath of death and wore the kamikaze white sash during the final encounters on Iwo. While Kuribayashi supported the spirit of the kamikaze, he forbade what he considered wasteful banzai charges against the Marines. These senseless and costly attacks, he knew, would not sustain his plan to delay the Americans and force them to pay the highest price for their gains; he ordered troops to stay at their posts, in their caves and pillboxes, and kill Americans until they themselves were killed, honor bound to fight to the end. Most did. Of the 21,000-man Japanese force on Iwo Jima, only 1,200 survived.

Japanese gunners in blockhouses had a wide field of fire at the invasion beach as this view from inside an enemy installation shows. This blockhouse was equipped with a 120mm gun.

National Archive

Still in all, banzai charges on Iwo Jima were not eliminated. A few, organized in the final days of the battle by lesser Japanese commanders after Kuribayashi lost contact with his outposts, were mounted against the Marines. But they were not effective, serving primarily a single purpose—the honorable, suicidal death of Japanese troops. The Japanese simply ran at the Marines, and the Marines mowed them down.

Knowledge that escape was impossible did not deter Kuribayashi from developing a masterful defense plan. He worked himself and drove his men to create a fortress on the island that was imposing—and effective.

Soon after he arrived on Iwo in the early summer of 1944, Kuribayashi undertook an ambitious construction project. He took advantage of the geology—Iwo stone was soft and easy to cut—and ordered engineers to create tunnels to link various defenses, provide escape routes for soldiers, and allow gunners to fire from several places consecutively, thereby confusing the enemy. Caves were enlarged, huge rooms were created for troops and for storage of weapons and ammunition. Before the construction was completed, miles of tunnels linked caves and other emplacements on tiny Iwo island.

Kuribayashi redirected antiaircraft weapons and used the big guns as artillery. He buried tanks, their effectiveness diminished because of the rocky, northern

topography, and fortified them as pillboxes. Extensive, elaborate camouflage hid heavy-weapon emplacements from aerial reconnaissance. Heavy canon were mounted on railroad tracks in tunnels, rolled out and fired, then rolled back under cover. Where tunnels were impractical, deep trenches were dug and camouflaged to permit troop movement unseen.

The general selected Suribachi as his lookout and made its garrison of some two thousand troops a separate entity; he knew the Americans would try to isolate the mountain by crossing Iwo's small neck at Suribachi's base. Marines did just that, but Suribachi served its purpose well in the first days of the battle. Spotters on the mountain called in artillery strikes on the clearly visible beaches and on the open ground beyond. Artillery hidden in the northern sections of the island, only a few miles distant, blasted away at the unprotected Marines. Cannon and mortars hidden in the caves on Suribachi's slopes zeroed in on the beach and added more gunfire.

Snipers and machine gun emplacements were so positioned as to back up one another, thus preventing or slowing Marine frontal attacks with flamethrowers. Marines learned that it was an effective defense.

American air and sea power was used extensively to disrupt Kuribayashi's plan. For seventy-two consecutive days prior to D-Day, U.S. bombers and U.S. Navy ships blasted away at the island. Tons of shells and bombs hit known targets pinpointed by low-level reconnaissance flights. Carrier-based fighters appeared suddenly and strafed workers on the airstrips and on Suribachi; bombers followed the fighters and drove workers deeper into their caves. At one point, some five thousand shell holes were counted on Iwo. Despite the bombing, however, the airstrips were quickly repaired, and Japanese fighters, their efficiency reduced, nevertheless mounted occasional attacks. Japanese artillery, which could have fired on naval vessels offshore remained mostly silent so as to not reveal their locations, awaiting the day when Marines would land on the island's black sands. Much construction was undertaken at night when American attacks could not be as effective.

U.S. ships fire rockets at Japanese installations on Iwo Jima in the hours prior to the invasion of the island Feb. 19, 1945. This photo was made from a nearby landing craft waiting for the word to go ashore. *AP Wide World photo from U.S. Navy*

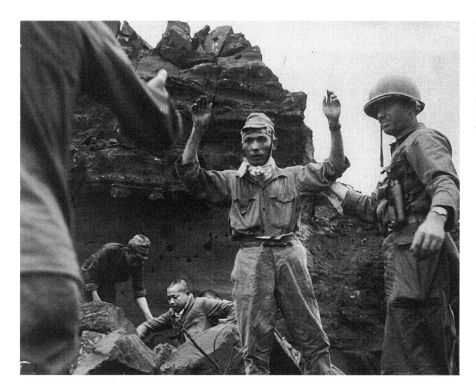

The first of 20 Japanese emerge from a cave in which they had hidden for weeks. The were discovered in early April after the battle for Iwo Jima was completed.

U.S. Army Signal Corps photo from AP Wide World

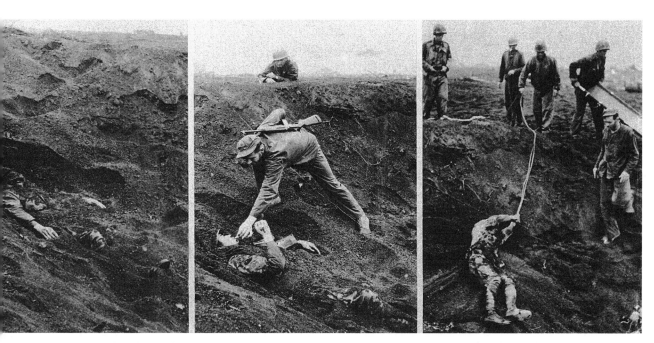

Three picture sequence shows Japanese soldier playing dead covered by volcanic ash of Iwo Jima. A Marine sees him breathing and offers a cigarette, then other Marines, fearing he might be booby trapped, pull him out of the ash with a rope. He had played dead for one or two days.

U.S. Marine Corps photo from Leatherneck

Marine Corps interpreter questions a Japanese prisoner soon after he was captured in the fighting in the rocky northern area of Iwo Jima.

U.S. Marine Corps photo by Cpl. Gene Jones

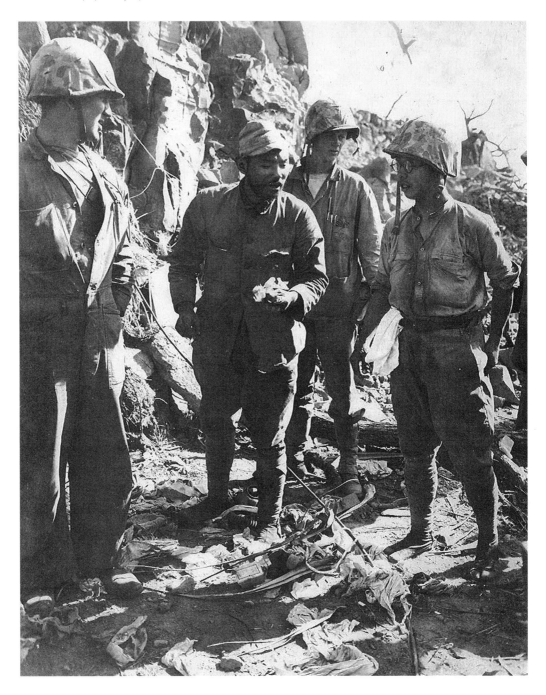

"We heard Tokyo Rose announce the day before the landing that a Marine landing on Iwo had been repulsed, and that their bodies lay scorching in the sun. But the Japs mistook the LCIs that supported the underwater demolition teams as the landing force. It was not comforting to learn that after all that shelling and bombing, their shore batteries could still hit our ships.

—SGT. ALBERT J. OUELLETTE
Squad Leader

"Any one who has been there can shut his eyes and see the place again. It never looked more aesthetically ugly than on D-Day morning, or more completely Japanese. Its silhouette was like a sea monster with the little dead volcano for the head, and the beach area for the neck, and all the rest of it with its scrubby, brown cliffs for the body. "I hope to God," a wounded Marine said later, "that we don't get to go on any more of those screwy islands."

—JOHN P. MARQUAND
HARPERS, May 1945

"Anyone who has been there can shut his eyes and see the place again. It never looked more aesthetically ugly than on D-Day morning, or more completely Japanese. Its silhouette was like a sea monster, with the little dead volcano for the head, and the beach area for the neck, and all the rest of it with its scrubby, brown cliffs for the body. 'I hope to God,' a wounded Marine said later, 'that we don't get to go on any more of those screwy islands.'

—JOHN P. MARQUAND
HARPER'S, May 1945"

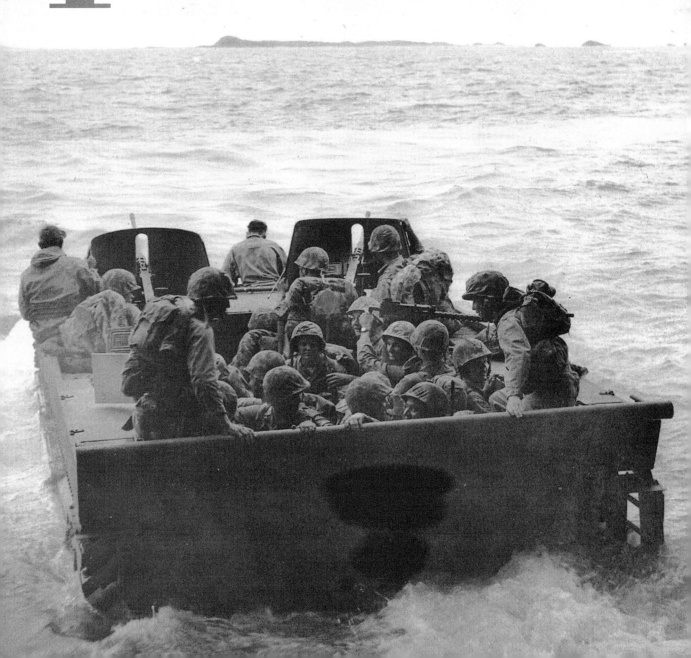

IWO JIMA WAS bombed from the air and shelled from the sea for more than seventy days before the invading fleet, moving closer each day from their embarkation points in Hawaii and Saipan, finally arrived off the coast of the island in the dark, where they rested quietly offshore.

It was February 19, 1945.

The troops on board did not see the daily pounding administered by naval ships, bombers, and carrier-based fighters, but on D-Day, about 3:00 A.M., a crescendo rolled across the water, a steady boom-boom of man-made thunder from the Navys big guns. Explosions on the island and bursts of orange and white fire from the Navy's cannons shook the vessels and the men in them as the softening up process commenced, interrupting the traditional invasion-day breakfast of steak and eggs.

Days earlier in Hawaii and Saipan, and during the ocean trip to Iwo, briefings were held regularly about this moment. Now, in these early morning hours before sunrise, the briefings became all too real, even though the island, a distant landfall on the horizon, was barely visible, lit for an instant at a time by the flashes of shells exploding on the beach and on the slopes of Mt. Suribachi.

Daylight broke bright and clear as the bombardment continued to pump tons of shells onto the enemy. The blasting ceased momentarily as planes bombed, rocketed, and strafed the beach and the sides of the mountain. The early light offered their first view of the island to the tens of thousands on the ships who had, until recently, never heard of Iwo Jima. They saw it now from the transports some Four

PREVIOUS PAGE: Marines in a landing craft head for the beaches of Iwo Jima.
U.S. Marine Corp Photo

thousand yards offshore—a scene alternately clear or obscured as smoke and dust from the bombing transformed the distant shore from a defined landfall on the horizon one moment to a dusty, smoky smudge barely visible the next moment. When the planes returned to their carriers to reload for another attack, the big guns resumed. The off-again, on-again pattern repeated itself numerous times.

Intense bombing continued virtually nonstop. Marines were told that attacks, which had been a daily drill for more than two months, were increased as the invasion force neared D-Day.

The aircraft and ships at sea sought to knock out radar monitoring and radio reporting to Japan about B-29 bombers headed for Tokyo and other Japanese cities. Shelling also targeted pillboxes, artillery installations, and as much of the Japanese defense system as possible.

Invading ships are off shore at Iwo Jima. Mt. Suribachi is silhouetted. The invasion beach stretches from Suribachi to the right.

U.S. Marine Corps photo by Kaffman

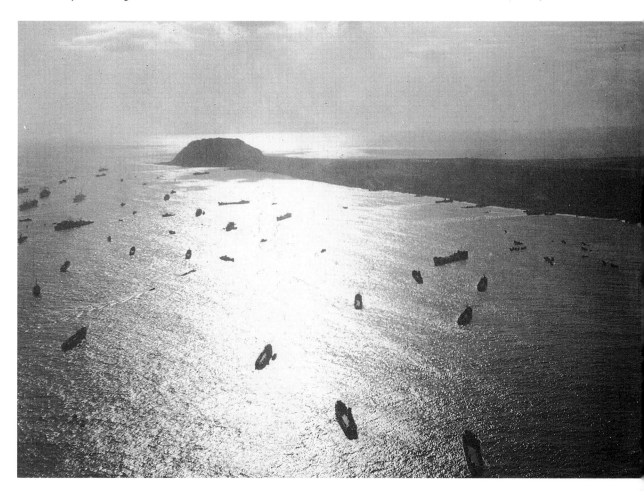

Joe Rosenthal recalls that, as he watched the bombing and strafing, he found it hard to believe that anything could withstand the tons and tons of explosives poured onto the island. The display of U.S. firepower raised troop morale, but at the same time he knew that similar attacks on Peleliu had not been all that effective. His colleague, AP photographer Frank Filan, told him about Tarawa, where the Japanese defenses buried deep in the earth survived the shelling and bombing relatively unscathed.

The new day also revealed a sight never before seen in the Pacific—an armada of 450 ships that carried a force of 80,000 Marines assembled for the assault on this eight-square-mile volcanic island.

Rosenthal knew from the shipboard briefings that this speck on the Pacific was vital to the eventual invasion of Japan, but that did not lessen his awe at the size of the gathered force.

"Ships covered the ocean as far as I could see," he says, "all sizes and shapes. Big ships, battleships and carriers, and smaller ships like destroyers, and still smaller vessels, the ones that would take us ashore. It was an amazing sight and, frankly, I was unprepared for it. Many of the Marines on deck felt the same way and commented at the size of the invasion fleet. That bolstered morale, too."

During the voyage from Pearl Harbor, with stops along the way in Saipan and Guam, the traveling force saw only a few ships at a time but now, at dawn, off Iwo's coast they had come together for this, D-Day, at Iwo Jima.

The invasion armada, largest gathering of war vessels in the Pacific campaign to that time, are assembled off the shore of Iwo Jima just prior to the landing.

AP Wide Wide World photo from U.S. Navy

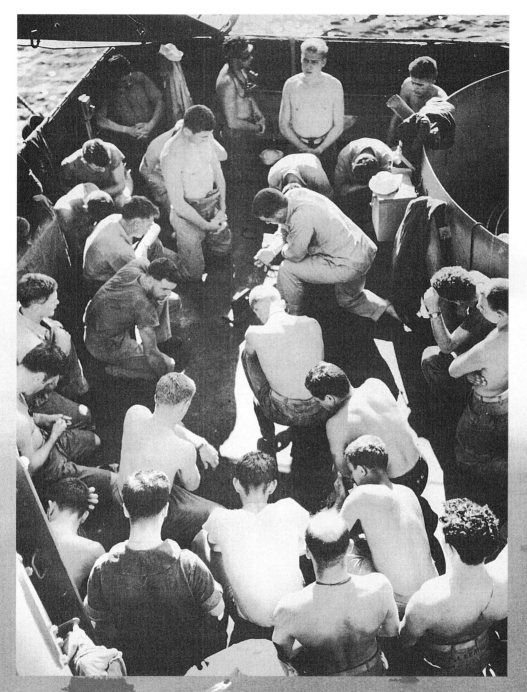

Marines, Seabees, and Coast Guardsmen kneel on the foredeck of a landing cfraft in final prayer before zero hour sends them into the D-Day battle for Jiwo Jima.

AP Wide World Photos from National Archive, U.S. Coast Guard photo.

The sight set Rosenthal to musing: "As I waited there on the ship, I thought to myself, 'I've been here before,' and I went over in my mind what I learned about combat photography from others and from the previous beach assaults at Guam and Peleliu and Anguar. I remembered Frank Filan telling me how he leaned on the rail of a troop ship (much as I was doing at the time) off the Tarawa beach, and watched Navy cannon and aircraft blow the hell out of that tiny atoll. Frank, like so many of the Marines who would land on Iwo, couldn't see how anything could survive the blistering attack on Tarawa. Admiral Keiji Shibasaki said that a million men couldn't take Tarawa in a hundred years.

"I thought to myself, as the cannons roared and shells exploded on the horizon, both Shibasaki and the Marines were wrong. Japanese defenders survived the bombardments and, relatively unhurt, allowed the Marines to bunch up in the water and on the beaches before opening fire. It was a bloody mess. Still, the Marines won Tarawa in a few days of the bloodiest fighting encountered to that time in the Pacific."

In the early phases of the Pacific war, the Japanese often resorted to so-called banzai attacks against advancing Marines. The banzai charge occurred when a force of Imperial soldiers—sometimes numbering in the hundreds—formed up and charged the Marines in an unprotected, frontal assault. Waving swords, firing rifles, and throwing hand grenades, they ran at the Marines headlong. These suicidal charges were invariably futile. The Marines decimated the attackers before they got close.

The banzai tactic was not used at Tarawa. Mortars and artillery carefully zeroed in on the beach, and deadly machine gun crossfire hit the Marines as they waded ashore. The Marines eventually prevailed, but only after suffering serious losses in the hand-to-hand fighting required to dig the Japanese out of their fortified emplacements.

Rosenthal wondered whether he same tactic could expected on the beaches of Iwo.

The Marines learned later that General Tadamichi Kuribayashi's study of the earlier battles convinced him to construct an elaborate defense system that involved the use of caves, interconnecting tunnels, and detailed use of camouflage. Kuribayashi forbade banzai attacks; he wanted his forces to last as long as possible, and inflict a high toll on the invaders.

He instructed his troops to take ten Marines with them for every Japanese killed. Every Japanese solider, Kuribayashi included, knew he was destined to die on Iwo Jima. Japanese soldiers would fight to the finish; surrender was out of the question.

Passage to the beach was not the straight line that Rosenthal and his Marines expected. Their boat and others circled waiting for still other landing craft to line up with them so they would hit the beach about the same time.

The first wave landed at 0900 hours, and Rosenthal thought that he had called it right for a H plus one landing, arriving ashore by 1000, pretty much as planned. But the circling continued in a delaying action until, finally, just before noon, his group of ships turned in unison and headed for the shore.

The first waves of Marines head for the Iwo beach on D-Day. Suribachi forms the backdrop. Dust covers the island bombed by aircraft and Navy shelling as the landing craft close in.
AP Wide World photo from U.S. Navy

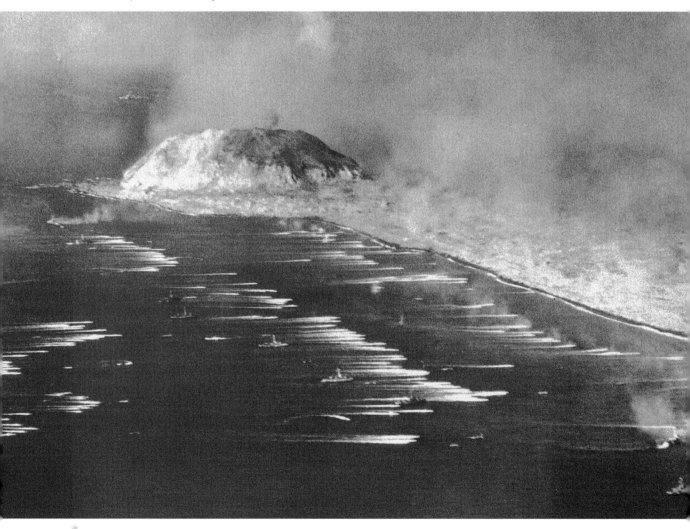

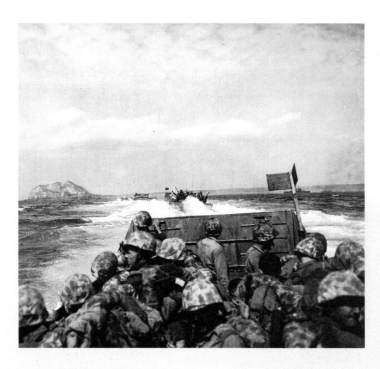

Marine landing craft approach Mt. Suribachi and the Iwo Jima beach on D-Day.

National Archive, U.S. Marine Corp photo by Sgt. David Christian

Marine landing craft head for the beach on Iwo Jima on D-Day. This photo was made from another landing craft of the invasion forces.

AP Wide World photo by Joe Rosenthal

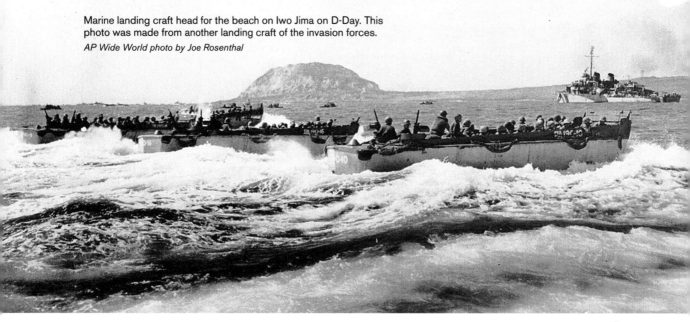

"I stood occasionally and made pictures of other boats loaded with Marines and their gear headed toward the beach, most of them lined up with our ship, and with Suribachi in the background.

"Even as I made the pictures, the Navy shelling and the air attacks continued. The sounds of the shrieking shells headed for the island mixed with the landing craft's engine noise and the water slapping the sides of our boat. The targets of the big guns were farther inland now and up higher on the side of the mountain.

"Dust cleared and the smoke drifted away, and as we moved closer to the island, the detail of its topography gradually emerged. There was no mistaking it—Suribachi Yama off to my left was the single descriptive feature of the island. It was not a pretty mountain. It lacked the graceful sweep I'd noted in pictures of Japan's Mt. Fuji; it lacked also the craggy majesty of our mountains in

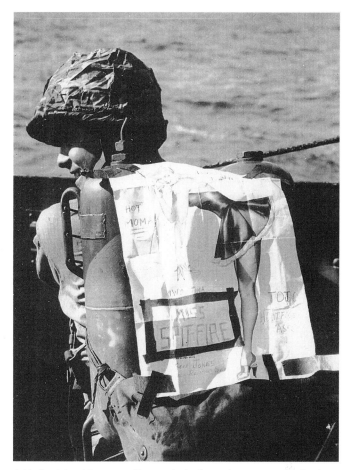

A Marine takes his sense of humor, in the form of a poster on his back, with him on the ride to the invasion beach of Iwo Jima.
U.S. Marine Corps photo

the United States. It was an ugly, brown hump, brooding and dominant, stuck by unthinking gods on the end of the island, its summit 556 feet above sea level and, as we knew, its caves and tunnels manned by Japanese watchers who marked our every move. I could not escape its presence, but my attention was focused on two things: survive the beach . . . make good pictures of the war. If someone had told me then that this homely hill would play the defining role in my life, I would have told them they were crazy.

"Concerned with survival, my thoughts naturally turned to my Marine comrades in the landing craft. They were really just kids, seventeen or eighteen or nineteen years old. I was, comparatively speaking, an old man of thirty-three, in

reasonable shape, but on the short side (I am only five-foot-five) and wearing glasses. I talked as little as possible to the kids. I knew what these beach landings were like. Some of these Marines, many of them as it turned out, would die in just a few moments, and maybe me with them. I guess it was selfish, but I didn't want to get to know them too well and then see them fall to enemy fire. They were kids. They hadn't lived yet. To see them die here, now, someone I had gotten to know, that would be terrible.

"As we moved along, I noticed one kid looking at me. I wagged my finger like a windshield wiper in front of my glasses against the spray coming over the side. He smiled. I smiled. And then we each returned to our own thoughts, with me hunched over my Speed Graphic to protect it from the salt spray. But the image of their youth stayed with me, these kids, these Marines. I'd seen kids just like these at football and basketball games, and now they were here facing a fanatical enemy in a place they first heard of only days before. They were mostly teenaged boys who at another time and place would be more concerned with winning Saturday's football game and wondering which girl would be their date at the prom. In just minutes, some of them would lose a leg, another a hand. Some would hurl themselves on hand grenades to protect their fellow Marines. Others would literally disappear in a sudden, unexpected mortar blast scoring a direct hit.

"I thought of myself and assessed the peril on the beach, but I looked at the landing from a different point of view, the point of view of an older person. Yes, I would hate to have been badly wounded, but it wouldn't have meant so much had I been killed. Lots of guys were.

"I also thought about my role here and how different it was from those around me, and how I ended up at this particular spot on the ship's deck. The civilian combat photographer, or correspondent, had an advantage over those who actually fought the battle. We correspondents picked our time and place for stories and pictures. The Marines couldn't do that. Their order was to go forward, no matter the cost in life and limb. After considering what I'd heard from Filan, and the experience gained covering Guam and Peleliu, I believed the best time for a photographer to arrive on the beach was H Hour plus one, or one hour after the first Marines landed. If I arrived earlier, it meant being pinned down with little chance for pictures, and I'd be in the way of Marines coping with the tough job of establishing a beachhead . . . if I arrived later, I would probably get better assault pictures as the Marines began to move forward and engage the enemy. So, in the days before we arrived at Iwo, I made a bargain with myself and decided on the slightly

later arrival. It made sense on the deck of a transport riding across the Pacific. But, as it turned out, I sure called it wrong.

"My choice for the later arrival prompted me to check around to see what landing craft would fit the schedule that suited me. I located an LCVP that would hit the beach at H plus one. I asked the Marine captain in charge of the group if I could board his boat for the landing. He said I'd be welcome if I didn't mind a ride in a craft that carried troops and mortar ammunition.

"So there I was at six-thirty am, on February 19, 1945, in the company of my carefully selected comrades, watching the relentless attack on the distant target and awaiting the ride to the beach."

The signal to board the landing crafts was issued, and the first wave headed for shore. Soon, Rosenthal's unit was called. It was their turn to board. Rosenthal remembers, "I said to myself, 'I'm ready,' and I scrambled down those clumsy, shifting, unsteady cargo nets into the LCVP. Some Marines boarded in the bowels of the ship, then a huge ramp fell down and a burst of sunlight lit them in a almost blinding flash. But my landing craft, once filled with Marines and mortar ammunition, simply moved away from the transport on the ocean's surface.

"My time would come when it was time to come. I had a sense of a hereafter, if I can put it that way, and that helped put aside thoughts of what would happen on the beach. That sounds fatalistic, but that is what I thought then, that was my mind-set."

The ship lurched to a sudden stop on the beach, the ramp fell down instantly, and the Marines ran forward. Some of them pulled a small, wheeled ammunition carriage loaded with armaments. Rosenthal stood up and made his first two pictures—the Marines as they charged from the boat toward what looked like a ridge line. It was actually one of several sand terraces, each about fifteen feet high.

"Charged" is not the right word; no one charged; no one could run in the classic sense on that beach. Iwo sand is volcanic ash mixed with small modules of granulated volcanic deposit. Running through it was difficult. Slogging through it, sinking up to the ankles, sometimes up to the thighs is what happened as the attackers moved forward. One Marine described it perfectly—it was like trying to run in a bin of wheat. The footing was made worse by bombs, mortar fire, and hand grenade explosions that loosened the ground still more.

Incoming fire hit the landing party immediately. Mortar rounds landed nearby and heavy machine gun fire, both U.S. and Japanese, chattered. There were calls for stretcher bearers. Then more explosions and rifle fire.

Rosenthal recalls the noise clearly:

"The noise was overpowering, more disconcerting even than the threat of death. Too often, I missed a picture as an explosion threw up the sand in a black shower but disappeared before I could raise my camera.

"After hitting the beach, the first thing I did was sort out a lot of confusing activity, and intuition played a great part in that. I missed as much or more than I could catch. Often the sound of an explosion nearby overpowered my thought process, the sheer sound of it taking over all of my attention.

"The picture part is another question. Often there was an explosion, but what I saw was so often gone before I could raise my camera . . . sound and smoke lin-

An instant after the landing craft hits the beach on D-Day Marines dash forward, pulling their munitions cart with them.

AP Wide World photo by Joe Rosenthal

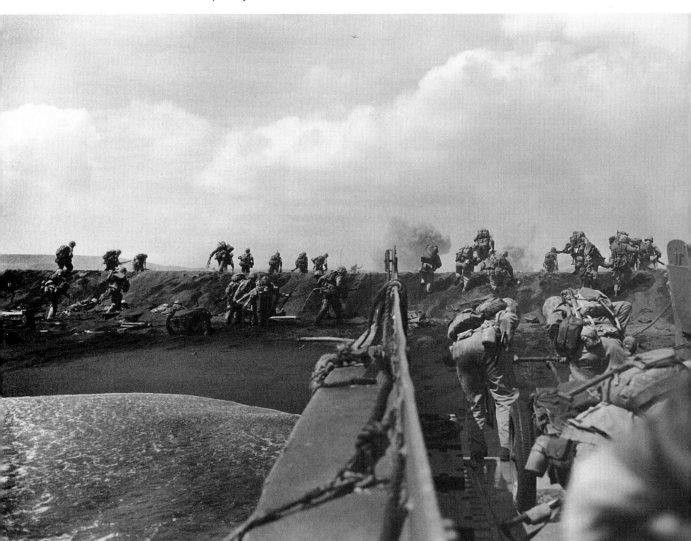

gered on. But the picture part was gone . . . I found myself turning from one loud, disturbing sound to another . . . and at the same time trying to get peripheral vision working so I could see more things happening . . . at the same time quickly respond to them . . . and look for composition of the picture . . . I didn't want to just snap away. A picture requires substance . . . it requires a kind of composition that emphasizes what's in the photo.

"Of all the sounds on that beach that live in my memory, none is more vivid than the call . . . 'Corpsman, Corpsman!' I knew someone was hurt . . . not dead, but hurt . . . probably in pain. It was seldom the wounded that shouted . . . it was their companions that sought help for their buddies.

"I have said this before, and I have written this before, and I mean it with all my heart. I say it again because it is one of the strongest recollections I have of that day more than a half century ago. Surviving that beach on D-Day was like walking in rain without getting wet. No one can explain how he survived. I surely can't.

"I ran up the beach and, as in the other assaults, I looked for some kind of quick cover . . . I never could escape that feeling of grabbing for Mother Earth . . . that

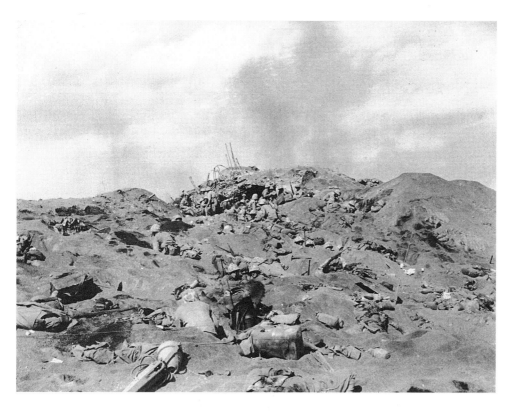

Marines dig in on the Iwo Jima beach after landing on D-Day. In the background is shattered Japanese pillbox.

AP Wide World photo by Joe Rosenthal

feeling of what the hell am I doing here . . . I didn't escape those thoughts on Iwo . . . but I just had to shake myself loose . . . focus my mind again to the job that had to done . . . let everything else be excluded.

"And so it was."

Rosenthal continues:

"Iwo sand was loose and gray/black . . . it was hard to move at anything that resembled running speed. As I ducked from shell hole to shell hole, I spotted bodies and body parts of those who ran this route before me . . . I remember patches of sand discolored to a deep red black by the blood of those who proceeded me . . .

"Death on this beach was violent . . . more so than other beaches. That is because it was mortar fire that killed so many . . . not rifle or machine gun fire . . . though they took their toll, too. But the mortars were powerful explosives . . . so very many died instantly from the fierce blast of a nearby mortar round . . . their bodies literally torn apart instantly by the tremendous force of the mortar.

"I shot pictures of Marines moving up the beach, then sought cover behind a blasted-out blockhouse or pillbox. I made more pictures of the Marines on the beach. I tried for pictures of a burning jeep but couldn't get it right.

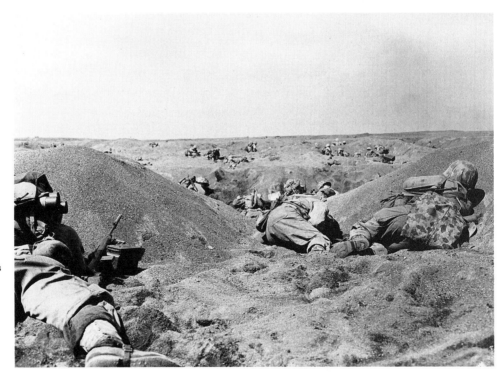

Marine is shot dead while others on the Iwo Jima invasion beach move forward against the enemy.

AP Wide World photo by Joe Rosenthal

"I got up and followed two Marines who were moving forward. That sand, I thought . . . it slows me down, makes me a target . . . I couldn't run from cover to cover . . . suddenly I heard a loud, metallic clang and I looked up in time to see the helmet of one Marine fly several feet into the air . . . he took two more steps and fell to the sand. I jumped in a shell hole and spent a few minutes catching my breath . . . I no sooner looked up and another Marine fell alongside me.

"In the face of the fierce fire from hidden Japanese gun emplacements, the advance of the Marines was impressive. No matter how many fell . . . more kept coming. I wanted to get a picture that told that story . . . I circled around from hole to hole and finally got myself into a position where I could photograph two slain Marines with other Marines running fearlessly past them, toward the enemy pillboxes.

"As much as the flag picture meant to me and to many others, I have always believed that these pictures on the beach captured the real story of Iwo Jima. They

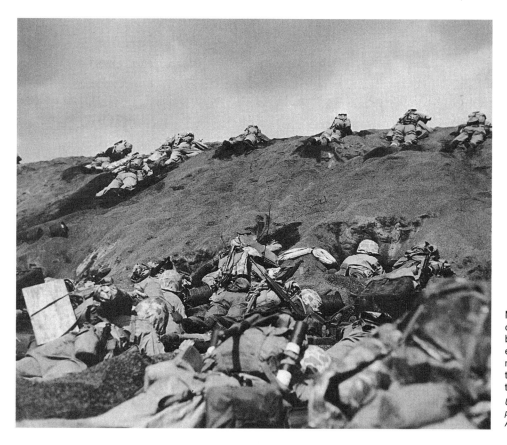

Marines keep low on the Iwo Jima beach as an earlier group moves forward to the top of a sandy terrace.

U.S. Marine Corp photo, National Archive

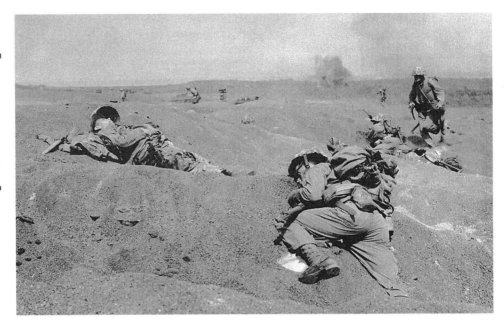

A Marine rushes past his slain comrades on the Iwo Jima beach on D-Day. Joe Rosenthal, who made this picture, said it most reflected what happened during the invasion. "No matter how many Marines fell, there were more coming forward to take their place. The Marines just kept coming."

AP Wide World photo by Joe Rosenthal

showed valor, gallantry, and courage in the deadly moments of the assault. I watched those Marines. They just kept coming and coming and coming. I watched them run past their dead and wounded, across the deadly beach where the Japanese mortars were so finely zeroed in on the attack zones.

"Japanese commanders, Kuribayashi probably among them, told their troops that Americans were afraid to die and that the Japanese therefore were superior fighters. The beaches of Iwo Jima proved that theory wrong.

"I made more pictures on the beach and then, at the end of the afternoon, I made my way back to the spot where the boats arrived with reinforcements. I wanted to hitch a ride to the command ship and send my pictures off to Guam."

When the shore came into view Rosenthal discovered the reason for his delayed landing earlier in the day.

"I suppose I noted the wreckage on the beach when we landed," he recalls, "but frankly my attention was focused on finding cover and getting set for picture taking, and getting inland a bit, away from the beach."

Now, at dusk, as he sought transport to the command ship to get his film aboard a plane to Guam, he got a better look at the tangled mass of twisted metal, jammed tanks, and overturned landing craft that clogged long stretches of the beach.

It was as it some heretofore unknown giant of enormous size had swept a massive hand in the surf and along the sand, turning over huge boats, vehicles, and

tanks. Of course, that wasn't what happened. High surf overturned many vehicles. Fire from enemy mortars and artillery zeroed in on the beach had torn apart both men and equipment, thrown men and machine asunder and created a disaster of the beachhead. And the peculiar black sands of Iwo stopped the tanks and other armored fighting machines.

Mortar fire continued to be especially deadly, their explosions walking across the beach as orderly as soldiers on parade. When it appeared that the barrage was past, it walked back again. It was this fire that Rosenthal encountered when he landed, coming as it did when Marines and equipment were bunched up on the beach during the early assault.

Then the sand took its toll. Vehicles bogged down. Even some of the bulldozers were unable to move forward and open corridors through the sand terraces. Marines unloaded supply vessels by hand and carried ammunition and equipment by hand to the troops because wheeled vehicles couldn't make it. And all the while, Japanese spotters on Suribachi were calling in fire from all over the island, literally from all over the island.

Amtracs, tanks, and boats are askew on the beach at Iwo Jima, victims of Japanese gunfire and the heavy surf of the island's shore line.
Coast Guard photo, National Archive, by Robert Warren

Rosenthal again, "I learned later that the first wave of Marines to land encountered very little resistance. They scrambled across the beach and headed for an inland airfield which was their first objective. To this day military historians are uncertain as to what happened. One theory was that Kuribayashi's troops were confined to their caves and shelters during the air and sea attacks, and were too dazed to strike the first troops.

"The other theory is that Kuribayashi had a plan—let the Americans pile up on the beach, then turn all hell loose on them with mortars and artillery aimed with pinpoint accuracy, and with spotters on Suribachi calling the shots.

"It was during this firestorm that I had hit the beach."

Military historians today believe that Kuribayashi waited patiently, returning only light fire on the first incoming troops. Marine units that landed early

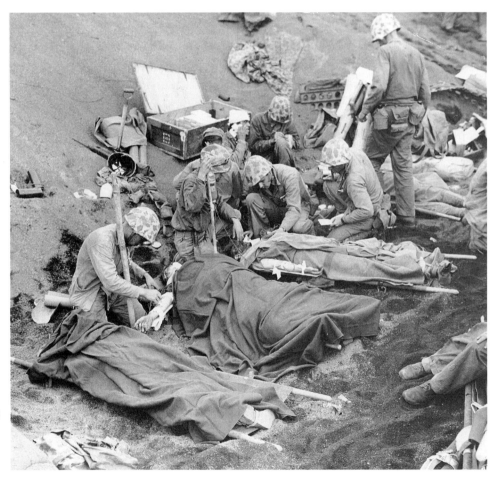

A medical team attends to the wounded at an aid station on the battlefield.

AP Wide World photo

reported later that they thought the intensive bombardment had done its job and that the taking of Iwo Jima would be a snap.

Once the strange sand of the island slowed progress and the high surf overturned huge ships and machines, and the mass of men clogged the beach, Kuribayashi turned on his devastating fire power, wiping out thoughts of an easy invasion with a rain of death.

The onslaught was hell's horror. No one could move . . . not forward, not backward, and not to the right or the left. Tumbling cans that looked like oil drums came soaring through the air and exploded, throwing shrapnel in every direction. Pillboxes emerged like magic from the terrain and poured a hail of fire onto the beach. Artillery from the other side of the island opened up. Other cannon in caves on Suribachi fired on the hapless Marines on the shoreline. Landing craft were hit in the water, the Marines on board slain before they fired a shot.

Covered bodies of Marines were lined up, as well as stretchers with the wounded awaiting evacuation. Still mortar and artillery shells came in, wounding again those already wounded.

Rosenthal finally hitched a ride on a vessel headed back out to the fleet offshore and, after several transfers to other craft, made it to the command vessel in time to get his photos on a plane to Guam.

He wondered whether he could return and face that beach yet again.

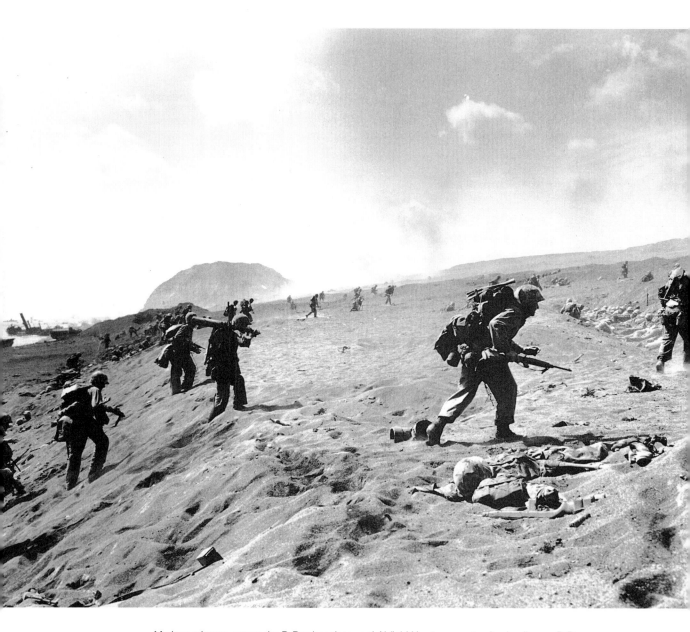

Marines advance across the D-Day beach toward Airfield No. 1 moments after landing on D-Day.

AP Wide World photo by Joe Rosenthal

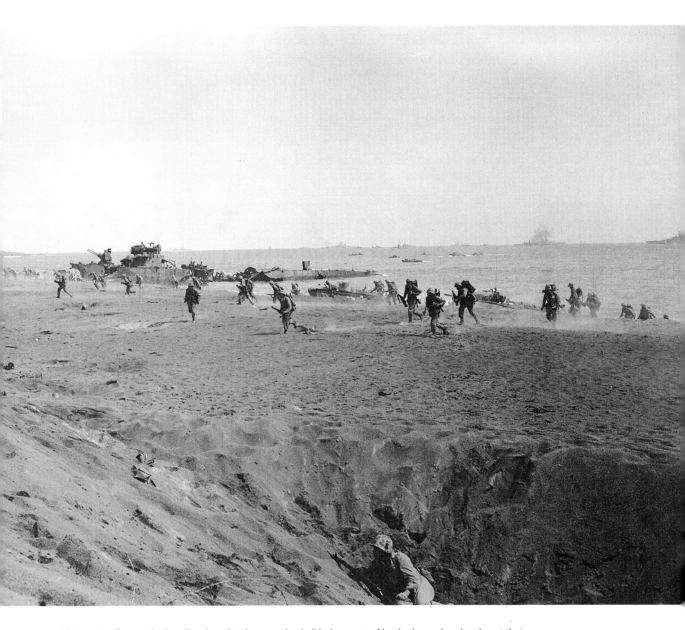

Marines landing on the Iwo Jima beach take cover in shell holes created by the heavy bombardment that preceded the D-Day invasion.

AP Wide World photo by Joe Rosenthal

On the afternoon of D-Day more troops land on the Iwo Jima beach, and with them tanks and other heavy war machines.

U.S. Marine Corps Photo, National Archive, by Pvt. Bob Campbell

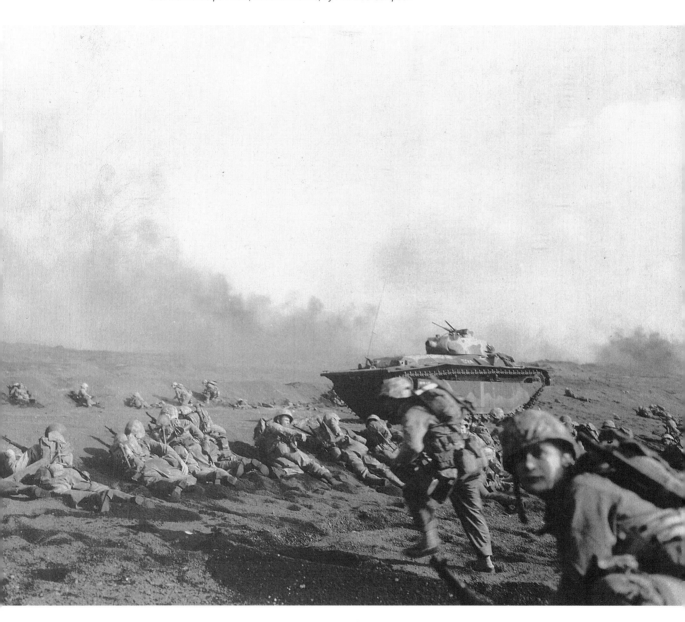

Marines under fire on the Iwo Jima beach on D-Day. Exploding shells in background are aimed at incoming landing craft.

National Archive, U.S. Marine Corp photo, by Warrant Officer Obie Newcomb

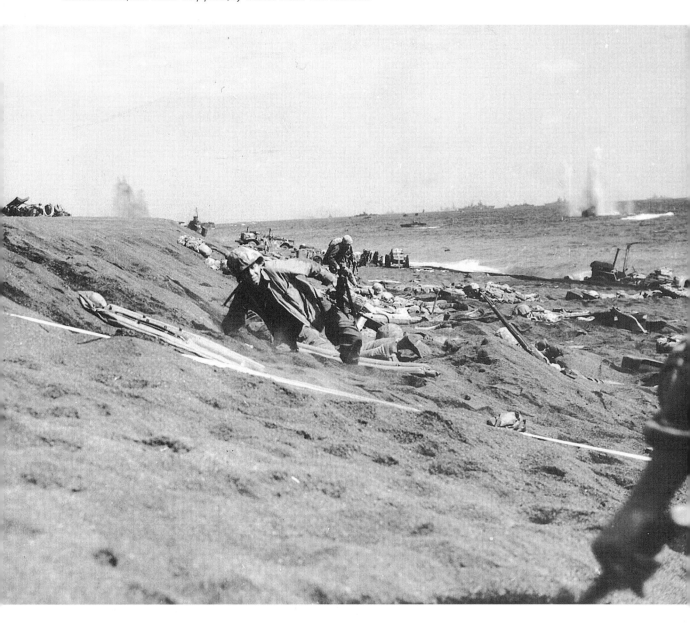

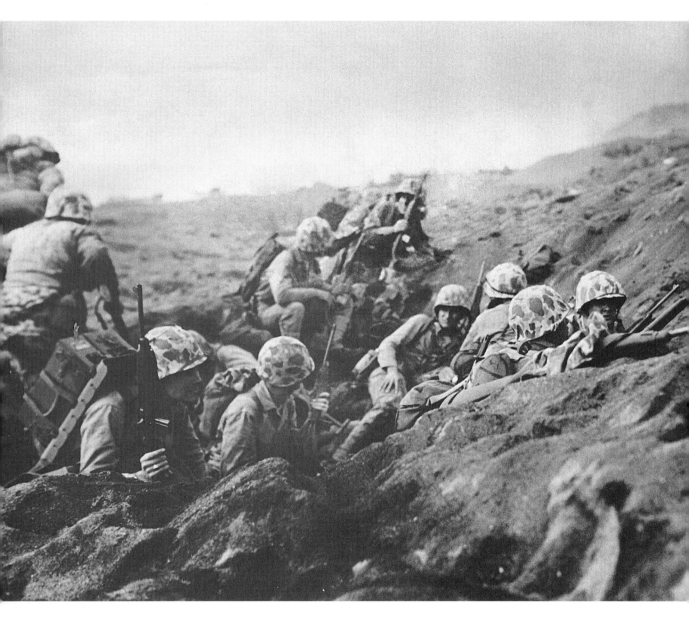

Marines take cover on the first ridge of the terraced Iwo Jima beach on D-Day moments after landing on the island.

U.S Marine Corps photo, National Archive

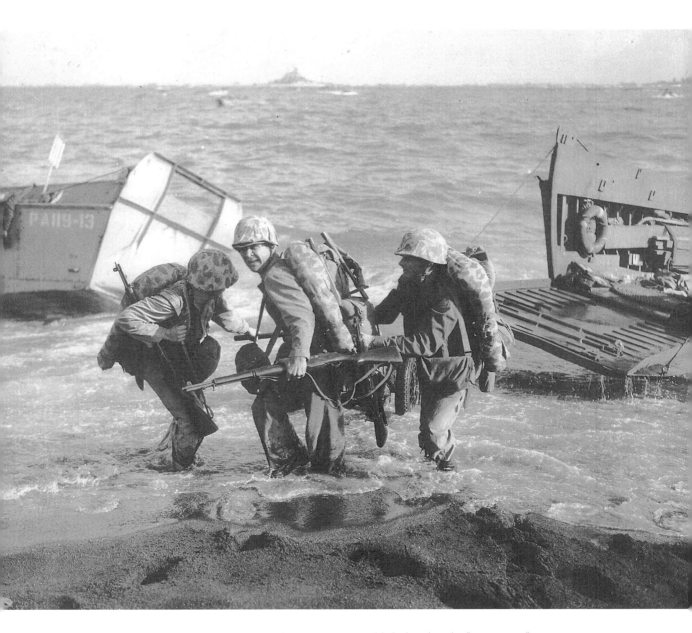

Marines pull their cart through the soft black sand of Iwo Jima as they hit the beach under fierce enemy fire. The black volcanic sand of the Iwo beach slowed the movements of men and machines during and after the D-Day invasion.

National Archive, U.S. Marine Corp photo by David Christian

Even in death, this U.S. Marine, killed by heavy Japanese sniper fire, holds his rifle with bayonet in the charge position on Iwo Jima D-Day.

Natuibak Archive US Marine Corp photo by Sgt. Bob Cooke

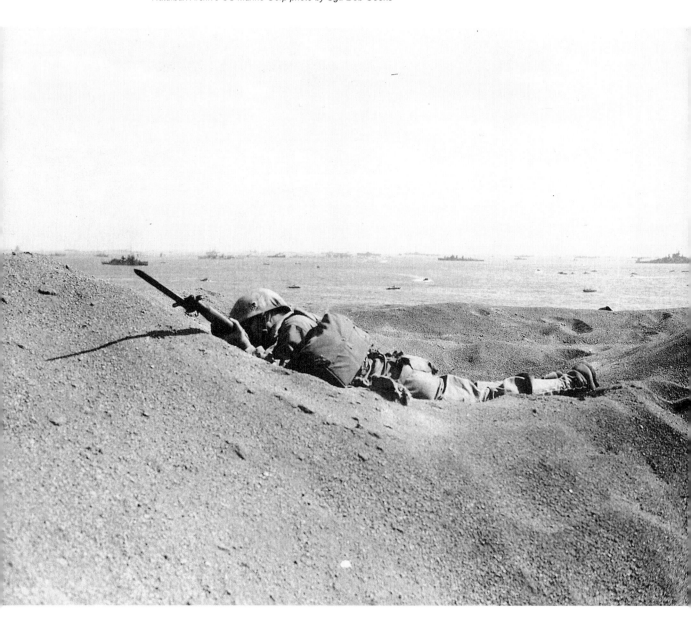

Mt. Suribachi forms the backdrop for Marines on the Iwo Jima beach on D-Day.
U.S. Marine Corps photo, National Archive, by Pvt. Bob Campbell

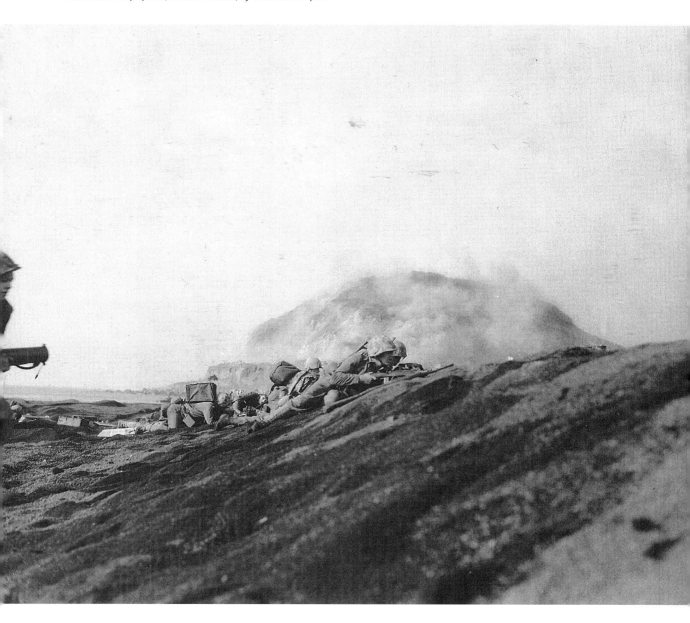

U.S. Marines Storm Ashore on Iwo Island
Landing Effected

Nimitz Reports Invasion of Volcano Isle
750 Miles from Tokyo

FIERCE FIGHTING IS ON
Japanese Report Battle at
Futatsune Beach on Southwest Coast

By THE ASSOCIATED PRESS

ADVANCED HEADQUARTERS, GUAM, MONDAY, FEB. 19– American Marines, their path cleared by the most intensive neutralization campaign of the Pacific war, have landed on strategic little Iwo Island, one of the Volcanoi group, 750 statute miles south of Tokyo.

The landing was made this (Monday) morning. The Fourth and Fifth Marine Division made this first Marine operation since the Palaus were invaded last September. (Lieut. Gen. Holland M. Smith, victor over the Japanese on Saipan, was in command of the Marines, the United Press said.)

Admiral Chester. W. Nimitz, announced in a special communiqué today the momentous development in the fast-moving Pacific War which put American troops on the logical ocean stepping stone to Tokyo.

Iwo is so close to Tokyo that it is administered by Tokyo Prefecture.

American fighters and medium bombers based on Iwo's large airdrome would be within land-based striking range of Tokyo for the first time.

Japanese Tell of Invasion

American troops gong ashore in 100 landing boats made a successful landing at 8 a.m. Monday (Japanese time), the Tokyo radio announced late last night.

A broadcast, recorded by the United Press in San Francisco, said "part of the enemy forces have landed."

It was the first indication from the enemy radio that a successful landing had been made. Previously Tokyo had reported four "attempted landings" were made of the island Saturday but had been "repulsed."

The text of the enemy broadcast said:

"Following a series of abortive landing attempts a part of the enemy forces have finally started landings on Iwo Jima since one o'clock this Monday morning.

Heavy Fighting Reported

"The landing is being made on the southeast coast of the island. The Japanese garrison immediately pushing the enemy invaders back to the shore is now engaged in fierce counter attack against the enemy.

"The landing was preceded by persistent naval and air attacks since early last Wednesday morning."

When we were approaching Iwo, you really couldn't see anything until the morning of D-Day. All you could see was ships, there wasn't any land. But on D-Day, there was the island right in front of you. You could hardly see it because of the dust and smoke from the bombing.

—CPL. ARTHUR J. KIELY JR.
Photographer

Because of my experience at Saipan, I knew the beach was zeroed in. The firing all along the beach was murderous . . . our medical team landed with two doctors and forty corpsmen. Before the day was out, one doctor was killed when he lost both legs, and only two corpsmen were left. All the rest were dead or wounded.

—SGT. ALBERT OUELLETTE
Squad Leader

"I thought for sure that as soon as I stuck my butt over the side, I'd be a dead man. But I was the leader, and I felt that if I were going to get killed, I might as well get it over with. I was up and over, and for some reason the machine guns stopped firing. I hoped all those new replacements would follow, and they did, and just then a guy to my left was hit by a shell from the Jap artillery. He just disappeared. All that was left was his dungaree jacket and rib cage."

—SGT. ALBERT J. OUELLETTE
Squad Leader

"On the second and third waves, that's when we caught hell . . . you've seen the pictures of all the wrecks on the beach. Well, I saw a boat take a direct hit, thirty-six Marines, plus two sailors. You didn't even see a toothpick in the water. But I kept going, and a shell would land here, a shell would land there, all around you, you didn't know where, you just kept going to the beach. You get hit, you got hit, that's all."

—ALBERT D'AMICO, USN
Higgins Boat Operator

5

D+1, D+2, D+3

D-DAY ENDED. AMERICANS held two lines on Iwo Jima. One crossed the narrow neck of the island isolating Suribachi, and the second crossed the island just south of Airfield One. The casualty rate was exceedingly high, however, and the Japanese defense showed no sign of weakening.

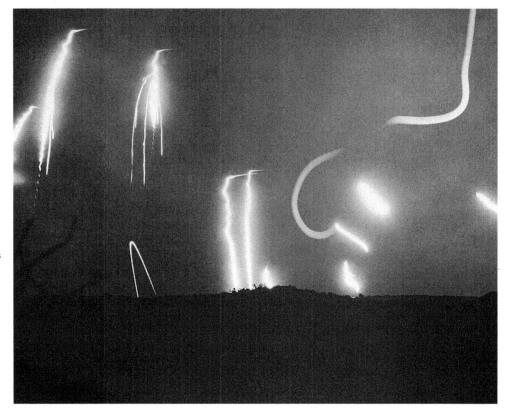

Weird patterns light the sky over Iwo Jima as Navy ships fire illuminating shells over the battle ground. The parachuted shells, fired every few minutes, helped protect the Marines from Japanese infiltrators.

AP Wide World photo from U.S. Marine Corps

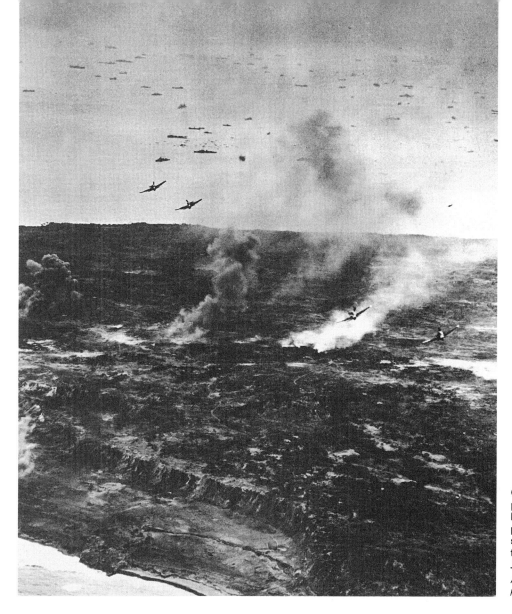

Carrier-based planes strafe and bomb Japanese positions in support of ground troops on Iwo Jima.

AP Wide World photo from U.S. Navy

Night settled in. Navy ships fired star shells over the fighting zone so Marines could monitor possible counterattacks and infiltration. One attack from the base of Suribachi was thrown back, but shelling from the mountain and artillery called in from other sites on the island continued through the night, inflicting more casualties. Naval ships fired back as the Japanese emplacements revealed themselves.

Chilly winds whipped across the battlefield at dawn of D+1 and dampened both spirits and terrain. Welcome air support against Japanese positions on the lower face of the mountain helped considerably, but isolating Suribachi from the

U.S. Marines move
across the sand
after landing on
Iwo Jima, headed
for the fighting
around the No.1
Airfield not far
from the beach.

*Pool photo by Paige
Abbot, International
News Photos*

rest of the island did not seem to lessen its firepower. Kuribayashi had planned well to make the outpost independent, though he had not believed the invaders would so quickly surround the mountain, nor did he think Marines would be close to Airfield One so soon. It didn't take a military genius to figure out the Marine's next step—take Suribachi and secure the airfield, which is easier said than done. Marines gained less than a hundred yards toward the mountain before digging in for the night of D+1, their positions on open fields exposed to the enemy hidden in caves on the high ground.

Northern progress was better, though still slow. The airfield was captured despite pillbox, minefield, and sniper protection. Each pillbox was a separate battle won primarily with flamethrowers and demolition charges. Tanks were helpful but were also easy targets for antitank fire.

The weather turned worse through the day—cold and rainy, so different than previous Marine battle experience in the Pacific and their training in Hawaii. Ponchos came out, but the cold penetrated and the rain loosened the volcanic soil, collapsing foxholes and creating muddy conditions.

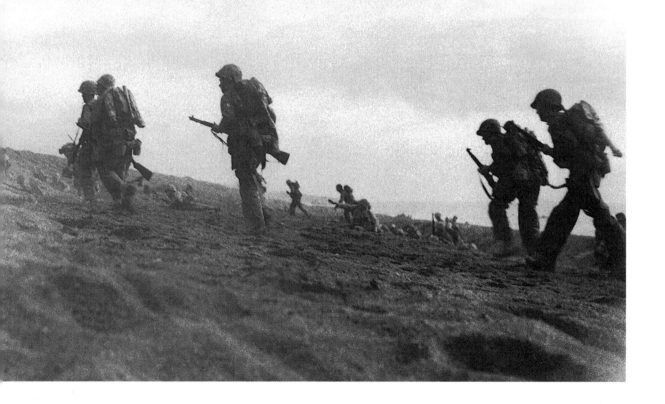

Weather on D+2 continued to deteriorate. The wind gained strength, some said reaching gale proportions. Rainfall increased, and the surf rose to more than five feet, causing the beach to be closed. The Marines found themselves in a sea of mud, a sticky, gooey kind of mud unique to volcanic soil. Dusty weapons jammed. Progress by foot was difficult; vehicles slowed down and eventually bogged down in slop created by the now-driving rain.

Attackers moved forward toward Suribachi behind air and naval gunfire support. Heavy barrages blew away brambles and other growth to reveal a new world of pillboxes and fortifications linked by trenches. Progress for the day totaled less than a thousand yards, in some places only five hundred yards.

On the northern front, around Airfield One, air and naval gunfire likewise supported ground troops. At one point, near the western side of Iwo some thousand yards was gained, but on the rocky east side, Marines gained only fifty yards as they battled Japanese troops in caves and cliffs and rocky ridges.

As the surf rose to more than five feet, derelict equipment, broached or overturned by earlier surf, was tossed asunder once again, blocking passages that had been cleared through the debris. Supplies and reinforcements could not land. Wounded awaiting transportation to hospital ships were stacked in rows on Iwo's black sand, where corpsmen did what they could to keep them dry and patched up despite the shelling from Suribachi.

At sea, the story was no better. A flight of some fifty Japanese kamikazes left Tokyo for Iwo's waters. They were spotted, and American pilots shot down several, but others flying in the low clouds continued on their mission, not interested in dogfights with American airmen. Their targets were the ships at sea. The kamikazes spotted the USS *Saratoga*, one of the oldest carriers in the fleet, about thirty-five miles from Iwo Jima.

The kamikazes came out the clouds, some of them streaming smoke from damage suffered in their encounters with the American fighters. They swooped down on the *Saratoga*. Two hit the carrier at the water line and exploded inside the ship, then two more hit the carrier. The *Saratoga* stepped up power and soon had fires under control when five more kamikazes appeared. One got through defensive fire, and its bomb blew a hole in the deck. Eventually the *Saratoga* limped back to Bremerton, WA, where she was repaired, then returned to Hawaii where she was used to train carrier pilots until the war ended.

The *Bismarck Sea* was also attacked by kamikazes from the same group. The attackers slipped through defensive fire and struck amidships, setting off torpedoes,

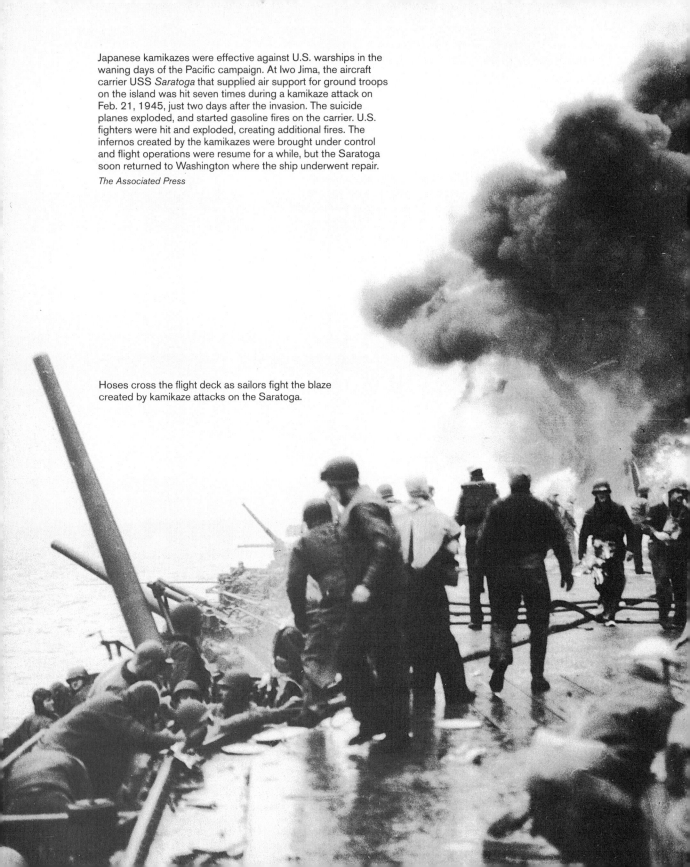

Japanese kamikazes were effective against U.S. warships in the waning days of the Pacific campaign. At Iwo Jima, the aircraft carrier USS *Saratoga* that supplied air support for ground troops on the island was hit seven times during a kamikaze attack on Feb. 21, 1945, just two days after the invasion. The suicide planes exploded, and started gasoline fires on the carrier. U.S. fighters were hit and exploded, creating additional fires. The infernos created by the kamikazes were brought under control and flight operations were resume for a while, but the Saratoga soon returned to Washington where the ship underwent repair.

The Associated Press

Hoses cross the flight deck as sailors fight the blaze created by kamikaze attacks on the Saratoga.

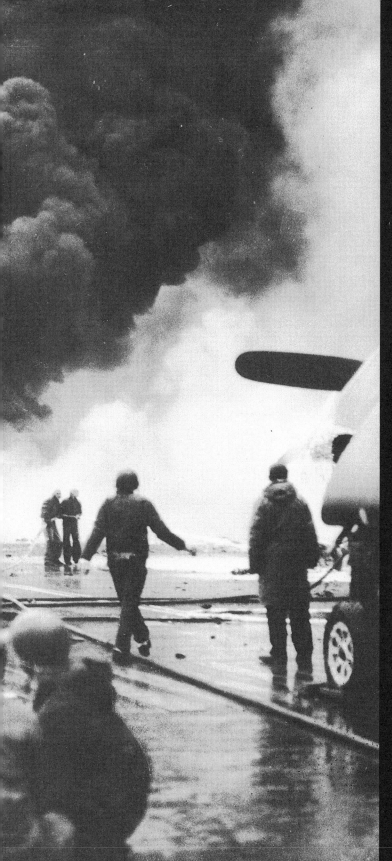

Navy fire fighers battle flames on the deck of the *Saratoga* after kamikaze aircraft successfully crashed into the ship.

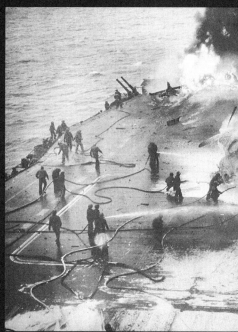

Wrecked and burning American fighter planes litter deck amid gasoline fires set by seven kamikaze aircraft that hit the *Saratoga*.

bombs, and other ammunition. American fighter aircraft on the ship exploded, their gasoline fires spreading quickly. The captain gave the order to abandon ship, and the crew dived into the icy waters. Moments later, an explosion blew away the stern of the ship, and it rolled over and sank to the bottom of the sea.

Three smaller ships were also hit, two suffering serious damage.

The attack was a preview of kamikaze action that would plague the American Navy during the invasion of Okinawa. Flying bombs with suicidal pilots at the controls would be a deadly, effective weapon.

D+3 turned still worse. Rainfall turned icy, and the wind increased. Air support was withdrawn because low mist limited visibility. Naval shelling support likewise was cut back as Marines reduced the distance between themselves and the enemy, especially along the slopes of Mt. Suribachi.

Japanese forces suffered losses, too. Some troops, separated from their units on Suribachi, attempted to slip through Marine lines to join Kuribayashi's forces in the north. Those successful were rewarded with fierce reprimands for leaving their battle stations. About the same time, Japanese leadership on the mountain sought permission for a banzai attack against the Marines. Kuribayashi ignored the request, but the abandoned positions on the mountain and the request for a suicidal banzai charge must have caused him to doubt that the Suribachi force could hold out much longer. Occupation of the mountain seemed imminent.

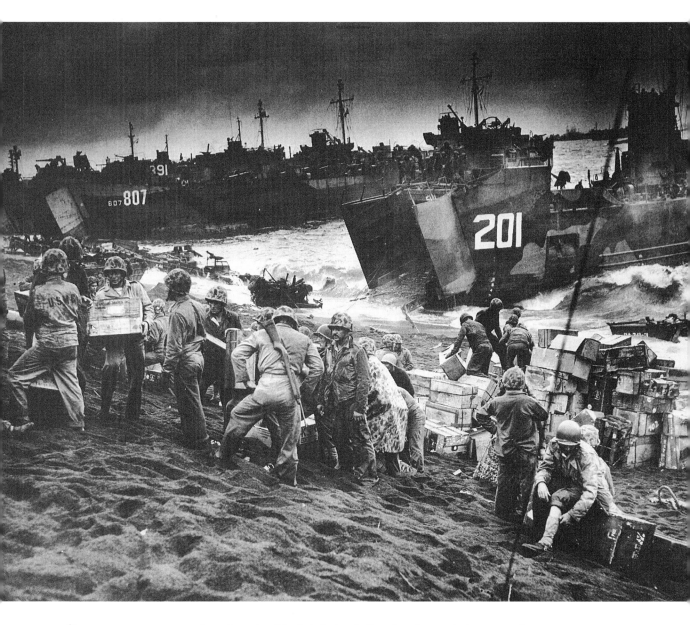

Sheer manpower overcomes the soft sand and the turbulent surf of Iwo Jima. In many instances supplies
were handcarried to the front lines because trucks and tractors were stalled on the beach.

Coast Guard photo, National Archive, by Paul Queenan

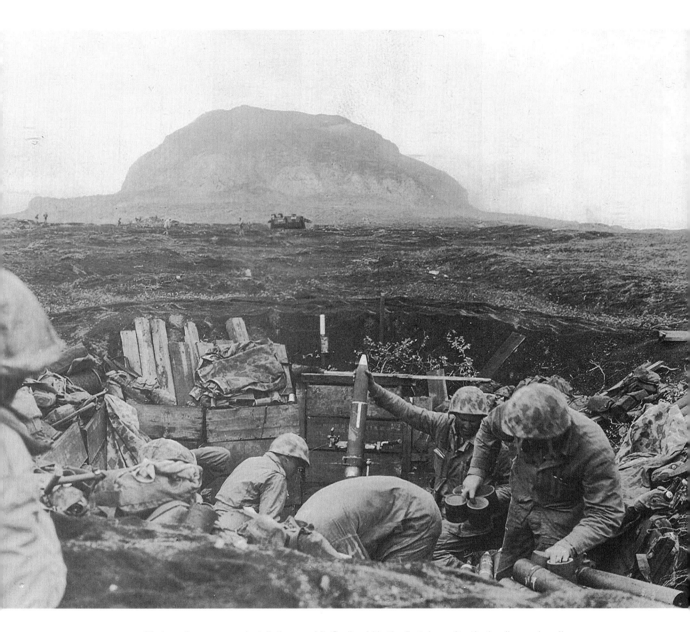

Marines fire on enemy installations on Mt. Suribachi in the first days after the landing on Iwo Jima.

U.S. Marine Corps photos, National Archive, by Mulstay and Cornelius

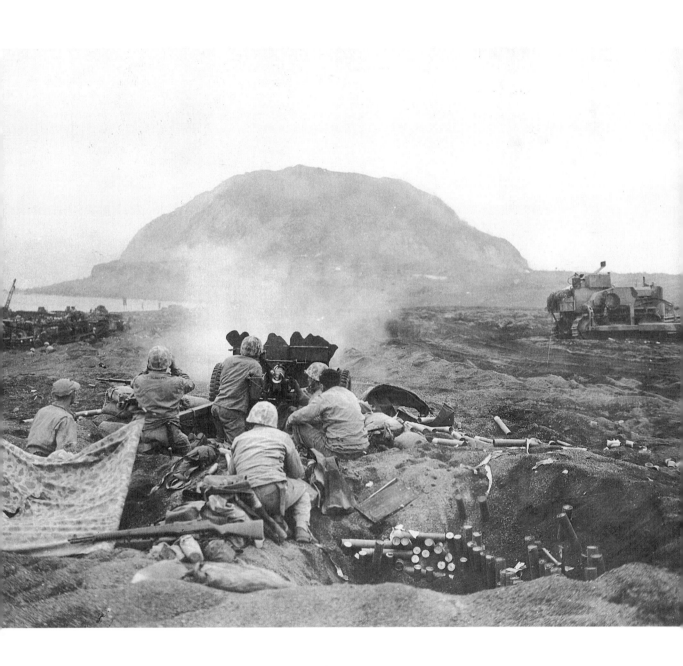

Carrying heavy communications equipment, these Marines dash across the open ground during the inland advance.

U.S.Marine Corps photo, National Archive, by Warrant Office Obie Newcomb

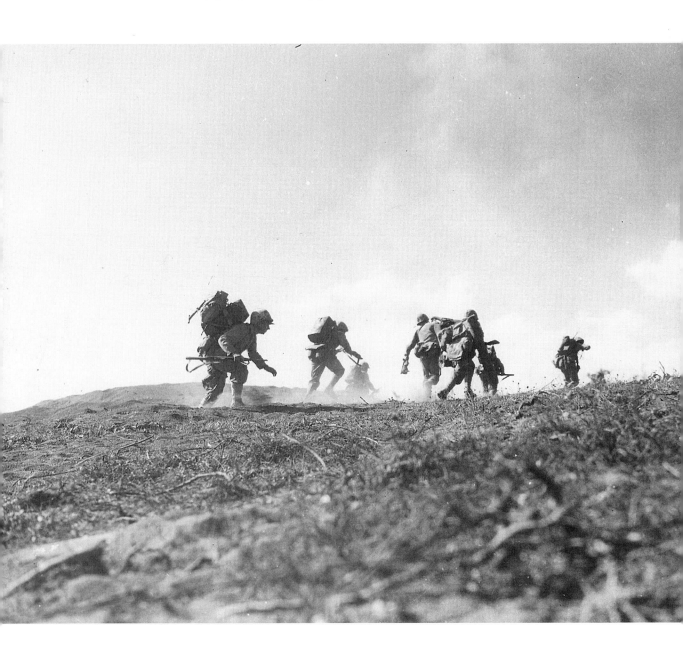

Explosions and fireballs scar the field as Marines advance with tanks in the open country below Mt. Suribachi.

AP Wide World photo from U.S. Marine Corps

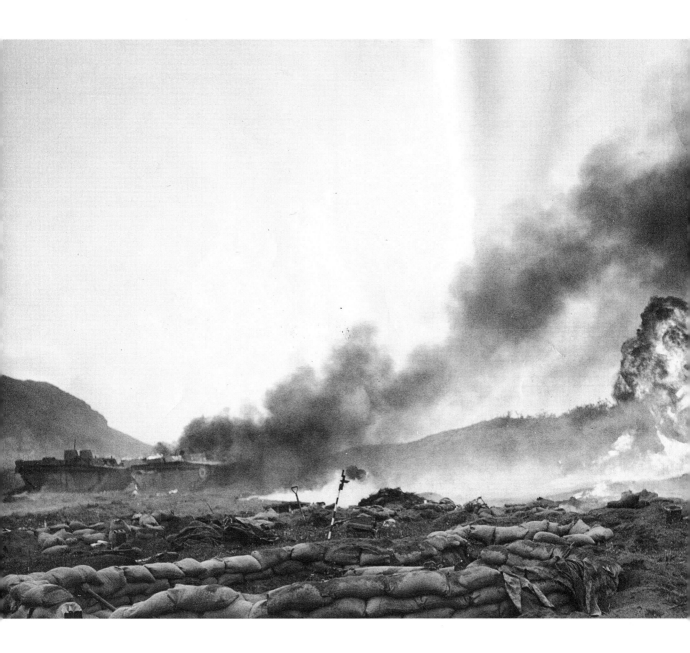

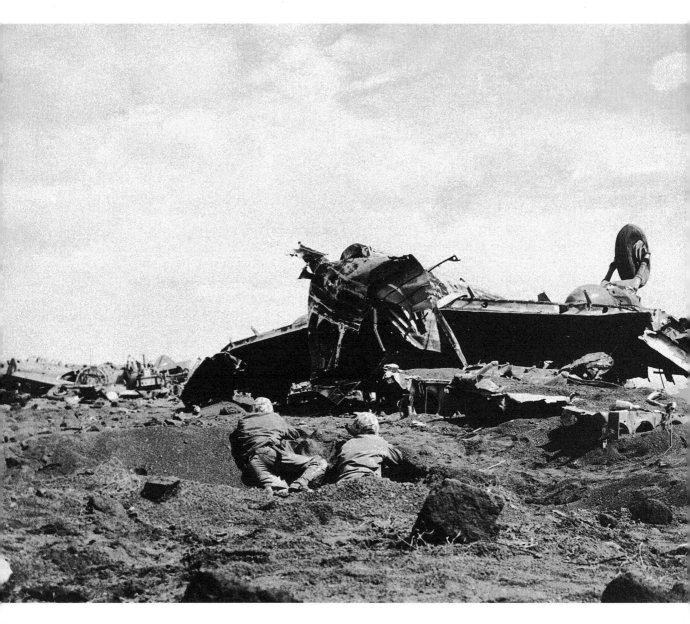

Two Marines take cover in a shell hole behind a knocked out Japanese airplane as they battle the enemy at Airfield No. 1.

U.S. Marine Corp photo, National Archive

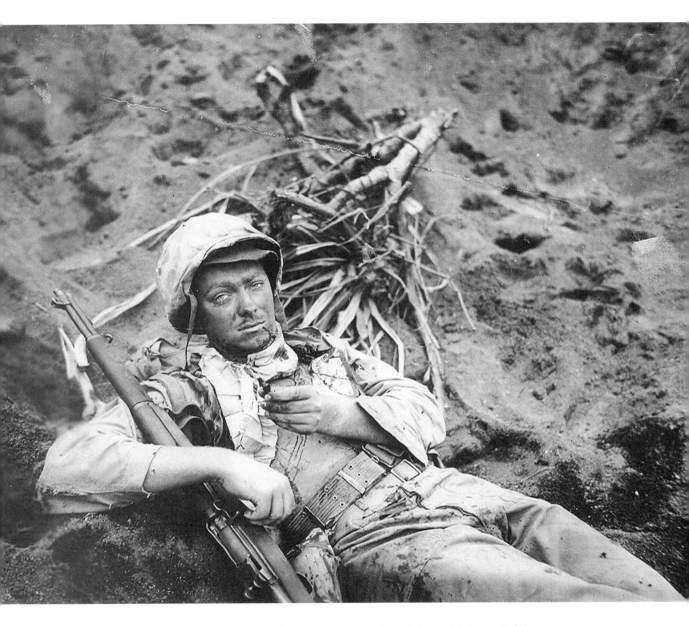

Cpl. Rudolph E. Engstrom rests in an Iwo Jima shell hole holding the piece of shrapnel that wounded him on the second day of the fight.

U.S. Marine Corps photo, National Archive. by Sgt. David Christian

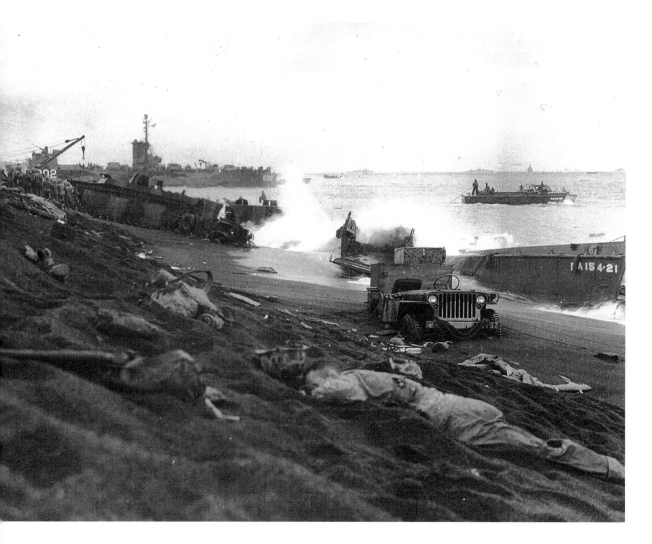

The morning after D-Day the beach held the memorial of the desperate struggle to gain a toe hold on the island. Bodies of slain Marines shared the sand with crushed and stranded vehicles.

U.S. Marine Corps photo, National Archive, photo by Mulstay

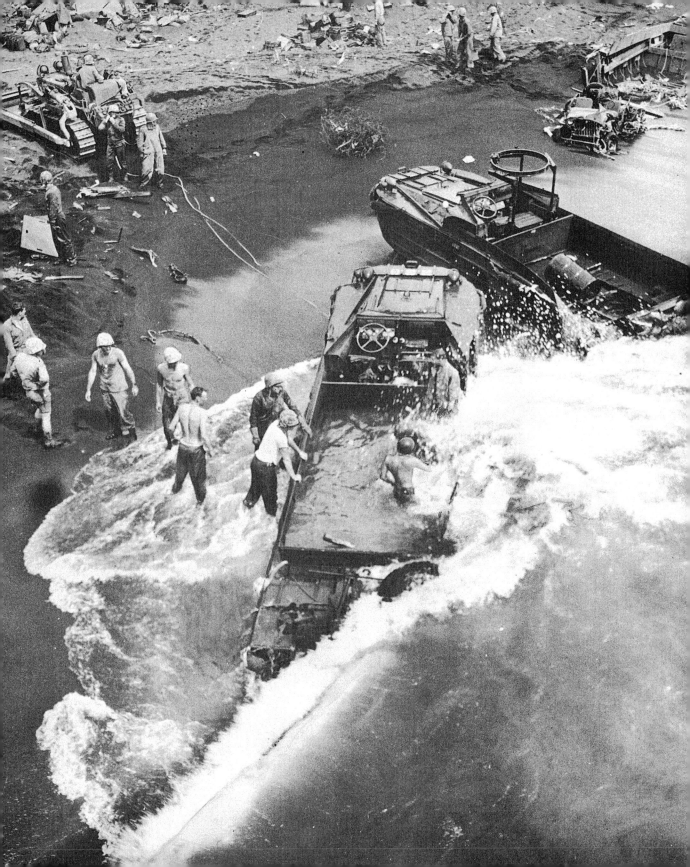

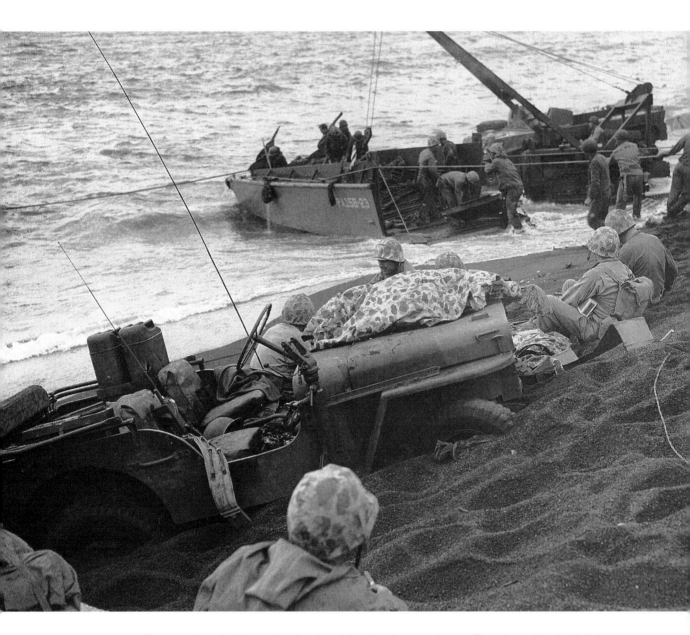

The volcanic sand of the Iwo Jima beach took its toll on heavy equipment. The ash, combined with high surf, disabled much of the equipment.

AP Wide World photo, from U.S. Marine Corps

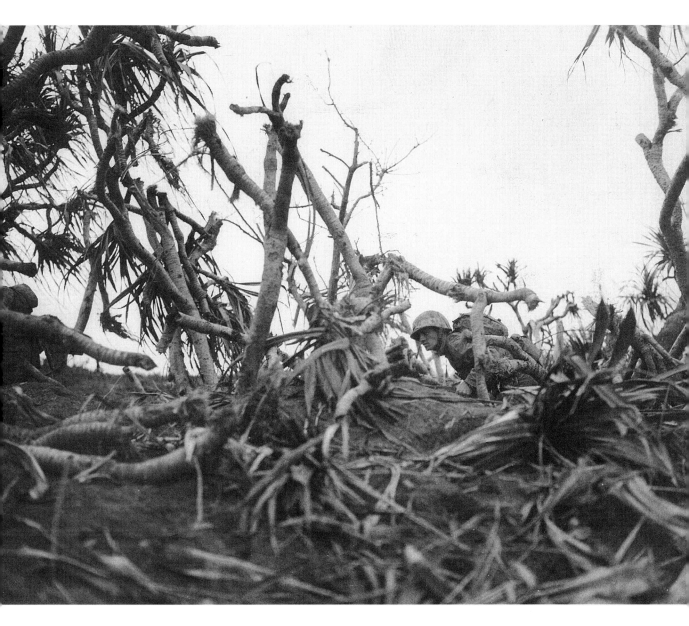

Twisted foliage blocks the way for Marines headed for Moyotoma Airfield No. 1 during the early days of the battle for the island.

U.S. Marine Corps photo, National Archive, by Dreyfus

An artillery spotter yells directions to a radio man who in turn sends information to artillery crew shelling a Japanese installation on Iwo Jima.

National Archive

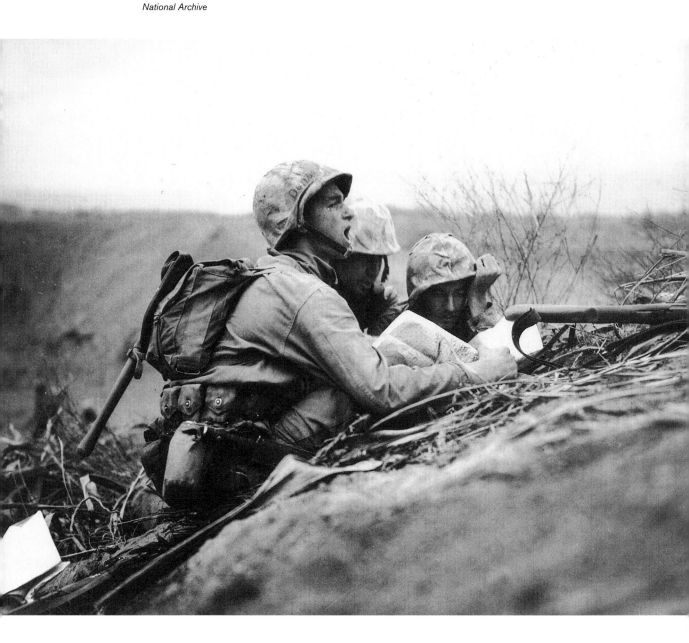

UNCOMMON VALOR, COMMON VIRTUE

Flamethrowers were the most effective weapon against the entrenched Japanese positions on Iwo Jima. Here Marines wipe out enemy troops in a cave as they battled their way to Mt. Suribachi.

National Archive

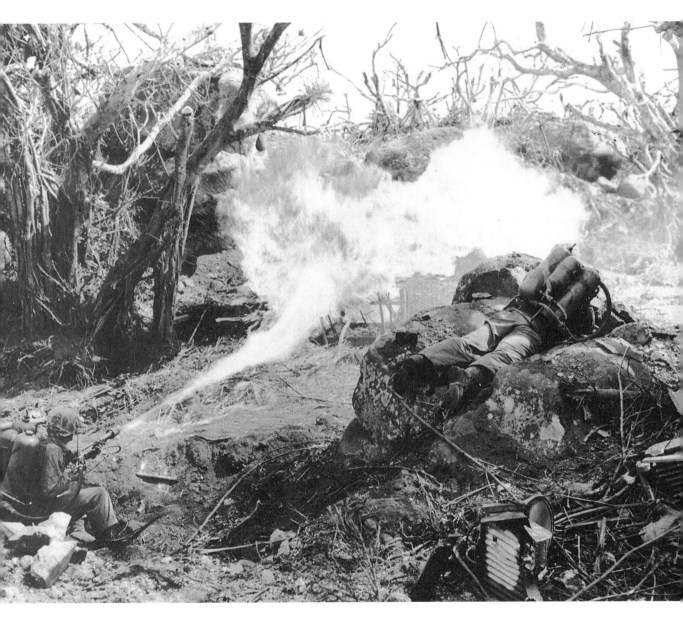

GHASTLY RUINS LINE IWO LANDING BEACH

Two-Mile Stretch Strewn with Wreckage of Boats, Trucks, Rifles, Packs, Masks, Etc.

By S.SGT DAVID DEMPSEY
MARINE CORPS COMBAT CORRESPONDENT
DISTRIBUTED BY UNITED PRESS

IWO ISLAND, FEB. 22—The invasion beach of this island, stormed four days ago by marines in the face of blistering Japanese mortar and artillery fire, today is a scene of indescribable wreckage—all of it ours.

For two miles extending northeast from Mount Suribachi at the southern tip of the island is a thick layer of debris. Wrecked hulls of scores of boats testify to the price we paid to get our troops ashore on this vital island.

For two continuous days and nights Japanese artillery, rockets and heavy mortars laid a curtain of fire along the shore. Their weapons had been aimed at the beach long before we landed. They couldn't miss and they didn't.

Volcanic sand on this beach is so soft that many of our vehicles were mired down before they had gone ten feet. In addition, a terrace a few yards from the water hampered their movements so that they became easy prey for Japanese gunners.

Supplies Moved by Hand

Only a few trucks got ashore and for two days practically all supplies moved by hand to the front.

One can see amphibian tractors turned upside down like pancakes on a griddle; derricks brought ashore to unload cargo are tilted at insane angles where shells blasted them; anti-tank guns were smashed before they had a chance to fire a shot. Even some bulldozers landed too early to clear a path for following vehicles. Artillery could not be landed for twenty-four hours.

Packs, clothing, gas masks and toilet articles, many of them ripped by shrapnel, are scattered across the sand for five miles. Rifles are blown in half. Even letters are strewn among the debris as though the war insisted on prying into a man's personal life.

Scattered amid the wreckage is death. Perhaps the real heroes of this battle for Iwo Island are the boys who sweated out the invasion. They are the coxswains who steered the landing boats through a gauntlet of fire and who did not get back., They are the unloading parties who for one entire day unloaded hardly a boat because few boats made it.

Instead they hugged the beach while shells hit into the sand and all around them.

On D-day beach parties suffered heavy casualties in killed and wounded.

And there were the aid and evacuation stations which could not move up to the comparative safety of the forward area. Our battalion aid station lost eleven of its twenty-six corpsman in the first two days.

Death is not a pretty sight, but it has taken possession of our beach. An officer in charge of a tank landing boat received a direct shell hit while trying to free his boat from the sand. He was blown in half. A life preserver supports the trunk of his body in the water.

Marines killed on the beach were buried under the sand as the tide came in.

On the third day we began to get vehicles and supplies ashore in quantity. Wire matting made the beach passable and naval gunfire knocked out most of the Japanese artillery.

The miracle was that we were able to supply our troops at all during the two days of increasing shelling on this beach.

The boys who did it, as the saying goes, deserve a medal, but a lot of them won't be around when the medals are passed out.

> Then we got some kamikazes. One flew over my head, and I could look him right in the eye. The lieutenant yelled, 'Take cover, take cover,' but it was mealtime, we were all standing on the deck with our mess kits. On a steel deck, where are you going to go for cover? Put your mess kit over your head? If we had been hit, we would have blown up because we had fifty drums of aviation gas in our bow. The ship next in line in back of us was the *Keokuk*, a minelayer, and a kamikaze hit its bridge and killed seventeen sailors. A disaster. They were all in the wheelhouse at the time.

—PFC JULIUM A. RUSKIN
Artillery

" I sat in the foxhole all night. In the front there was a ravine. I could tell by the way the sound was coming. There was moaning and groaning, and I figured, well, there were wounded there, but you never knew whether or not it was a Jap playing tricks. Sometimes they would moan and groan and yell, 'Corpsman, corpsman,' to get you to come down there, and they'd do a job on you. So you just stayed put, that's all, and listened to it all night long. That had to be the longest night of my life. "

—PFC GEORGE G. GENTILE
Rifleman

RESISTANCE GROWS

Japanese Fighting Back Fiercely as Americans Push Inland on Iwo

MORTAR FIRE IS HEAVY

Bitter Battles Develop In Uplands Following Smooth Landings

BY WARREN MOSCOW
BY WIRELESS TO *THE NEW YORK TIMES*

ADVANCED HEADQUARTERS, GUAM, TUESDAY FEB. 20—The troops of the Fourth and Fifth Marine Divisions forced a landing yesterday at 9 a.m. on the key Japanese bastion of Iwo Island, and when night fell had carved themselves a beachhead in the rocky island's terrain five hundred yards in depth and two and one-half miles long, running northeast form the volcano, Mount Suribachi, in the face of strenuous Japanese opposition.

The American expedition was an amphibious one, with between thirty and forty thousand combat troops borne to the scene of operations by an armada of more than 800 ships, including landing craft, and with the operation supported by escort carriers, cruisers, destroyers, minelayers and six of America's oldest battleships, ideally suited by means of heavy deck armor and big guns for beachhead support. [A front dispatch said new battleships augmented the old ones in the attack.]

Casualties Are "Moderate"

By nightfall, according to a second communique issued during the day there by Admiral Chester W. Nimitz, the operations were proceeding according to plan. American casualties suffered at the hands of the Japanese defending force were described as "moderate," though the operation was viewed in advance as possibly one of the toughest nuts an amphibious force has ever tried to crack, tougher than Tarawa or Saipan.

[Larry Tighe, Blue Network war correspondent, said in a broadcast Monday there was sound reason for believing "the stiffest fight yet faced by the Fourth Marine Division is now going on at the south end of Iwo Island." The division included veterans of every Marine landing since Guadalcanal.

[The Fifth Division, which front dispatches indicated was fighting to the northeast of the Fourth,—apparently also was meeting fierce resistance, The Japanese radio, speaking of the Japanese garrison "intercepting" invading forces on the west, suggested the possibility of a new landing on the west coast.]

Airfield First Objective

The immediate objective, following the landing, apparently was the main airfield on the small island whose total expanse is 7.79 square miles, and two hours after the landing the marines, by means of advance patrols, had reached the southern end of the airstrip, one of two on the island, and had penetrated airfield defenses east of the airstrip.

The landing was made on the southeast beaches, easily visualized if the island is remembered as a pear-shaped volcanic rock, with the stem of the pear pointing southwest and the round end to the northeast.

"We went about fifty yards and put the tripod (machine gun) down, put the gun down, and spare parts and bullets in the cans. I looked up, and in this bunker I saw a flash, a gun flash. I hollered, 'Nips!' I ran to the right, jumped in a hole, Russell jumped in with me. As he jumped in, here comes a grenade. He jumped this way, I jumped the other, and here's this Nip with the rifle, looking at me. I had my carbine, I dropped down like this and I came up and he whacked me, and as I was going down, 'poom-poom-poom,' I nailed him. Then I dropped.

One of the lieutenants said, 'Get the gun out,' and Degrafenried went over to pick the gun up off the tripod. He got hit right in the head. Over the gun he laid."

—PFC STRANLEY ZEGARSKI
Machine Gunner

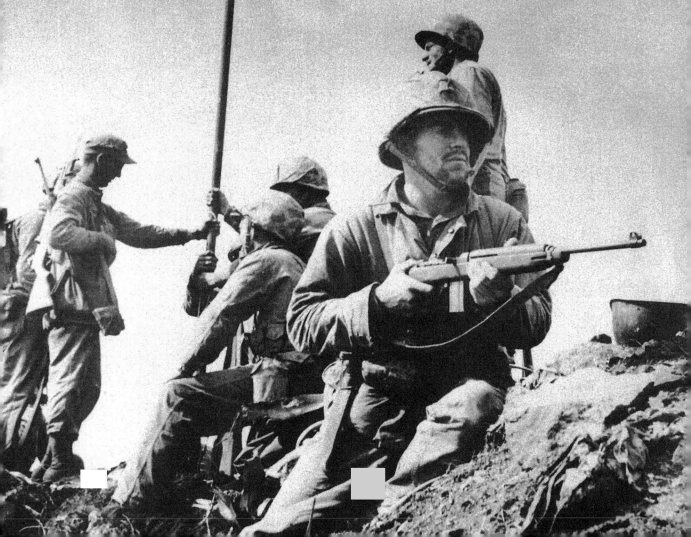

6 D + 4: The Flags of Suribachi

D+4 **BEGAN AS** an ordinary day—ordinary as a day can be in an extraordinary time and place. Joe Rosenthal would come closer to death than at any other time as a combat photographer. Later in the day, about noon, he would experience the defining moment of his life, though he would not realize it at the time. Elsewhere on Iwo, Marine casualties would approach five thousand; one Marine this day would receive the Medal of Honor, the front line would move forward a scant hundred yards.

Just an ordinary day in extraordinary times: D+4, February 23, 1945, the fifth day of the Iwo Jima battle.

Joe Rosenthal spent the night of D+3 on the command ship, the *Eldorado*. He captioned the day's pictures and sent them off to Guam. On the island, at the base of Suribachi, commanders made their decision: Marines would climb Suribachi the next day.

Early in the morning of D+4, as he walked along the deck of the *Eldorado*, Rosenthal with his photographer's eye, noted that the morning light was gray under a cloudy sky, a chilling wind similar to that of the last several days blew across the ship. The ocean was uneven, choppy, inhospitable. But the rain had let up, and the weather overall was improved. While arranging a ride to shore, he learned that Secretary of the Navy James Forrestal was on a smaller vessel nearby watching action on the beach through binoculars. The Washington brass would, later in the day, visit the Iwo beach as he had done previously at Normandy. But Joe didn't

Secretary of the Navy James Forrestal, left, and Lt.Gen. Holland Smith, commander of Marines in the Pacific, stand at the rail of a ship and watch the battle for Iwo Jima on Feb. 23, 1945. Just moments before he made this photo Joe Rosenthal was almost killed when he fell between two ships.

AP Wide World photo by Joe Rosenthal

know that and thought it best to get a picture of the secretary early. He met *Newsweek* writer Bill Hipple, and the two arranged to ride in a small vessel to meet, photograph, and interview Forrestal and, as it turned out, General Holland "Howlin' Mad" Smith, commander of the Marine force at Iwo.

Rosenthal tells the story:

"There was a high sea, and we had to, of course, transfer to an LCVP to be taken over to where the brass was. The command ship bobbed up and down in the rolling sea of eight to ten feet as we walked down a gangway to board a smaller vessel.

"At the bottom of the gangway was a platform, maybe three feet square, and when I got to the platform, it was wet and slippery, with a lot of water on it. Making the transfer was a matter of timing. Bill went ahead of me and made it just right, and got on board the other vessel.

"The LCVP was bobbing up now, and I swung my camera bag, with the four-by-five Speed Graphic in it, to a seaman on the small ship. On my shoulder, I carried a waterproof bag with my personal Rollei, my backup camera in case something happened to the Graphic.

"At that moment, I slipped on that bottom platform and tumbled into the water. My helmet came off and I could look up at the LCVP rising above me. It went up maybe six feet and came down and started to veer toward me. I was in a space of about six feet between the two boats . . . in that space floating . . . and I thought, well, I think they got me . . . because I could easily be crushed. And the LCVP was really bobbing. I still had hold of the Rollei bag, and I could see . . . look up and see the tillerman spinning the tiller madly, and I thought I sure hope he's got it right. And the LCVP just hung there . . . it seemed to be getting much closer than six feet . . . it hung there . . . and the guy in action, I could see it . . . and then the ship leaned back. He knew just how to do it.

"They pushed a pole to me, with a hook on the end, and I grabbed it, and they pulled me toward the boat—still in heavy seas—and they pulled me into the LCVP."

At this point in his telling, Rosenthal chuckles a bit, and then completes the story:

"Of course, you don't smoke coming down the gangway. But I always smoked cigarettes then, and I smoked in a holder. That left my hands free to use my equipment. But I always said it left my hands free to talk. When I was fished out of the water, I felt relieved, of course, but thought it was very funny . . . I had that holder still clenched in my teeth, and the cigarette—which hadn't been lit—was wet and bedraggled, hanging down."

Rosenthal, a helmetless, shivering, wet survivor, and Hipple rode to the ship where they photographed Smith and Forrestal. Suribachi formed the backdrop to the scene. The mountain, an unconquered watchtower, was still occupied by Japanese troops, camouflaged and hidden in caves from which they called in artillery and mortar attacks on the advancing Marines.

While Rosenthal made his pictures of Forrestal and Smith, a small patrol of Marines was organized at the base of Suribachi to reconnoiter the top of the mountain. If the patrol was successful, the Marines would commit a full platoon to ascend the mountain, take the high ground, destroy the enemy watchers, and eliminate Suribachi as a haven for artillery spotters.

Sgt. Sherman Watson was selected to lead the patrol, which consisted of himself and three privates, Theodore White, Louis Charlo, and George Mercer. The assignment was dangerous. Fighting at the base of the volcano had been fierce and violent. Air support and naval shelling was minimized because the targets were mostly discovered by up-close searches. In the end, it was Marine flamethrowers, hand-thrown grenades, and satchel charges that subdued the resistance cave by cave, pillbox by pillbox. Despite all that, and even though Suribachi had been isolated from the rest of the island since D-Day, the enemy remained a potent, stubborn force, active, resourceful, and deadly.

The early phase of the climb was difficult because the earth was soft, chopped as it was by bombardments. At the higher levels, the earth was firmer and the going easier, but the angle of climb was steeper. The four Marines moved upward, passing blackened pillboxes and ripped-out fortifications that had been hit by the shelling and air strikes.

The patrol reached the cone of the volcano in about forty minutes and peered over the side. They saw lookout stations and machine gun emplacements with ammunition stored nearby, but no sign of enemy personnel. They scrambled back down the slope and reported their findings—no Japanese sighted.

Lt. Col. Chandler Johnson summoned Pacific campaigner Lt. Harold Schrier and told him to take a platoon and occupy the top of Suribachi. He handed Schrier a small American flag that measured 54 by 28 inches, and told him that he should raise the flag on top of the mountain.

Schrier and his forty-man platoon started cautiously up Suribachi's slope accompanied by *Leatherneck* magazine photographer Sgt. Lou Lowery. Their knowledge of the enemy and the mountain came from the first four days of constant fighting around its base and on its lower slopes. Anything could happen now

as they moved upward—sudden attack from caves . . . tossed grenades . . . sniper fire . . . machine gun emplacements . . . artillery barrage called in from distant sites on the island. The platoon and Sergeant Lowry were visible from much of the area at the southern end of Iwo Jima, and thousands of Marines, Coast Guardsmen, and sailors at sea watched their progress on the face of the mountain.

For reasons no one could ever determine, they reached the rim unopposed. The only Japanese they saw were dead; the only fortifications they saw were the same as noted by the earlier patrol. The platoon moved over the lip of the cone into the crater. Riflemen and Marines with 72-pound flamethrowers of heavy-duty death strapped to their backs made the rounds probing for possible Japanese opposition. To their continued surprise, there was no sign of the enemy.

Schrier ordered several Marines to find a suitable flagpole, and they came up with a piece of pipe that had been either an air vent or a collection pipe for rainwater. A convenient bullet hole was used to lash the flag to the pole, they dug a small pit in the earth near the top of the cone, raised the pole, secured it, and the flag was firmly placed. It was raised by six Marines—Schrier, Sgt. Ernest Thomas, Sgt. Henry Hansen, Cpl. Charles Lindberg, and Privates Charlo, a member of the first patrol on the mountain, and James Michels. The Stars and Stripes snapped briskly in the breeze.

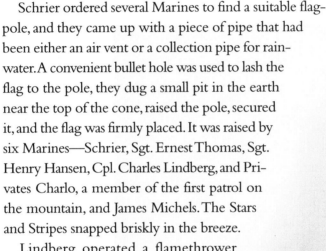

Lindberg operated a flamethrower and had lugged the equipment up the slopes of Suribachi. He remembers putting it aside temporarily to help with raising the flag and

Marines stand beneath first flag raised on Iwo Jima. Wearing soft cap with hand on pole is Sgt. Henry O. Hansen. It was believed that Hansen was also in the photo of the second flag raising but that was corrected more than a year later when Marines ruled that Harlon Block was the correct identification. Picture was released by the Marrine Corps in March, 1945.

U.S. Marine Corp photo, National Archive, by Sgt. Lou Lowery, Leatherneck

recalled the moments years later in *Never in Doubt*, a collection of oral histories of Marines on Iwo Jima.

"After we had tied the flag on (the pipe turned flagstaff) we carried it to the highest point we could find, and we raised it at 10:30 A.M. The troops down below started to cheer, and the ships' whistles sounded offshore. It was a great patriotic feeling, this chill that runs through you. But then the Japanese started coming out of the caves, and we had to move against them My proudest moment of my time in the Marines was raising the American flag on Iwo Jima. My feeling of being a Marine is I served with the finest, and I feel proud every day that I can tell somebody that."

History was made: for the first time a conqueror's flag flew over Japanese territory on D+4. Horns and bells on ships at sea tooted and rang. There were shouts of celebration; warriors turned for a moment to see the tiny flag high on Suribachi, then quickly returned to focus again on the battle. Fighting would last another four weeks, thousands more would die, and many thousand more would suffer wounds.

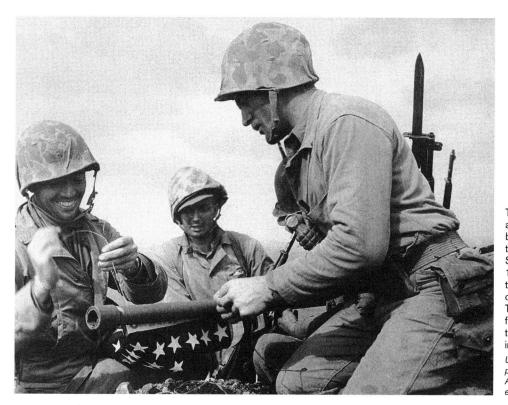

Three Marines tie a flag to a pipe before raising it on the summit of Mt. Suribachi Feb. 23, 1945. This was the first flag raised on the mountain. This photo was first released by the Marine Corps in March, 1945.

U.S. Marine Corps photo, National Archive, by Lou Lowery, Leatherneck

Lowery and his camera were hard at work. He photographed the scene, the flag tied to the pole, the flag up and in place. He made a picture of Michels with his carbine on lookout as the flag was fixed in place.

Suddenly, two Japanese soldiers, one waving a sword and both throwing grenades charged the Marines from a cave. The swordsman was shot immediately, and his grenade exploded harmless nearby. The second Japanese was likewise killed, but not before he threw a grenade in Lowery's direction, forcing the photographer to leap over the rim of the volcano to avoid the blast, tumble 40 or 50 feet down its slope, and smash his cameras. His film was safe, but the cameras were useless, Lowery started down the mountain to get fresh equipment. Marines in the cone dynamited several cave openings after tossing grenades inside. Flamethrowers burned out others. There were no further attacks by the enemy, and the top of Suribachi was considered secure by early afternoon.

On the *Eldorado*, Rosenthal and Hipple, their coverage completed, boarded a small vessel that would take them ashore. They overheard radio chatter about a group of Marines going up the mountain, or had already ascended the mountain, with an American flag. The boatswain confirmed that he had heard an earlier conversation about the same thing.

View of Motoyama airfield No. 1 occupied by Marines Feb. 23.

U.S. Marine Corps photo, National Archive, by Sgt. F. Scheer

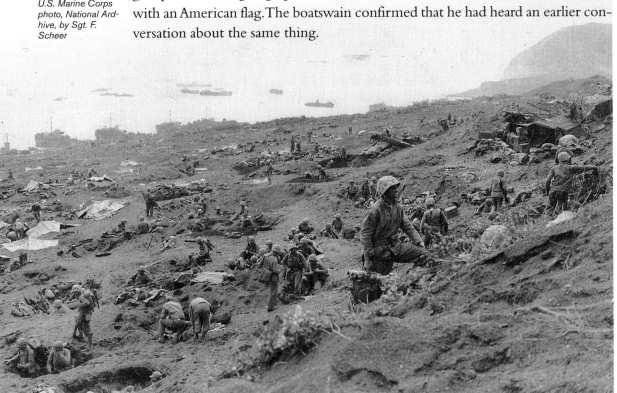

Joe recalls his reaction:

"My response was, 'It happened in four days, less than five days! In view of all the carnage of those days . . . frontline movements at times measured by inches—not even by yards . . . sometimes it would recede.' All that was in the back of my mind as I got ashore. I knew I was late, of course, as Bill and I stepped on land. Bill said he heard that a Japanese soldier had been captured (there hadn't been many at that phase of the battle), and he wanted to see what he could get. I said, 'Well, I'm more interested in trying to get some marker on this battle.' That's what I thought of . . . an important marker . . . a turn in the battle . . . part of the island was taken. And so Bill and I went our separate ways."

Rosenthal headed for the base of Mt. Suribachi, where at about this time Colonel Johnson was looking at the small flag 556 feet above him. He had received word that Forrestal wanted the flag for posterity. Johnson thought otherwise; his Marines fought and bled to get that flag in place, and it would remain

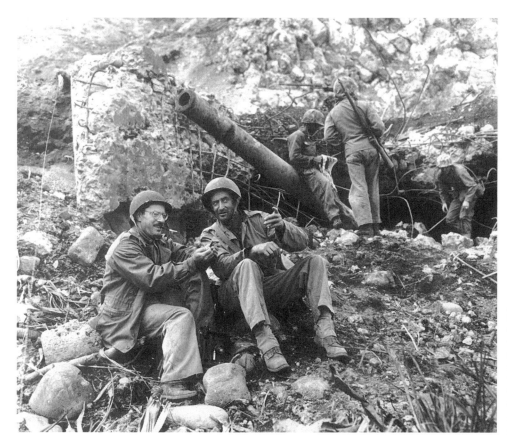

Joe Rosenthal, left, and Pvt. Bob Campbell, pause for a rest at the base of Mt. Suribachi. Behind them is a knocked out Japanese gun emplacement.

AP Wide World photo

with the unit in the future. He ordered one of his men to find a larger flag, and one was located on an LST on the beach, a flag that measured four-feet-eight inches by eight-feet, roughly twice the size of the first flag.

Johnson had a request for fresh radio batteries from the top of Suribachi. Pvt. Rene Gagnon, a young Marine runner, was designated to carry the batteries to Schrier and had started to move on when the flag from the LST turned up. Johnson called Gagnon back, gave him the larger flag, and told him to give it to Schrier. Johnson said, "Tell Schrier we want that first flag, and we want the larger flag on the mountain so that every Marine could see it."

Gagnon took off with the batteries and the flag. On his way to the summit, Gagnon met four Marines who had been ordered to pull telephone wire to the top of the mountain. They were Sgt. Mike Strank, Cpl. Harlon Block, and Privates Franklin Sousely and Ira Hayes. Together, the five moved forward, flag and batteries in hand, and telephone wire trailing behind them.

About this same time, Warrant Officer Norman Hatch, the military officer in charge of photo coverage of the Iwo assault also heard of the climb up Suribachi. Marine motion picture photographer Sgt. Bill Genaust and Marine still photographer Bob Campbell came by his site, and he told them, "We had better get some coverage of the flag up there." The two photographers made their way to Suribachi, where they met Rosenthal at the foot of the mountain. He told them that a flag had been raised. At

Joe Rosenthal waves his camera from beneath the first flag raised on Iwo Jima.

U.S. Marine Corps photo, National Archive, by Pvt. Bob Campbell

first, they thought that the flag raising was over and the picture was not worth the climb, but Rosenthal convinced them to go. "I said, 'C'mon, you guys have rifles, and I can't carry a weapon.' And so, not knowing what we would encounter, we started up the slope."

The weather had changed from its dreary conditions of early morning. A chill was still in air, but the sun, now higher in the sky, burned through a light cloud cover to provide a gentle, photographer's light—bright enough for good exposures, but diffused enough to eliminate the harsh shadows associated with bright sunlight. A brisk wind blew across the face of the mountain.

As the three photographers climbed, they noted the same quiet that the Marine patrol and the platoon encountered. Interruptions were infrequent, just an occasional shout, "Fire in the hole!" which warned that a dynamite blast was about to seal a cave opening. The trio took momentary cover behind a rock or a ridge, then continued their climb after the blast.

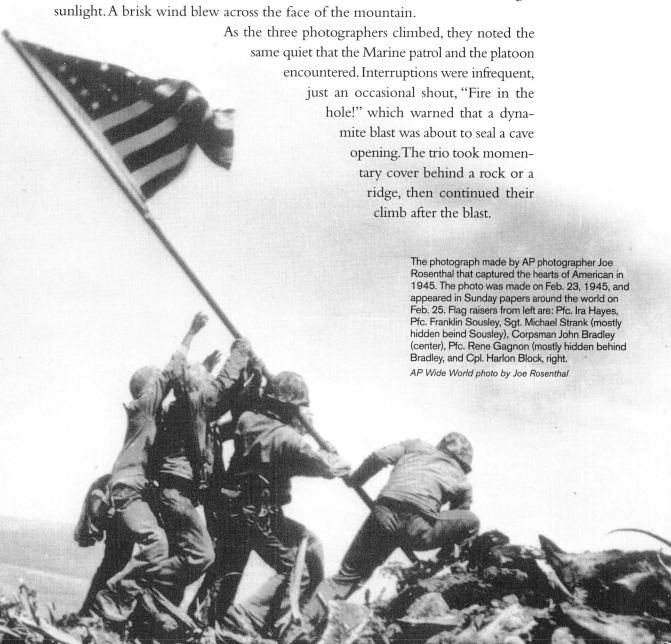

The photograph made by AP photographer Joe Rosenthal that captured the hearts of American in 1945. The photo was made on Feb. 23, 1945, and appeared in Sunday papers around the world on Feb. 25. Flag raisers from left are: Pfc. Ira Hayes, Pfc. Franklin Sousley, Sgt. Michael Strank (mostly hidden beind Sousley), Corpsman John Bradley (center), Pfc. Rene Gagnon (mostly hidden behind Bradley, and Cpl. Harlon Block, right.

AP Wide World photo by Joe Rosenthal

Halfway up, they met Lowery and his smashed cameras on the way down. Rosenthal did not know Lowery, but Campbell and Genaust did. Greetings were exchanged, and Lowery told them, "You're late . . . flag's already up, and I got some pictures. But it's a helluva view up there."

Rosenthal was disappointed at missing the flag raising, and almost decided to turn back and seek pictures on the beach or at the airfield where fighting continued. Encouraged, however, by Lowery's comments about the view, the trio went forward and some thirty minutes later approached the lip of Suribachi's cone. They arrived only minutes after Gagnon delivered the larger flag to Schrier.

"I was coming up toward the brow," Rosenthal recalls, "and I was possibly two hundred feet away. I stopped because, emerging over the edge of the mountain, I could see this small flag waving on a very long pole. And it gave me a jolt, and I get it now. It was our flag. The American flag. I think of what went on D–Day and subsequent days in order to get that flag there. And then I had to take myself in hand again, get some of that objectivity, some of that . . . get the job done.

"And I went up—not knowing what kind of a picture I would get . . . certainly not a picture of a flag going up because it was already up.

"I walked around. As I came closer to the pole . . . the wheels go around like they do in the photographer's mind . . . what can I make of this situation . . . what are the possibilities?

"I saw kneeling on the ground three Marines forming around a pole, and one of them had a flag tucked under his arm in that usual triangular fashion in which you fold the American flag. I said 'What's doing, fellas?' And they said to me something like, 'We're preparing to raise this bigger flag. The colonel down below wants a bigger flag so it can be seen by the troops all over the island. And he also wants to make sure they get that first flag back.'

"So then I knew that I had a minute or two to figure out something concerning that flag. My first thought was . . . from the way they said it to me . . . that it would be a simultaneous exchange so that an American flag once having been planted there . . . there was always going to be one. And so one would come down as the other went up. I started to think, well, I'll go around to the other side where I could get the two.

"Then I started thinking about the possible picture itself, I thought, it's chancy that I would get the position right. In the first place, most of this kind of stuff is like shooting a football play. Things change so quickly in action. Chancy . . . it might also be awkward. The position might be awkward or I might miss it entirely. And I said, well, let's look again

"I walked around to watch those guys who were about fifty feet away at another high point at the top of the volcano. I estimated where they would be, where the flag would be, how tall is this thing, how far back do I need to get in order to get them in . . . and I started sloping backward and slightly downward toward where the shoal of the old volcano sloped toward the interior.

"I looked quickly around . . . there were a couple of stones there from an old bashed or bombed headquarters or viewpoint up there . . . and a couple of old sandbags . . . and I rolled up the stones and put the sand bags on top . . . made sort of a platform . . . and that raised me about a foot and half or so higher . . . I was trying to avoid a lot of bramble that would be in what I estimated to be the forepart or the lower part of the picture . . . the lower legs and so forth . . . and I still could get some of the bramble that showed where they were. Well, my being already close to the ground in height, this foot and a half gave me just enough clearance.

"Again, these were the things that go through the photographer's mind.

"Just about the time I climbed aboard, Bill Genaust, the Marine photographer with the movie camera came across in front of me and went to my right. The flag's out there and he's just to my right . . . I'd say just arm's length . . . maybe off the tips of my fingers.

"Bill called out 'I'm not in your way, am I, Joe?'

"I turned and said, 'No, that's fine . . . Hey, there it goes, Bill.'

"I had peripheral vision then, and I could tell that they had just lifted the pole off the ground, and it was on its way up. I swung my Graphic around close to my face and held it, watching through

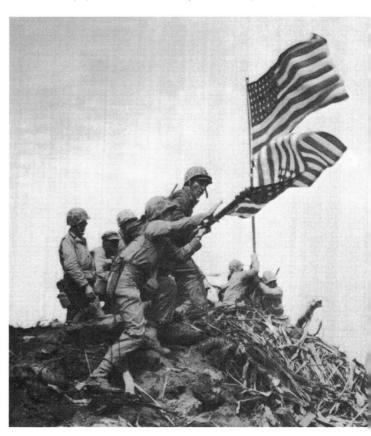

One flag in the background goes up while a second flag comes down atop Mt. Suribachi on Feb. 23, 1945. The larger flag in the rear was put up so that everyone on the island could see that Suribachi had been taken. The larger flag was the one photographed by Joe Rosenthal, the one that became famous and won a Pulitzer prize.

U.S. Marine Corps photo, National Archive, by Pvt. Bob Campbell

Marines steady the flag after raising it atop Mt. Suribachi.

AP Wide World photo by Joe Rosenthal

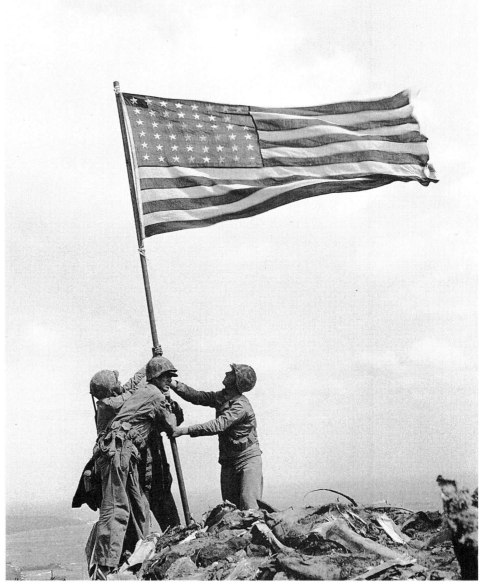

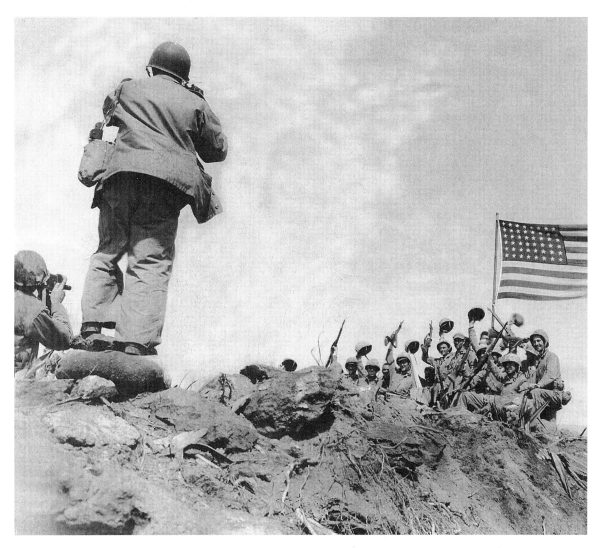

OPPOSITE PAGE: This sequence is taken from the film of the same scene that Joe Rosenthal photographed with a still camera. It was made by Marine Sgt. Bill Genaust at the same time Rosenthal made his picture. To create this sequence seven frames were taken from the Genaust film, individually scanned electronically and then merged together digitally by computer artist George D'Atrio.

Photo courtesy of Lou Reda Productions

ABOVE: AP Photographer Joe Rosenthal stands on a few boulders and Japanese sandbags to photograph a group of Marines waving their helmets and weapons beneath the American flag atop Mt. Surbachi. Rosenthal made the picture shortly after he photographer the raising of the flag. He called this his "Gung Ho" picture and it figured in the controversy that arose over the flag raisings. At the extreme left, only partly visible, is Sgt. Bill Genaust, who photographed the scene with a motion picture camera.

Marine Corps photo, National Archive, by Pvt. Bob Campbell

Sgt. Bill Genaust, Marine motion picture cameraman who photographed the famous flag raising on Iwo Jima.

U.S. Marine Corps photo, courtesy Norman Hatch

the viewfinder to see when I could estimate the peak of the picture. And Bill, of course, he started his camera right away.

"I wasn't thinking about first picture ... or second picture. My response was good ... and I could only hope that it turned out the way that it looked in the finder."

Rosenthal made the photo with his 4 x 5 Speed Graphic, at 1/400th of a second, his lens aperture between f8 and f11 on sheet No. 10 of a 12-sheet, 4 x 5 Agfa–Ansco Superpan Press film pack.

Rosenthal was not the only photographer on Suribachi at the moment he

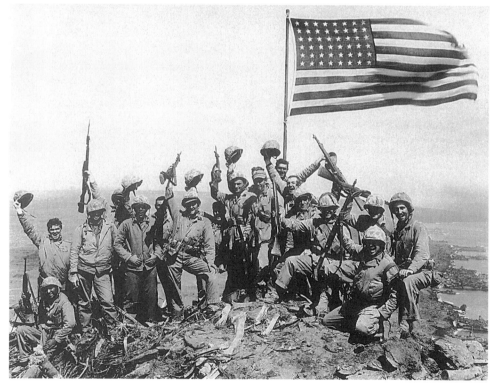

This is the picture Joe Rosenthal calls his "Gung Ho" photo. After photographing the flag raising, he asked the Marines to stand under the flag and wave their weapons and helmets. Rosenthal, who did not see his flag raising photo for several days, thought this was the picture that made such a hit in the U.S. and around the world.

AP Wide World Photo by Joe Rosenthal

made the photo. Genaust, the motion picture photographer, let his roll of Kodachrome film run out as the flag went up, making 198 frames of the sequence in a Bell and Howell Autoload camera. He was uncertain that he got the raising from start to finish; he would never learn the truth, or that his film, like Rosenthal's, would inspire a nation. Genaust was killed in a cave several days later by Japanese gunfire.

Bob Campbell, the Marine still photographer who accompanied Rosenthal and Genaust up the mountain, chose the position that Joe skipped; Campbell made a fine photo of one flag coming down as the other flag went up.

Other photographers arrived on the scene before the flag raising. Pfc. George Burnes, of *Yank* magazine, was there as was Sgt. Louis Burmeister, another Marine cameraman. A Coast Guard photographer had also arrived, but has remained unidentified for more than half a century.

Rosenthal, like Genaust, was uncertain that he had the picture right. It had been a quick shot, almost lost by the exchange with Genaust seconds before the flag was raised.

"To back up the picture," Rosenthal says, "I took a second picture . . . it (the flag) was up. It was only one thrust of flag number two There was just one crack at that picture If for one reason or another . . . and there were plenty of reasons . . . it didn't turn out, I needed another picture so there would be something from me from the top of the mountain

"Spirits were high because of the capture and taking over this important sector. And so more or less I started to take a couple of other pictures. It (the flag) was up and three Marines held it in position while others searched for a rope to guide it into position and tie it down. I thought it was a mediocre picture, but I wanted a back up.

"By this time, there were a couple of other photographers around, and I called out to some of the Marines, 'Come on, fellas . . . gather around.' By this time there was some action below and around . . . there was still shooting at a couple of caves nearby but, in all honesty, we were out of the line of fire. There were things like bursts of mortars that were down in the lower part of the mountain, but I can't say that there was shooting directly at us.

"Anyway, to get a crack at another picture, what we did was get some of the Marines to gather around the flag Some said, 'We're not Hollywood Marines' . . . that kind of thing . . . but others of them were happy to have the picture made. One of them even asked me, 'How much do you charge for these pictures?' . . . and we laughed."

Rosenthal made the group wave their helmets and rifles in a classroom-like pose beneath the flag. That finished his 12-sheet filmpack, and he quickly changed packs to make one more photo that largely duplicated the group shot.

After the picture, taking Rosenthal made his way down Suribachi. He had K rations for lunch and remembers looking at his watch, which showed a few minutes after 1:00 P.M. Not wanting to miss the courier to Guam, Rosenthal headed once again for the *Eldorado*, wrote his captions, and saw the plane lift off after a jet-assisted dash through the sea. Its destination was Guam and the Wartime Still Picture Pool headquarters.

Rosenthal bumped into AP writer Hamilton Faron on the *Eldorado* and Faron asked, "Did you get the flag raising on Suribachi, Joe?" In response Rosenthal, told him about photographing the second flag, and about how the first flag was there when he arrived on the mountain. Faron wrote a story about the capture of Suribachi, identified at least one of the Marines who was involved in the raising of the first flag and mentioned that the flag was then replaced by a larger flag. The story appeared in papers of Saturday, February 24, the day before the flag-raising picture was printed.

So ended the day, an ordinary day in an extraordinary time and place—D+4, February 23, 1945. Rosenthal didn't know it, but his life was set on a new course.

FLORIDA MAN RAISED FLAG ON SUMMIT OF SURIBACHI

By THE ASSOCIATED PRESS

WITH FIFTH MARINES DIVISION, IWO, FEB. 24 (VIA NAVY RADIO)—Platoon Sgt. Ernest Ivy Thomas Jr., 21, of Tallahassee, Fla., was identified today as the Marine who raised the United States flag atop Mount Suri-Bachi during the height of the battle for the extinct volcano yesterday. Thomas broke out the ensign, which was about three feet long, while the company was under enemy sniper fire. He is the son of Mr. and Mrs. Mart Thomas.

The small flag was supplanted soon by a larger one on a high staff, which all members of the group—company E, Second Battalion, Twenty-eighth Marines—helped carry to Suribachi's 566-foot crest.

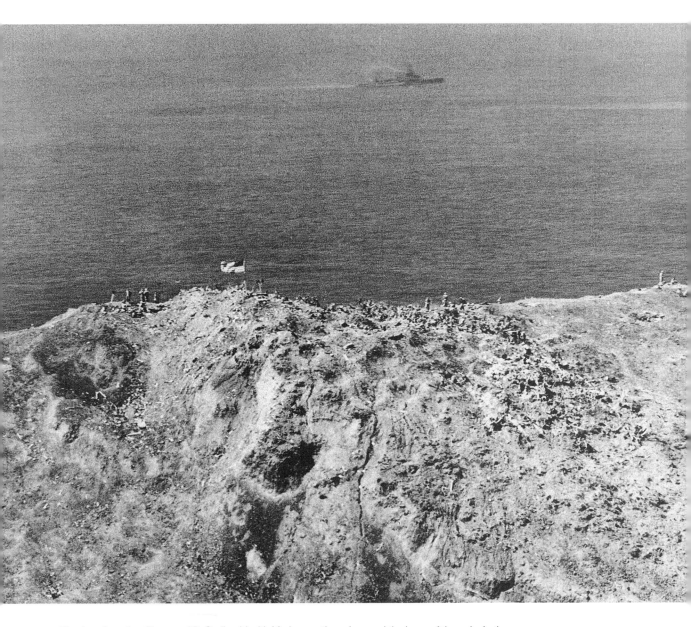

The American flag flies over Mt. Suribachi with Marines gathered around the base of the pole. In the background is a U.S. warship. Down the slope, in the center of the picture, is a Japanese cave once manned with heavy guns.

AP Wide World photo from U.S. Navy

With the flag firmly in place, Marines return to the business of clearing caves and gun emplacements on Suribachi.

U.S. Marine Corps photo, National Archive, by Burmiester

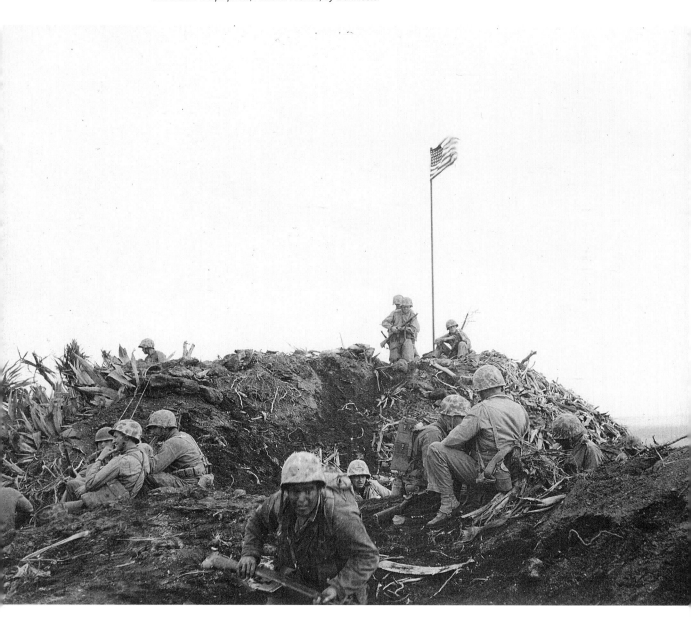

After the flag raisings on Mt. Suribachi, Marines carefully checked out several caves on the mountain's summit. In this photo they examine a cave entrance in sight of the flag.

U.S. Marine Corps photo, National Archive, by Sgt. Cornelius

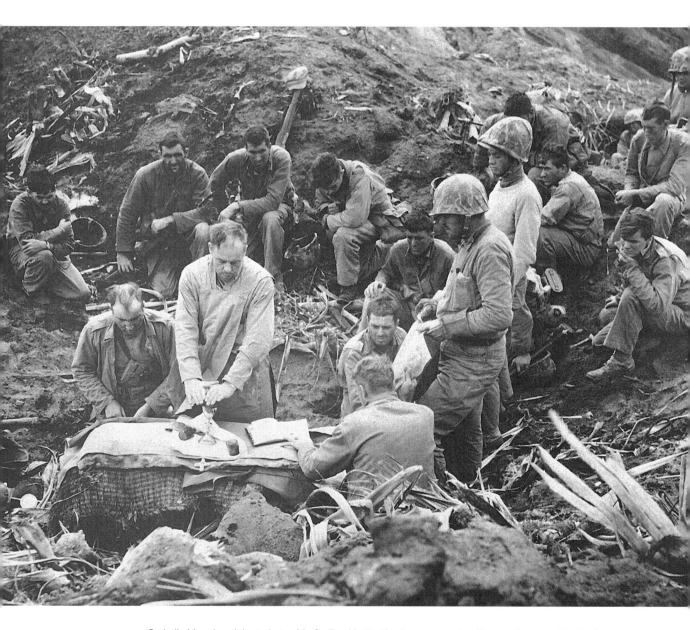

Catholic Mass is celebrated atop Mt. Suribachi after the flag ceremonies. Even as they worship, Marines keep their weapons nearby. Two wear helmets as they hold a poncho to keep the ocean winds from disrupting the chalice, candles and books used during Mass.

AP Wide World photo from U.S. Marine Corps.

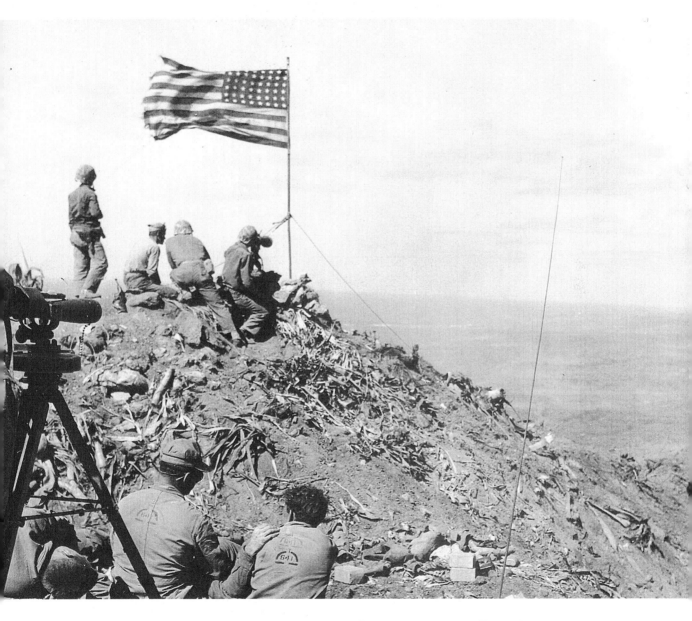

Like the Japanese before them, Americans use the summit of Mt. Suribachi as a watchtower. The watchers look for flashes of heavy Japanese guns, then call in Navy shelling or air attacks to silence them. The now famous flag photographed by Rosenthal marks the capture of the vital high ground.

U.S. Marine Corps photo, National Archive, by Mundell.

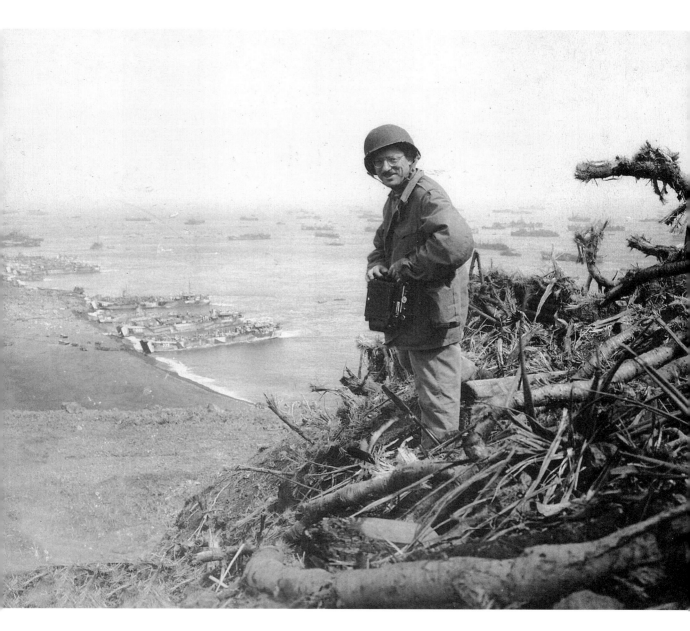

AP Photographer Joe Rosenthal stands on the summit of Mt. Suribachi, overlooking the invasion beach of Iwo Jima, Feb. 23, 1945.

U.S. Marine Corps photo, National Archive, by Pvt. Bob Campbell

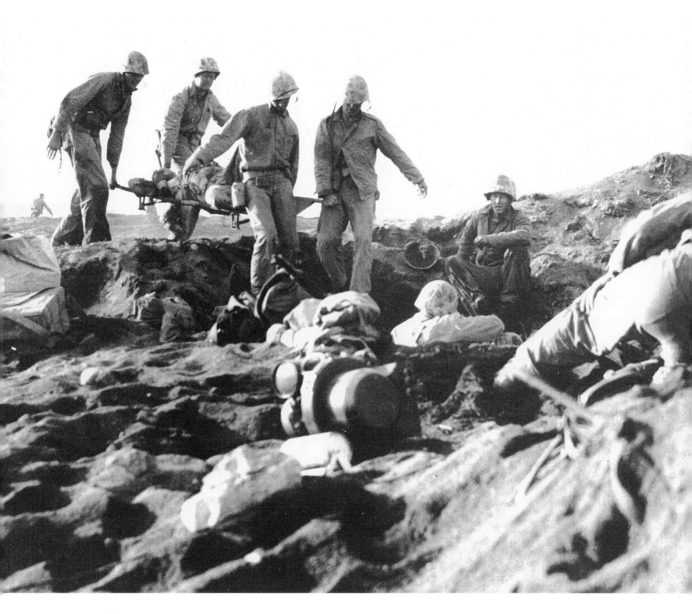

The wounded are carried past Marines in fox holes.

AP Wide World photo from U.S. Marine Corps

Marines occupy a Japanese sniper post near Motoyama. For cover they use the wings of a Japanese fighter plane with the rising sun symbol.

U.S. Marine Corps photo, National Archive, by R. Cooke

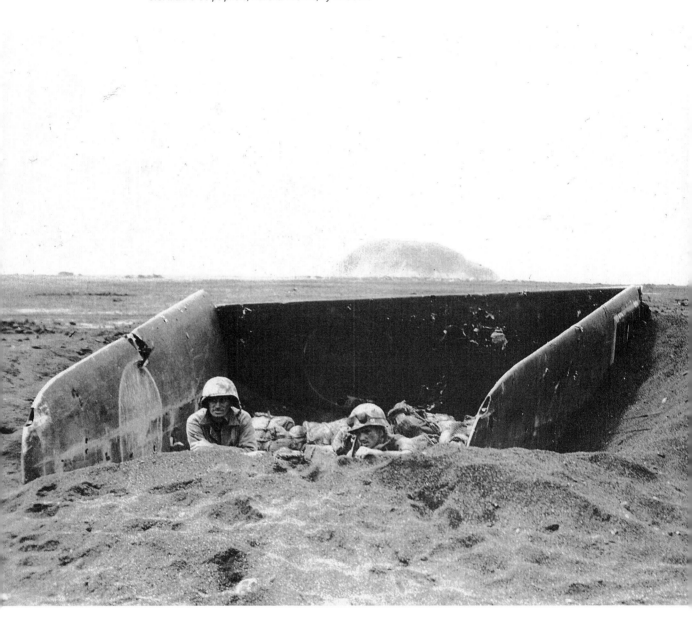

Uncommon Valor, Common Virtue

Marine column moves past a captured Japanese gun emplacement at Motoyama airfield the same day that flags were raised atop Suribachi, at left.

U.S. Marine Corps photo, National Archive, by Cooke

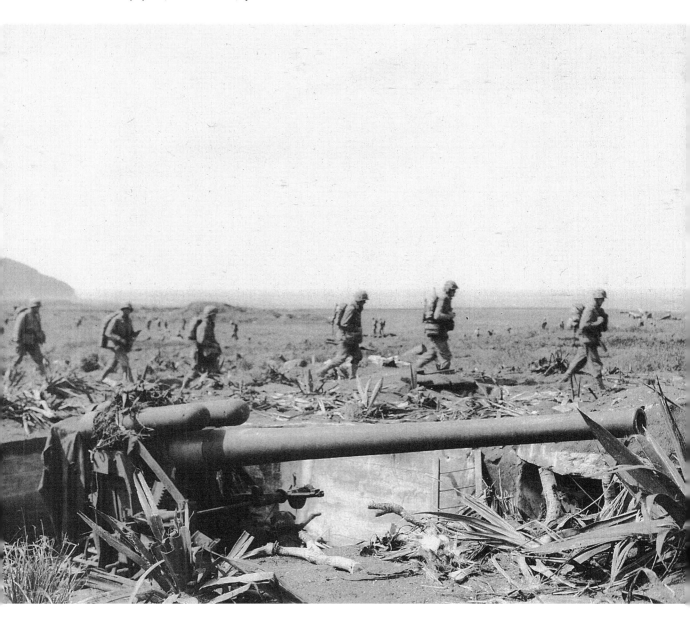

Pfc. Willard L. Dart is a lucky Marine. He holds the helmet he wore that was hit by a 40mm shell that did not explode. Dart was unhurt.

U.S. Marine Corps photo, National Archive, by Tsgt. George Kress

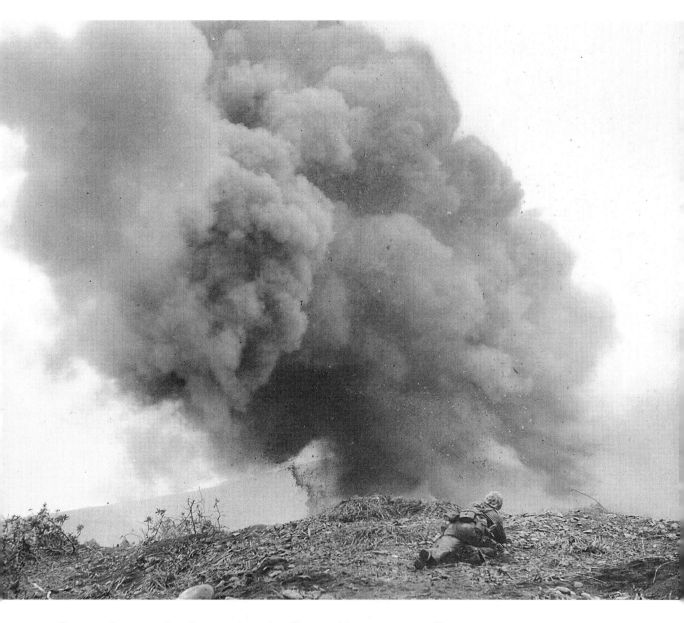

To prevent Japanese snipers from returning, a demolition team blows up an enemy pillbox.
U.S. Marine Corps photo, National Archive, by Warrant Officer Obie Newcomb

1945.

VOLCANO IS SEIZED

Marines Put Flag at Suribachi's Crest and Strike Foe in North

JAPANESE HIT BACK

One of 2 Heavy Blows Believed Repulsed— Our Casualties at 5,372

By WARREN MOSCOW
By Telephone to *THE NEW YORK TIMES*

ADVANCED HEADQUARTERS, ON GUAM, FRIDAY, FEB. 23— American marines fought their way up Mount Suribachi, volcano dominating the southern end of Iwo Island, and at 10:35 this morning raised the American flag on its summit, Admiral Chester W. Nimitz announced in a special communique this afternoon.

The last previous word on the assault at this end of Iwo had been that the volcano cone, in which the Japanese were strongly entrenched encasements, tunnels, etc., had been surrounded and that the marines were pushing their way up the slopes in the face of murderous Japanese fire. This had been on the previous day, so the direct assault up the slopes probably lasted twenty-three hours.

The outfit that put the flag at Suribachi's crest was the Twenty-eighth Marine Regiment, under command of Col. Harry B. Liversedge, holder of the Navy Cross, after leading Marine units in the southwest Pacific, born at Volcano, Calif.

Reaching the summit of Suribachi does not mean immediate capture. The Japanese are not using the volcano crater for emplacements, but the tunnels and caves interlacing it. However, the move was the most definite gain on Iwo since the capture of the airport at the end of the first day's operations, and the Japanese on the mountain, now losing the advantage of height domination, can be caught from the rear. The complete wiping out of Japanese in the southern end of the island will free large areas from Japanese gunfire and aid the forces pushing northward in bloody fighting.

JAPANESE STRIKE

ADVANCE HEADQUARTERS, GUAM, Friday, Feb. 23(AP)—From Suribachi, whose slopes had been blasted by battleships and dive-bombed by carrier planes, the Japanese had raked Marine positions throughout the southern sector with deadly mortar and artillery fire.

Admiral Chester W. Nimitz announced the victory in a brief communique soon after one that had reported only minor advances through Thursday against fierce opposition.

No invasion of the Pacific war for a comparative period has cost so many American casualties. At Tarawa, previously considered the bloodiest fight of the war, marine casualties for its entire seventy-two hours slightly exceeded 3,000.

Small Advances Made

Admiral Nimitz in his last previous communique covering the casualty count up to 5:45 p.m. Wednesday reported 385 killed and 4,168 wounded. Today he reported casualties had reached 5,372.

Today's communique reported more of the same type of bitter fighting which has built up the casualty totals.

The press camp on Iwo Jima was nothing more that a few tents hastily put up on the sandy beach of the island. Reporters and photographers would stop by to exchange gossip and information.

AP Wide World photo from U.S. Marine Corps

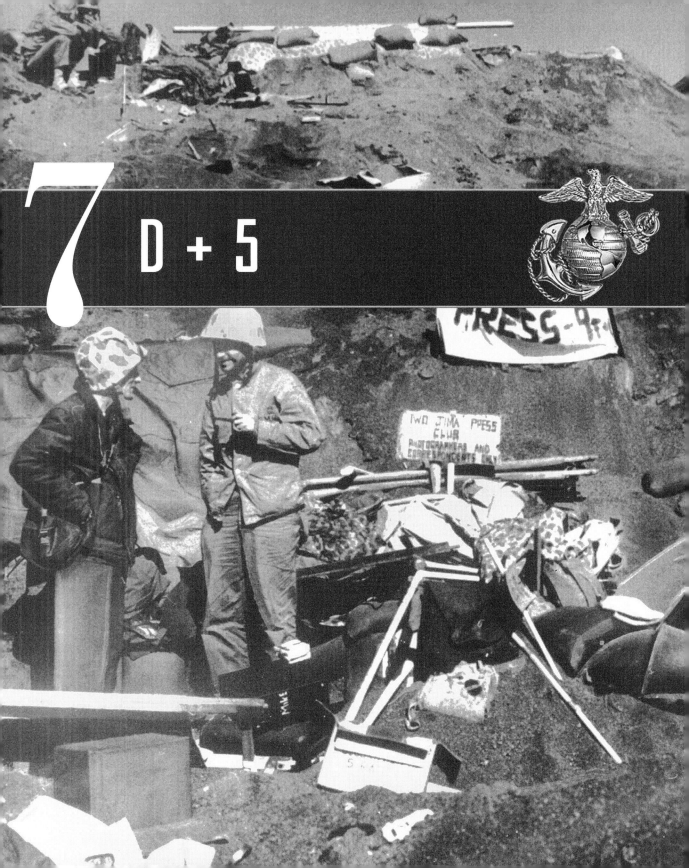

7

D + 5

THE FIRST STOP for Joe Rosenthal's film after it left Iwo Jima was the Wartime Still Picture Pool headquarters in Guam, where an eclectic mixture of civilian photo editors, military photo editors, some with a professional civilian background, and military technicians handled combat photography from various war zones in the Pacific. Military censors were part of the mix, too.

Censorship, in the early phases of World War II, was concerned primarily with two subjects: pictures that might reveal Allied positions prematurely, and pictures of dead Allied personnel. By the time of the Iwo invasion, however, the issue of dead personnel had been overridden by Washington. The long war and the mounting casualties in the Pacific inspired noticeable and growing impatience on the home front. Washington believed that pictures of American casualties would revive the post-Pearl Harbor fighting spirit and dampen growing perceptions that the Pacific war was not being handled properly.

Civilian companies that participated in the pool included Associated Press, Acme (forerunner of United Press Newsphotos), International News Photos (the Hearst newspaper group), and *Life* magazine. The agencies paid the salaries of their civilian staff but the military transported them and provided food and billets in the Pacific areas they covered.

The media complained that handling of war news, dependent as it was on access to military transportation, couriers, and communications, was not efficient in the latter years of the Pacific war . Some picture shipments were lost or delayed (and therefore outdated) as compared to text coverage, which itself was slower than had been hoped for. At Tarawa, for example, pictures did not arrive in the United States until after the battle was over.

U.S. Navy patrol plane rests in the waters off Iwo Jima's coast awaiting its shipment of news reports, photographs, film, audio reports, and other messages. Once the material is aboard the plane takes off for Guam where the material is sent by radio circuits to the U.S. mainland. The flight was made once daily from Iwo Jima and accounted for the fast delivery of war information from the island.

AP Wide World photo from U.S. Navy

At Iwo Jima, an all-out effort was made by the Navy to expand facilities for press coverage and overcome the delays. Some text and radio broadcast transmissions were made from ships at Iwo. Norman Hatch estimated that some ninety military motion picture and still photographers from the various services were assigned to cover the Iwo invasion, with their film available to the still picture pool. A seaplane flew daily from alongside the *Eldorado* to courier news materials as well as battle reports to Guam.

Film from photographers on Iwo was processed in Guam and edited. Selections were made of key photos, and these were transmitted to the United States by radio-photo link, then retransmitted on the separate, nationwide wire networks of the agencies. Original film was sent by courier to Washington. Some film from specially assigned photographers, such as Lou Lowery of *Leatherneck*, was exempted and dispatched directly to the magazine.

Undeveloped Iwo film—including pictures from Suribachi—arrived on Guam the evening of February 23, where it was immediately processed. Rosenthal, in

Picture transmitter newly assigned to Guam. It was from this location that Rosenthal's picture was transmitted to San Francisco via radio signal, and them into picture networks world wide.

AP Wide World photo from U.S. Navy

his meticulous way, provided several sets of captions with his film so that one set could be sent to censors for clearance while the film was processed and edited with the help of another set.

Jack Bodkin, an AP photo editor in civilian life and a Naval officer during the war, was one of the professional picture editors assigned to Guam. He was the first to see Rosenthal's remarkable photo, still wet as it was pulled out of the chemicals after processing. Bodkin took one look and exclaimed, "Here's one for all time." The picture was prepared immediately and transmitted to San Francisco via Navy radiophoto circuits.

On Saturday, February 24, George Sweers, an AP wirephoto operator in Kansas City, reported for his 7:00 A.M. start time, and responded to the New York roll call indicating that Kansas City was manned and ready for transmissions. It was the duty of wirephoto operators to make film recordings of network pictures. The photos were then printed and distributed to newspapers in Kansas and Missouri, a process duplicated at cities throughout the United States.

On that Saturday, during the course of the day's picture transmission, New York announced over the network that a photo showing a flag raising on Iwo Jima would be transmitted from San Francisco. Sweers lined up his wirephoto receiver to be in synchronization with the transmitting machine, recorded the picture, and processed the film.

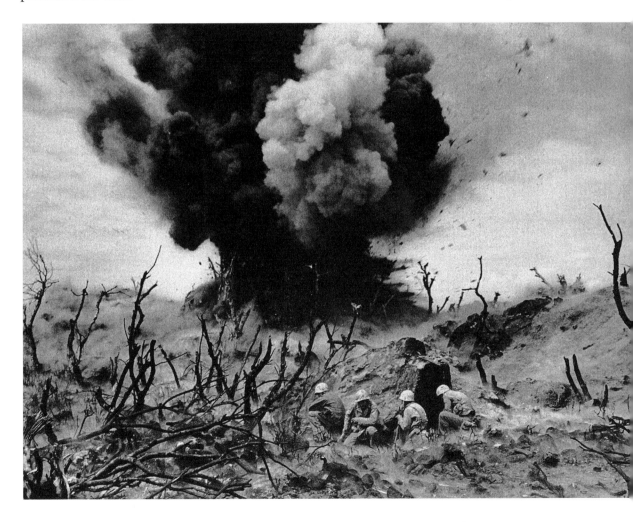

A shattering blast puts an end to a three-tiered blockhouse on Iwo Jima.
Life *magazine pool photo.*

"When I saw the film," Sweers recalls, "I said, 'Wow! What a picture! It looks like a statue.' I made prints immediately. My work station was just around the corner from the art department of the *Kansas City Star* and I took a print over to show to an artist. Without prompting, he said the same thing . . . it looks like a statue.

"'It's from Iwo Jima . . . they're still fighting over there,' I told the artist.

"Usually pictures sent by radiophoto were streaked, and many of the war pictures from both Europe and Asia were of pretty poor technical quality. But this photo was quite good, and it had that statuelike look. The *Star* used it on the front page on Sunday morning."

The flag-raising picture was distributed by all the agencies, and it dominated the front pages of Sunday editions throughout the land. Americans fell in love with the photograph. It promised victory.

On that same Saturday, at a naval installation in the Washington, D.C., area, a Navy artist saw the picture. It looked like a statue to him, too. He immediately went to work on a small sculpture that replicated the picture in three dimensions. The finished model was Felix de Weldon's first version of the monument that ten years later would be the 100-ton bronze statue in Arlington, Virginia. He planned to show his model to Marine brass promptly and seek support for his idea to build a magnificent memorial to Marine valor.

On Iwo Jima, however, victory was still a long way off. Old Glory continued to fly briskly atop Suribachi, but the celebration of February 23, was brief, overcome by the sound of gunfire and the cry, "Corpsman, corpsman." Attention was riveted each day on the excruciating task of closing down caves, blowing up pillboxes, searching out snipers, and crawling through the ridges and rocky outcroppings, each a potential death threat. Advance was slow and deadly, the steady march of stretcher bearers carrying dead and wounded unending.

Wounded Marines are carried on pontoon barges from the Iwo Jima beach to a landing craft that will take them to a hospital ship nearby.
AP Wide World photo by Joe Rosenthal

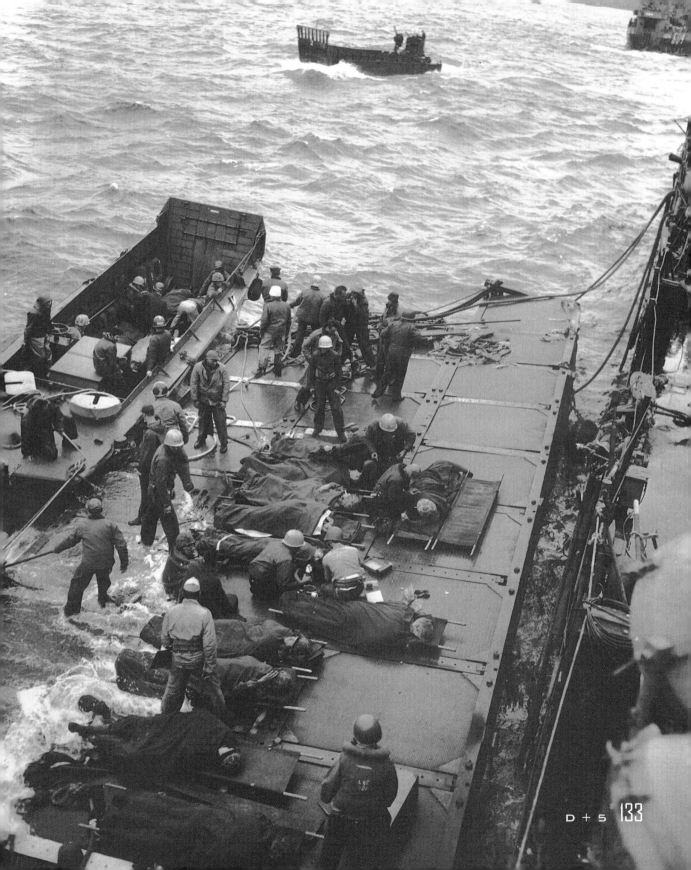

D + 5 133

Marines walk down a rocky path from the top of a hill, some of them carrying a wounded companion to an aid station. *AP Wide World photo by Joe Rosenthal*

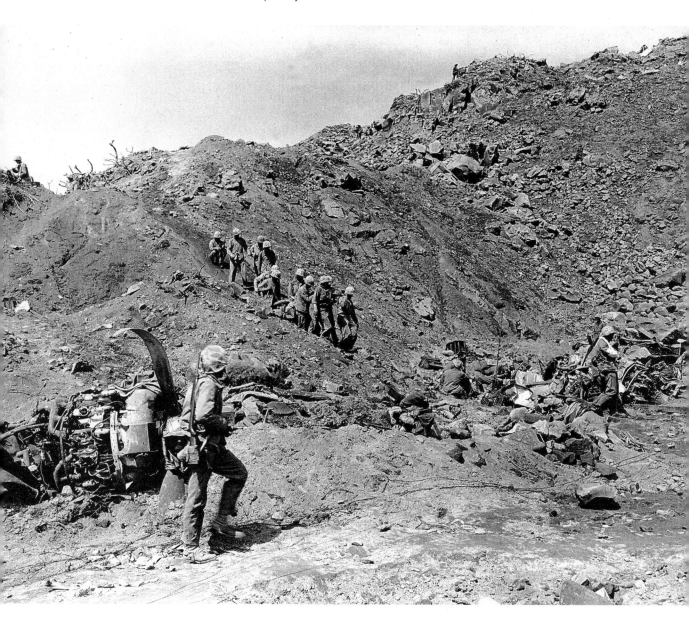

The booted feet of a dead Japanese soldier protrude from beneath a mound of earth while Marines nearby find protection in a fox hole. *AP Wide World photo by Joe Rosenthal*

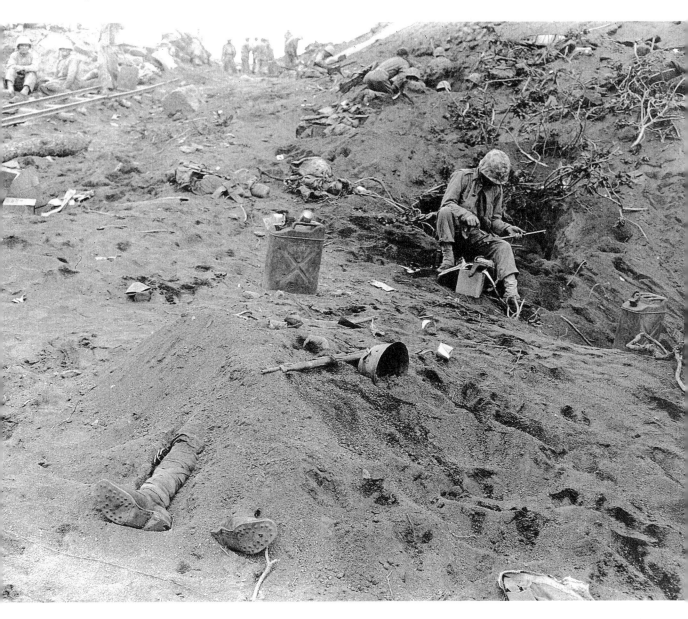

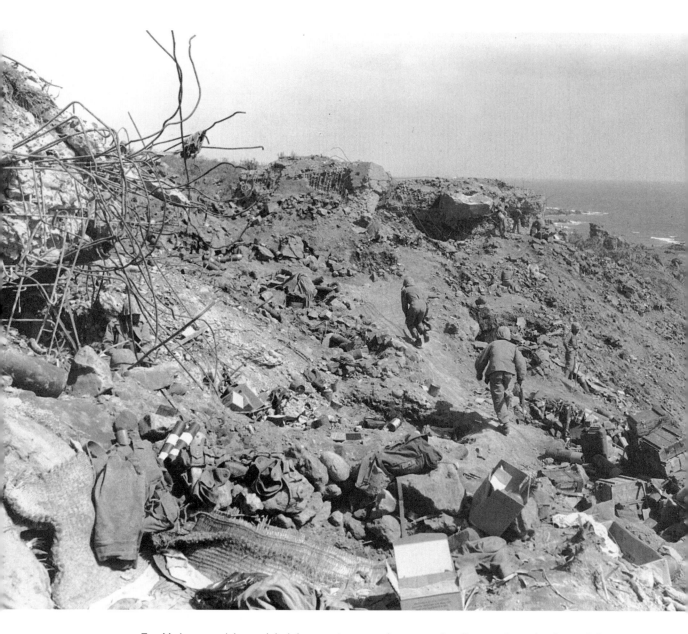

Two Marines crouch low and dash for cover to escape Japanese sniper fire on a slope of rocky terrain in early March. The concrete blockhouses in the picture were knocked out by Navy shell fire.

AP Wide World photo by Joe Rosenthal

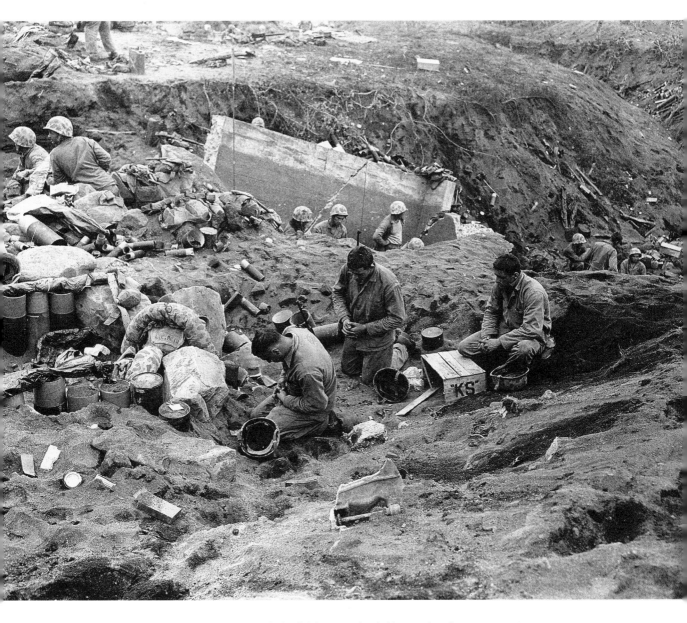

U.S. Marines kneel in prayer during a pause in the fighting near airstrip No. 1 on Iwo Jima.

AP WIde World photo by Joe Rosenthal

Tanks attack a Japanese pillbox on Iwo Jima. *U.S. Marine Corps photo*

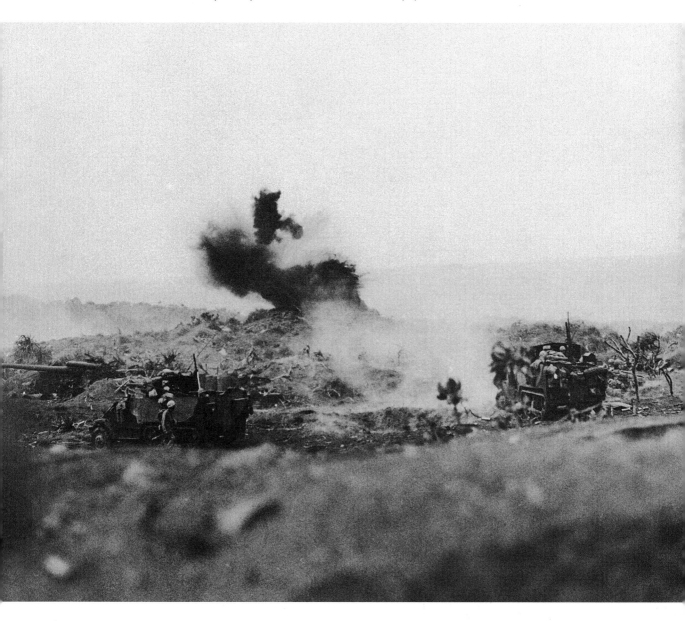

Rockets are fired at Japaese emplacements on Iwo. The mounted weapons are mobile and allowed Marines to make hit and run attacks on enemy positions. *National Archive*

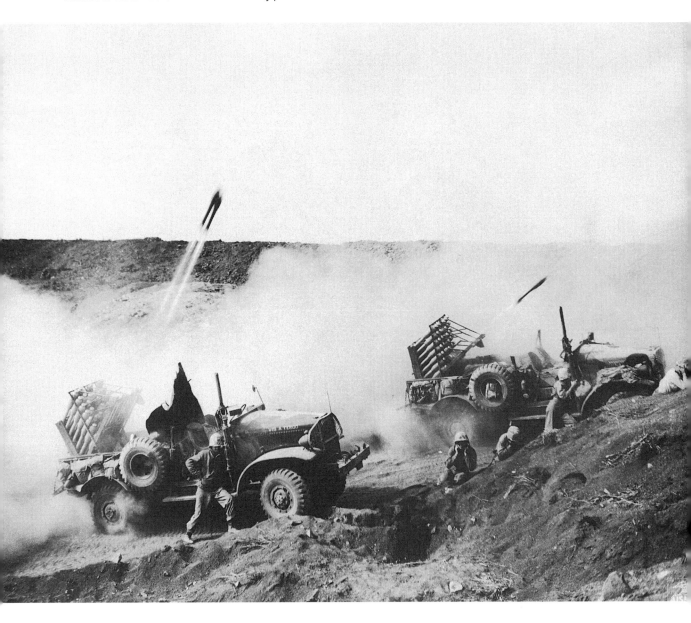

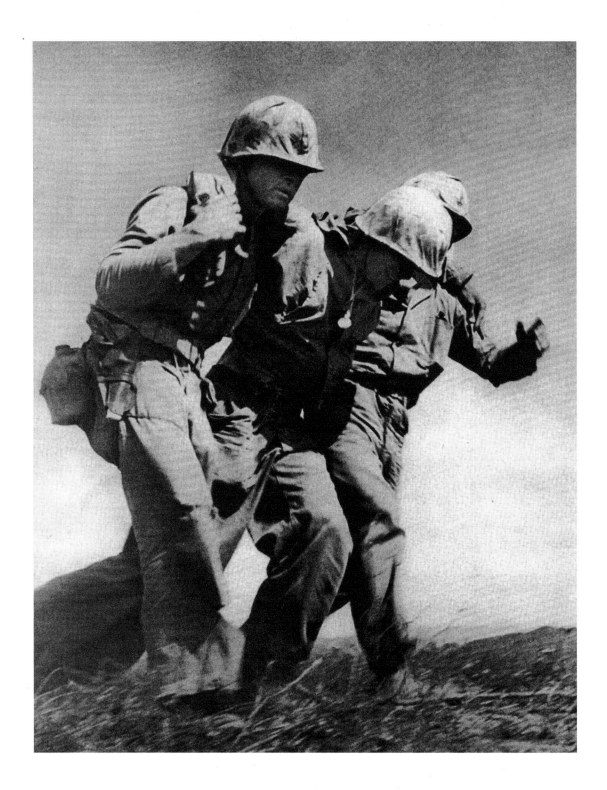

Uncommon Valor, Common Virtue

Marine gets a helping hand from his buddies after taking a bullet.
U.S. Marine Corps photo, National Archive

Rocky terrain on Iwo Jima proved a tough obstacle to Marines who had to climb ridges and hills pocked marked with enemy sniper and machine emplacements.
U.S. Marine Corps photo, National Archive, by Dreyfuss

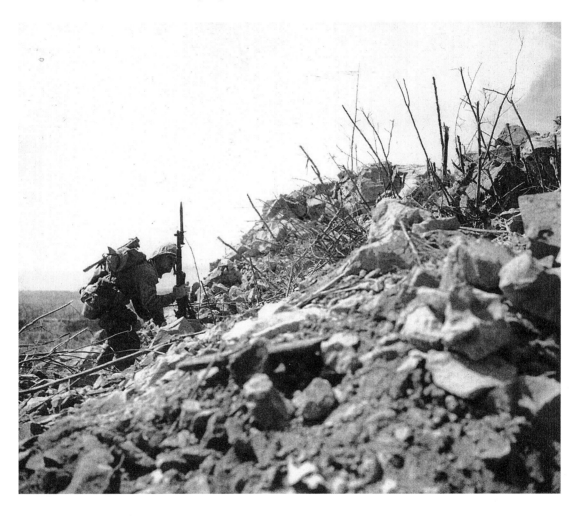

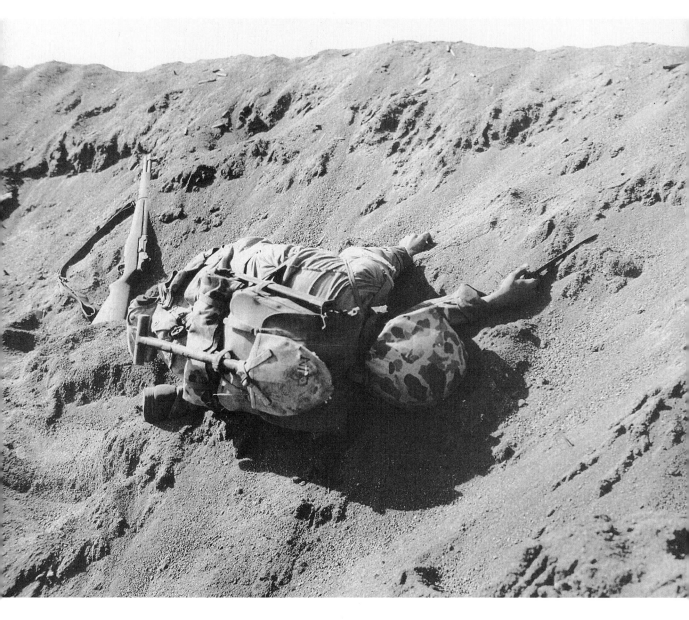

Even though slain in a shell crater, this Marine clutches his bayonet.

U.S. Marine Corps photo, National Archive, by. Sgt. D. R. Francis

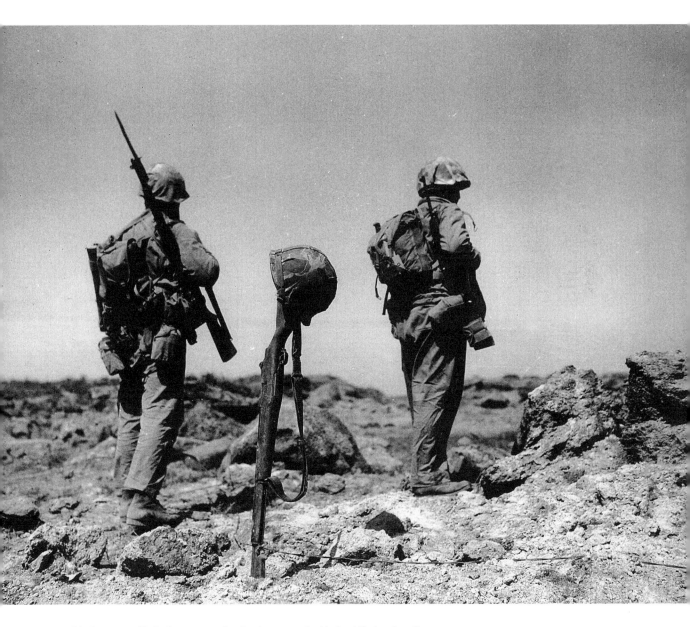

A helmet on a rifle is the mute marker for the grave of a Marine killed on Iwo Jima.

U.S. Marine Corps photo, National Archive, by Pfc Charlie Jones

Mortar fire is directed against Japanese positions during the second week of fighting on Iwo Jima.
U.S. Marine corps photo, National Archive, by Pfc Robert Campbell

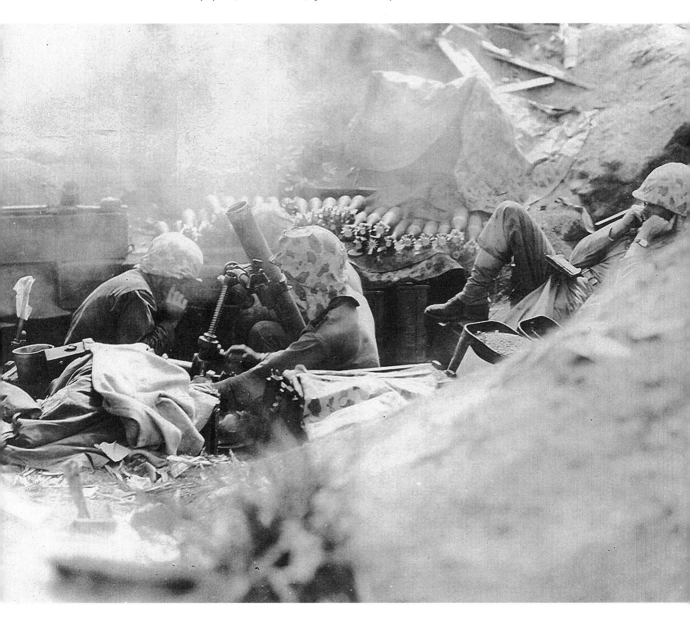

A deadly pattern of tracers lights the night sky over Iwo Jima as antiwaircraft fire repels a Japanese air attack on positions held by Marines. *U.S. Marine Corps photo, National Archive*

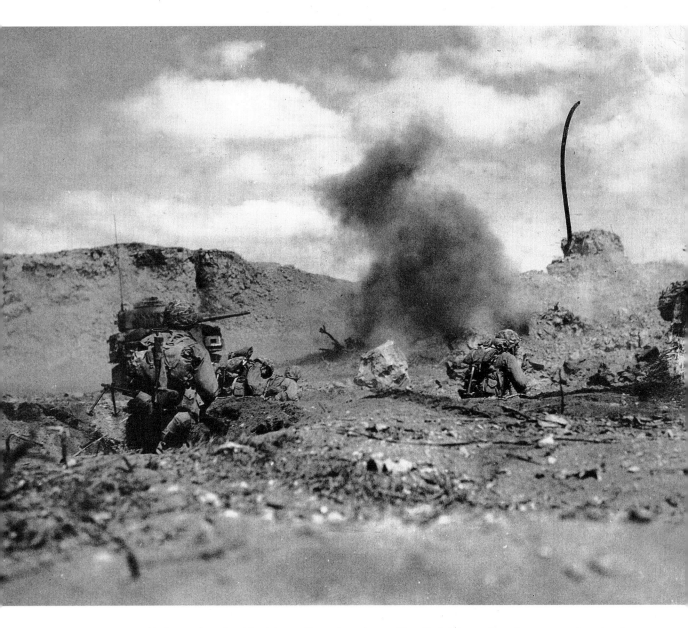

Marines make a direct frontal assault on a Japanese position. Explosions are from Japanese mortars aimed at a U.S. tank. Photographer's caption with this photo said, "Gained 30 yards of ground, loss of 30 men."

U.S. Marine Corps photo, National Archive, by Cpl. Eugene Jones

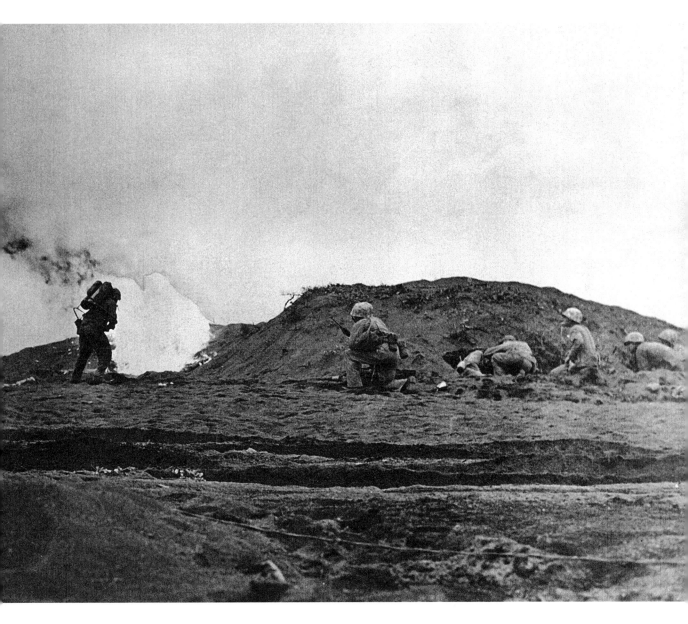

A Marine armed with a flame thrower wipes out a Japanese fortified position while fellow Marines provide cover, and watch for enemy troops attempting to escape the attack.

U.S. Marine Corps photo, National Archive

These Marines were crawling over a rise in the ground when one of them, carrying a flamethrower, was hit, and all perished in the explosion.

U.S. Marine Corps photo, National Archive, by Pfc. R. R. Dodds

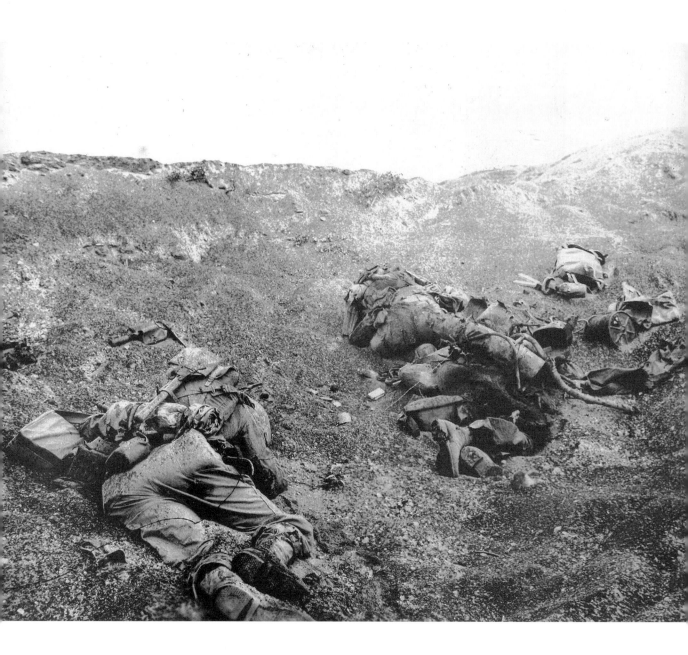

A wounded Marine gets some shuteye but even in sleep clutches his knife at the ready.
AP Wide World photo

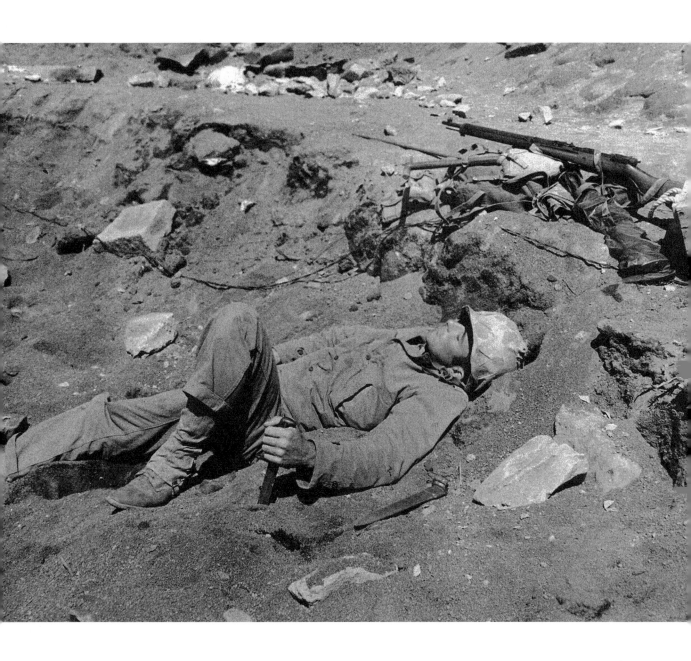

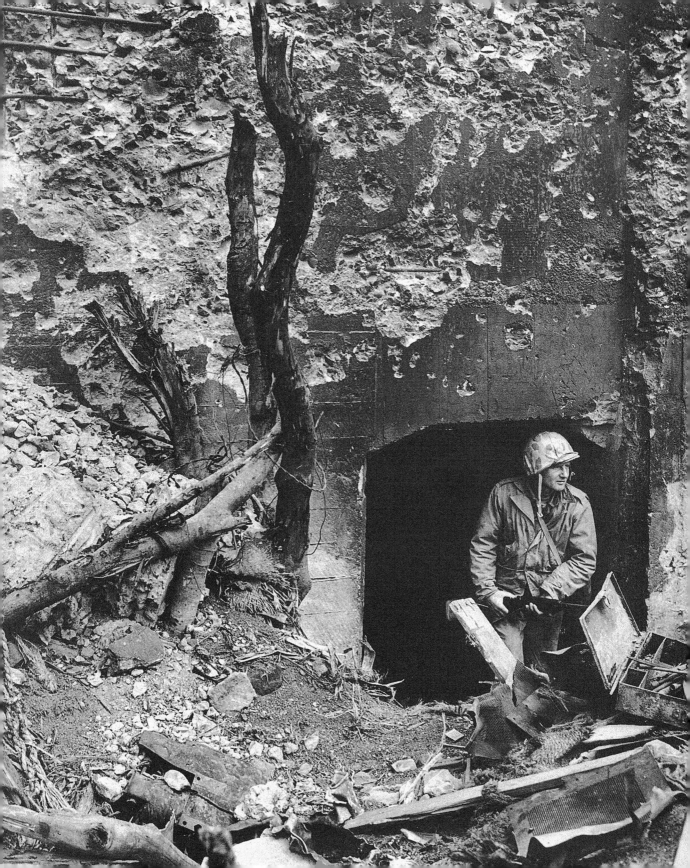

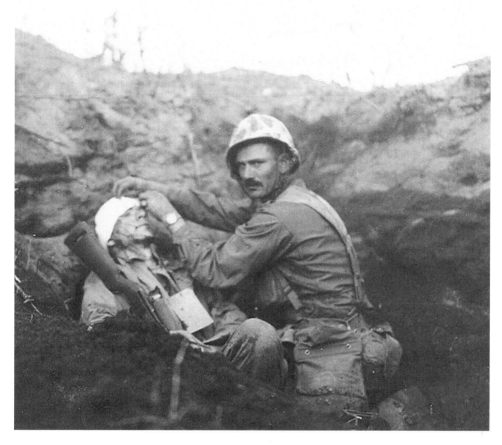

Photographer Sgt. David Christian is treated for his wound by a corpsman on Iwo Jima.
U.S. Marine Corps photo, National Archive, by 1st Sgt. Robert Follandorf.

Marine stands in the entrance to a three-tiered blockhouse, one of Iwo Jima's most formidable defense installations. The chambers inside were filled with the charred bodies of Japanese soldiers who where killed by flame throwers

Life *magazine pool photo by Eugene Smith.*

"On the men I carried back on the stretchers, there were all kinds of wounds. Some were missing legs. One fellow, his stomach was almost completely blown apart, some were hit in the head. The hospital corpsmen would fix up whatever they could and gave them morphine or something. We even carried dead ones back and didn't realize it. I carried my best friend back and didn't even know it was him. Somebody told me the next day."

—PLATOON SGT. JAMES BOYLE
Quartermaster HQ

"They had great big things, huge things, and they'd blow up over you, they'd be flying all over. I remember one time . . . I was standing next to this fellow named Libby. We were just standing there and talking, and all of a sudden, this great big piece of metal comes and takes Libby's head right off. And I began to think, maybe I have some special power, you know, being saved when these other guys are gone, and Libby's head is there, and the rest of him over there. And these things happened a lot. These are lasting things, when you're standing face to face with a guy and he loses his head on you, you know."

—PFC. EDWIN P. DES ROSIERS
H&S Battalion

"But the fighting was done at the four-man, fire-team level, and the twelve-man squad level. And with those fortified bunkers that had only a slot for a machine gun to fire from, the only way to neutralize them was by small-team action in which two men fired at the port and tried to keep them covered, and two other men moved to the side to plant a satchel charge, drop a grenade, whatever."

—CAPT. LAWRENCE SNOWDEN

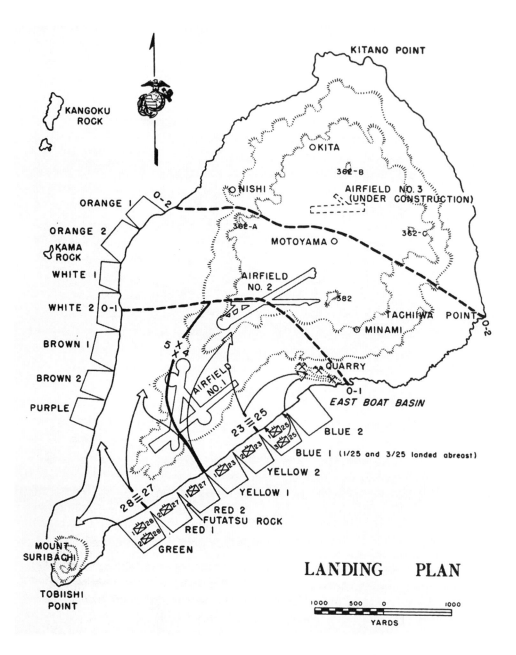

The Marine Corps map outlines the plan of battle for the invasion of Iwo Jima. Actually, the Marines did not land on the western side of the island, only on the eastern side. It took from February 19 until March 26 to completely route the Japanese force. Even after March 26 some Japanese holdouts harassed American forces.

U.S. Marine Corp Map

8 D + 6 to D + 14:
An Icon Is Born, A Battle Continues

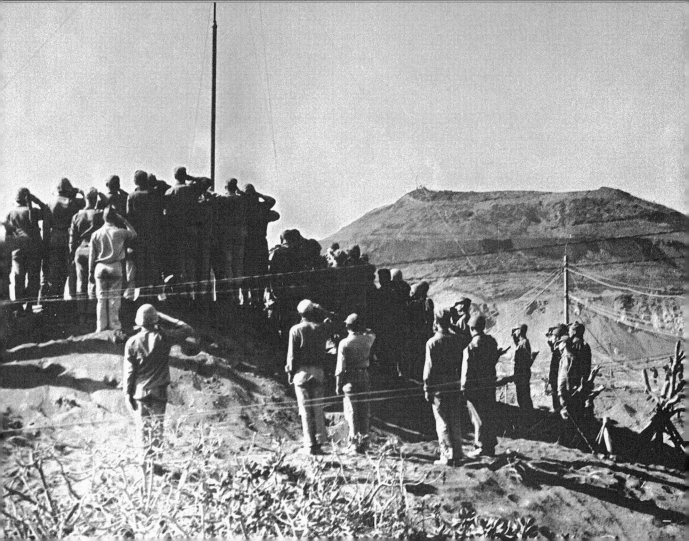

AMERICA FELL IN love with the photo.

It was in every sense of the word a perfect picture. Filtered light gave it a sculptured effect, the flag snapped in the wind, the six warriors strained as one in a team effort to raise the banner, a strong diagonal line emphasized the action, bramble around the feet anchored the photo in a time and place, a plain background without distraction all added to the photo's posterlike impact.

The picture's visual force and its iconic qualities struck a chord in the American psyche. Great icons have that special power—they reach into the spirit where viewers identify in a visceral way with their message. Icons represent not only a special, frozen moment, but in an instant, they recollect in the viewer's mind what has gone before and they suggest what is yet to come. They are of the moment, and at the same time they transcend the moment; they are specific, and they are far reaching. Some, like Rosenthal's flag-raising photo, speak of enduring qualities shared in common beyond time and place.

The flag picture in the American winter of 1945 found a fertile environment. Allied victory in Europe was clearly on the horizon. Americans understood the war in Europe where names like London, Rome, Paris, and even Berlin, were embedded in the nation's history. The home front was patient with the duration of the campaign and the casualties. The Pacific was another story. Strange names with mysterious histories jumped from the headlines—Guadalcanal, Eniwetok,

PREVIOUS PAGE: An American flag is raised over Marine headquarters on Iwo Jima, March 16 signifying that the battle is won. Marines in the rocky northern part of the island saw a bit of irony in this scene; the fighting continued ferocious for nearly two more week with many killed and wounded before Japanese forces were eliminated. On this same day the flag photographed by Joe Rosenthal, now ripped in places by the ocean winds atop Mt. Suribachi, was taken down.

AP Wide World photo from U.S. Marine Corps

Saipan, Peleliu, Tarawa. Casualties soared in places unseen on most maps Based on fighting in the islands, the coming battle for Japan promised to be long and bitter.

Then came Iwo Jima, another no-place name on a endless ocean. Casualties were the worst yet, prompting one woman to write to Secretary of the Navy James Forrestal:

"Please for God's sake stop sending our finest youth to be murdered on places like Iwo Jima. It is too much for boys to stand, too much for mothers and homes to take. It is driving some mothers crazy. Why can't objectives be accomplished some other way. It is most inhuman and awful—stop, stop."

Forrestal replied that the nation had the choice to run or fight, and the choice was to fight, not be overrun, that there was no other possibility.

Covered bodies of slain Marines await burial on the beach at Iwo Jima while the battle continues only a few thousand yards away.
U.S. Marine Corps photo, National Archive

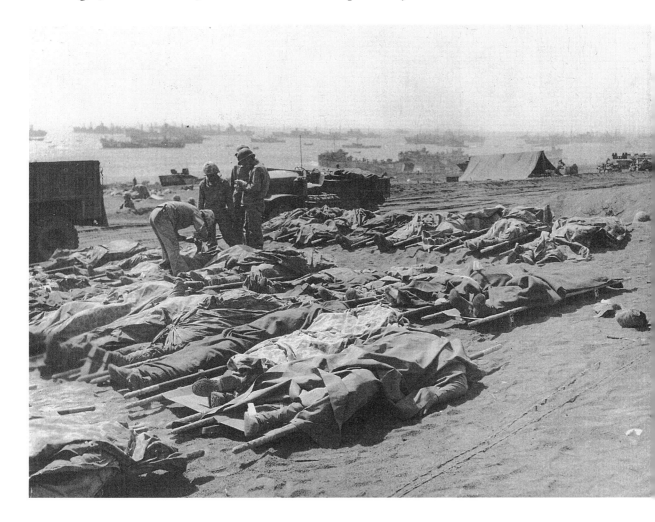

Then the flag-raising picture appeared. It literally altered the mind-set. The photograph articulated what Americans at mid-twentieth century saw as their mission. It showed Americans as Americans saw themselves and as they wanted to be seen—strong, all for one, getting the job done . . . and most of all, it showed Victory. The photo became a rallying symbol greater even than Old Glory itself. It was easy to love at a time when there was a need for such love.

The picture was cited by members of the Senate and the House of Representatives. Sen. Joseph O'Mahoney wrote: "It is a memorial to the men in whose blood our victory is being written. It is a reminder of the ideals for which we fight."

Marines prepare to investigate a cave in the side of a cliff at the bottom of a sulfur pit. Eliminating enemy soldiers in these unusual locations was dangerous work with high casualties.

U.S. Marine Corps photo, National Archive, by Dodds

One critic compared its artistic qualities to those of Leonardo da Vinci. A newspaper printed a painting, The *Spirit of '76*, into the upper portion of the photo and received 47,000 requests for the rendition. The caption that accompanied the montage read: "The Iwo Jima picture proves that the Spirit of '76 has not perished and that the courage and bravery of the present day American soldier is reminiscent of that of the warrior who fought for liberty in the Revolutionary War."

The Pulitzer Prize, awarded each spring for news photography from the previous calendar year, made a one-time exception and presented the Pulitzer to Rosenthal in 1945, the same year the photo was made. The picture was loudly proclaimed as a symbol of the nation's fighting sprit, of its courageous military, and of the certainty of victory. It is next to impossible decades later to fully relate the spirited energy that the photo generated.

On Iwo, however, little was known of the picture's success. Two days after his photos were transmitted, Rosenthal received a message forwarded by Guam to the *Eldorado*: It read, "Congratulations on the great flag-raising picture," and it was signed, "KC," signoff of Kent Cooper, legendary general manager of Associated Press. Joe was pleased at the compliment but bewildered—he didn't know which picture merited such praise. He wasn't certain he got the picture of the flag going up, and he didn't think the Gung Ho picture, which is what he called the shot of the Marines waving under the flag, was all that great.

Meanwhile there was a war to be covered, and Rosenthal returned to Iwo's wet, chilly, windy landscape where, despite the occupation of Mt. Suribachi, the fighting seemed to get worse, not better. Marines now held the two airfields on the island and moved north into the island's moonscape terrain of rocky ridges, ravines, gullies, caves and more pillboxes. New names entered the lexicon of war— the Quarry, the Meat Grinder, Turkey Knob Hill, the Ampitheater.

The Quarry: On the far right flank of the invasion beach and inland not too far from Airfield One rugged cliffs created a quarrylike topography that hid caves and heavy weapon emplacements. Difficult to spot except up close, the Japanese in the area blasted away at the beach, and for several days frustrated efforts by Marines to straighten their line across Iwo Jima. Some days an advance of fifty yards was considered a success. Rooting out the enemy inevitably resulted in high casualties.

The Meat Grinder: An area east and slightly north of Airfield Two, was the site of the highest hills on Iwo Jima, after Suribachi. The collection of hills came to be known as the Meat Grinder, the highest point being Hill 382 (so named for its height above sea level).

Turkey Knob Hill: Another high point Four hundred yards south of the Meat Grinder and so situated as to provide protective fire for any Marine force attempting to capture Hill 382. A heavily fortified blockhouse stood atop the high ground.

The Ampitheater: A wide, open area in front of the Meat Grinder and Turkey Knob Hill that, because there was no cover, represented a challenge that was different than other places on the island. The area was 300 yards long and 200 yards wide. One side was a sheer cliff sixty feet high and Japanese weapons in the nearby rocky areas had a clear field of fire on anything moving across the field. Marines attacking the Meat Grinder and Turkey Knob Hill had to cross the Ampitheater to reach their target.

Tanks with flamethrowers were an important weapon against Japanese troops in pillboxes, blockhouses, and caves on Iwo Jima. Marine snipers worked with the attacking tanks to watch for enemy soldiers that ran from their positions.

U.S. Marine Corps photo by Mark Kaufman

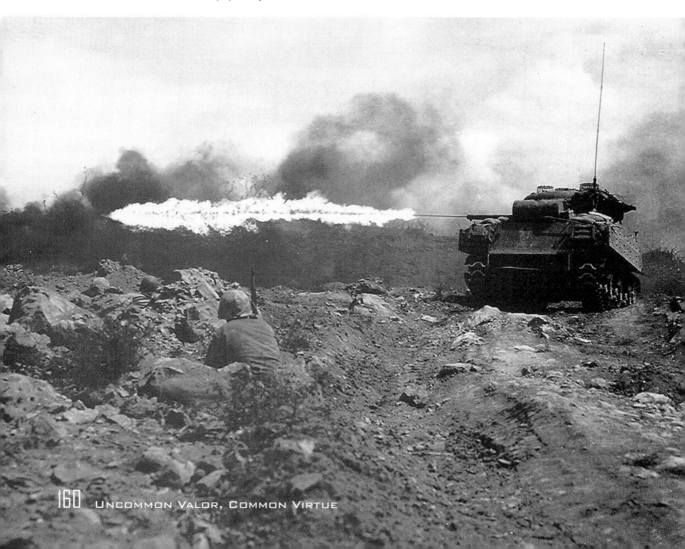

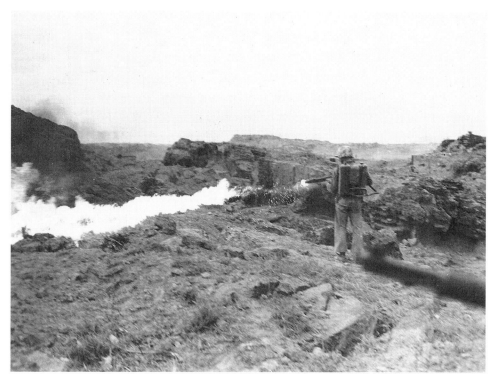

A Marine with flamethrower, a widely used weapon on the island, cleans out a cave entrance.

U.S. Marine Corps photo, National Archive

The assault on the Meat Grinder and Turkey Knob Hill began on D+6 and was not completed until D+13. The first attack started with heavy naval barrages on the area, but these soon became dangerous as Marines moved closer to targets. Tanks were used that fired explosives into enemy blockhouses and spewed flames into caves and pillboxes. But the rugged terrain made them less and less effective as advancing forces probed deeper and deeper into the heavily fortified area.

Several times, Marines mounted the summit of Hill 382 only to be thrown back by intense mortar attacks and machine gun fire from Turkey Knob. In the end it was hand-to-hand fighting, use of flamethrowers, grenades, and satchel charges that took their toll on the enemy and finally won the day. Casualties soared.

By the first week in March, the Meat Grinder was finally and permanently in Marine possession, but the fighting in the area had been the bloodiest of the whole battle thus far, which would not actually end until March 26.

About the same time, on March 4, with Seabees finishing the runway of Airfield One, the crippled B-29 *Dinah Might* landed safely on Iwo Jima. It was the first of more than 2,000 B-29s that found sanctuary on Iwo after taking hits during

bombing runs over Japan. Their crews numbered 24,000 airmen who otherwise faced the possibility of ditching in the Pacific—perhaps rescued, perhaps not.

The B-29 landing might have been the subject of Sgt. Bill Genaust's motion picture camera, but the weather—dark, misty and dreary—made photography impossible with the very slow Kodachrome film he used. Instead, Genaust, who shot film alongside Joe Rosenthal on Suribachi, helped Marine buddies mop up remnants of Japanese resistance. On that day, March 4, just a mile from the Meat Grinder, in a cave on Hill 362-A, Genaust was slain. He never saw the 198 frames of Kodachrome he shot showing his fellow Marines push the flag up in a single thrust.

Just how Genaust died is not known, the details lost to history. Some say he entered a cave to rescue a fellow Marine; another story says he and a companion ducked out of the rain for a moment; another says he saw a Japanese reading maps outside the cave and went to check it out. What is known is that he entered a cave, used a flashlight to investigate his surroundings, and was shot and killed immediately by Japanese riflemen. Marines had no choice but to seal the cave with dynamite and a bulldozer.

Marine Corps policy stipulates that their dead are not left behind, and the dead of Iwo Jima were eventually brought home for burial in the United States. But not Genaust. The probability of live explosives buried in the closed cave entrance made it too dangerous to recover his remains. His Suribachi sequence was widely

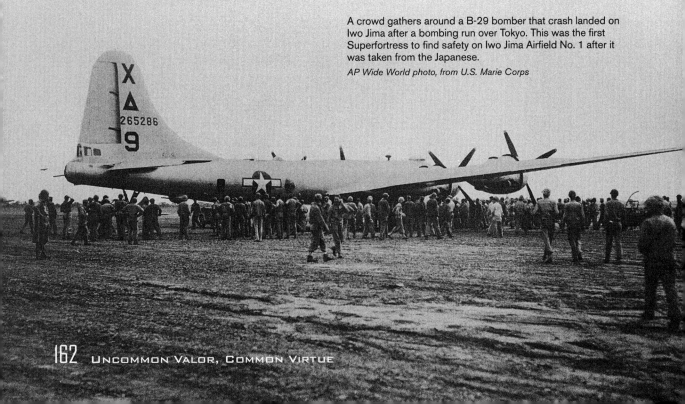

A crowd gathers around a B-29 bomber that crash landed on Iwo Jima after a bombing run over Tokyo. This was the first Superfortress to find safety on Iwo Jima Airfield No. 1 after it was taken from the Japanese.

AP Wide World photo, from U.S. Marie Corps

shown in movie houses and on television and still turns up in documentaries, but a quirk in Marine regulations denied Genaust an official byline credit. Unknown by most, forgotten by many, unrecognized for decades, he was and remains today a Marine left behind on that distant island, entombed forever in a forgotten cave without a marker on Hill 362–A. His film has lived on gloriously and, with Rosenthal's still picture, continues to inspire a nation.

Celebration of Rosenthal's picture spread quickly now. Washington decided to use the photo as the symbol of the Seventh War Bond Drive and ordered that the Marines who raised the flag be identified and brought back to the United States to participate in the fund raising. A search was on to find the flag raisers.

Rene Gagnon, as he started up the mountain on D+4 with his batteries and the larger flag, met fellow Marines from his unit stringing wire communications between headquarters and the mountain top. The group climbed together—Gagnon, Sgt. Michael Strank, Cpl. Harlon Block, Pfc Ira Hayes and Pfc Franklin Sousley. At the top of the mountain, Strank took the flag from Gagnon and offered it to Schrier with word from Johnson down below: "The colonel wants this flag to replace the first flag so that every son of a bitch on the island can see it. And he wants to keep the first flag."

This is Hill 382-A where photographer Bill Genaust was killed nine days after he made his famous motion picture sequence of the flag raising on Iwo Jima. He never saw or knew about his pictures.

U.S. Marine Corps photo, National Archive, by Pfc. Robert Campbell

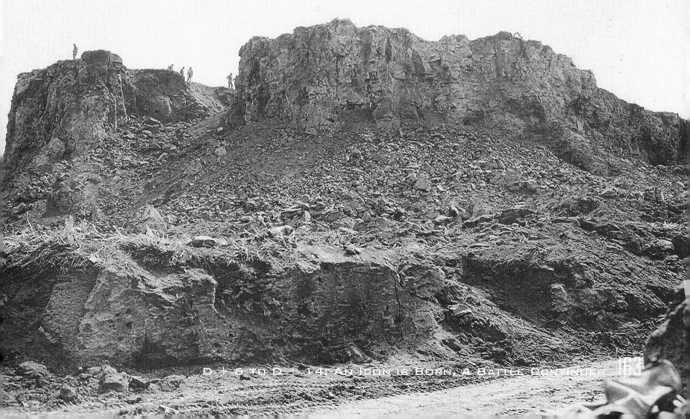

The group of Marines went to the task, found a long pipe for a staff, attached the larger flag, and prepared to raise it on the lip of Suribachi's cone. It was heavy, and they labored to lift it. Pharmacist Mate John Bradley, a Navy corpsman assigned to the Marines, jumped in to help and the flag went up in a single thrust. Three Marines held the pipe in place while others sought material to tie it down. They did not notice the two cameramen—one a still man, the other a film man—photograph the raising. The eight men—flag raisers and photographers—would become famous only if they survived the bloody battle from which machine guns and cannon echoed in the background.

Marine photographers Sgt. Bill Genaust, left, and Cpl. Atlee Tracy share a moment in a protected area on Iwo Jima. Genaust was killed a few days after this picture was made.
U.S. Marine Corps photo, National Archive, by Pfc. Bob Campbell

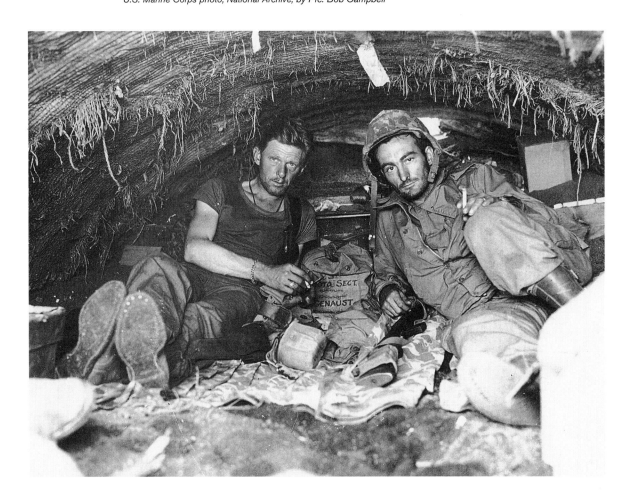

Who were these six men?

A publicist would search long and hard to locate a group of six who so represented the American population. One was from the industrialized Northeast, another was an immigrant, another a Native American, another from Texas, another from small-town Midwest, and another from the hills of Kentucky—Americans all, and thoroughly All-American. Their makeup so represented the nation that some said they were carefully selected for the flag raising, another factor that encouraged the charge of "posed picture."

MICHAEL STRANK: A Marine veteran before the war started, he joined the Corps in 1939 at the age of 20. He was the son of Czech immigrants who took up residence in Conemaugh, Pennsylvania. He fought in the Pacific on Pavuvu Island and on Bougainville, and was a member of the elite Marine unit, Carlson's Raiders. Promoted to sergeant in 1942, he landed on D-Day with the 5th Marine Division, Company E, 2d Battalion, 28th Marines.

HARLON H. BLOCK: Drafted into the Marines in 1943 after graduating from high school, Block had worked as a farm laborer and oil field worker. He was the son of a Yorktown, Texas, family. Block attended Marine parachute school and fought as a rifleman in Bougainville. The parachute unit was disbanded, and he was assigned to Company E, 2d Battalion, 28th Marines. Block was promoted to Corporal, landed on Iwo on D-Day, and fought around the base of Suribachi.

RENE A. GAGNON: Dropping out of high school after two years, Gagnon worked in the textile mills of his home town, Manchester, New Hampshire. He enlisted in the Marines in 1943 and was assigned as an MP in Camp Pendleton, California, where he was assigned eventually to Company E, 2d Battalion, 28th Marines. Gagnon carried the second flag and radio batteries up Suribachi in 1945. He was of French-Canadian descent.

JOHN H. BRADLEY: Born in Antigo, Wisconsin, his family moved to Appleton, where he graduated from high school in 1941. He attended mortician school and then enlisted in the Navy in 1943. Bradley attended several medical schools in the Navy, including medical combat training. He was eventually assigned as corpsman to the 28th Marines, 5th Division and landed on D-Day with his unit.

IRA H. HAYES: A Pima Native American, Hayes dropped out of high school after two years. He was a resident of the Gila River Indian Reservation at Sacaton, Arizona, worked for a short time as a carpenter, then, enlisted in the Marines and attended paratroop school. The unit was disbanded, and Hayes was assigned to combat units that fought at Vella Lavella and Bougainville. He was transferred to the 28th Regiment of the 5th Marine Division and landed with them on Iwo Jima on D-Day.

FRANKLIN R. SOUSLEY: After graduating from high school in Flemingsburg, Kentucky, in 1925, he moved to Dayton, Ohio, where he worked in a factory. He was drafted into the Marines in 1944 and was assigned to Company E, 2d Battalion, 28th Marines, landing on D-Day as a Browning Automatic Rifleman with his unit.

Company E, the flag raisers included, spent several days atop Suribachi securing it, posting watches, and setting up shop for their replacements. Their assignment to depart came soon enough, however, and they advanced north to join the fight against the enemy on Hill 362-A.

On March 1 (D+10) Company E struggled through the twisted topography of the hill. Antitank ditches, outcroppings, ravines, and ledges complicated movement. Enemy fire up close and from distant caves drove up the casualty rate. It was in this area that Harlon Block fell to enemy fire. Michael Strank was pinned in a ravine for four hours and decided to tell supporting fire where his group was located so that they did not get caught in friendly fire. A mortar scored a direct hit on the group as Strank instructed a runner. He died instantly. Two days later, corpsman Jack Bradley suffered serious leg wounds and was evacuated to a hospital ship, and then to Hawaii. Three days later, in the same area, Bill Genaust, the motion picture photographer who filmed the flag raising, was slain in a nearby cave. On March 21 (D+30), just a few days before the battle for Iwo was finally concluded, Sousely was killed near Kitano Point, the last area of resistance. Only Hayes and Gagnon survived unhurt.

The battle for Iwo Jima was finally over. Company E boarded the *Winged Arrow* bound for Hawaii. Of the 40 Marines that climbed Suribachi on D+4, only four boarded the ship unhurt. The two flag raisers aboard were still unaware of their celebrity. The efforts to identify and locate the Marines were frustrated by the fierce fighting that continued until the final days. Gagnon was the first to be located on

board ship. He was about to identify Hayes but was dissuaded from doing so. Hayes wanted no part of what appeared to be a publicity tour in support of the Seventh War Bond drive. He pledged Gagnon to secrecy about his role on Suribachi. Gagnon promised, but the Marine brass put an end to that. Hayes was soon located and sent to Washington, joined by Bradley, now on crutches.

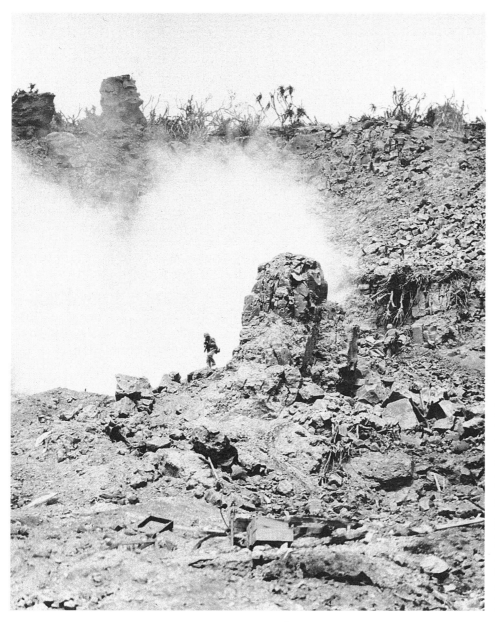

A lone Marine is silhouetted against a cloud of smoke and dust thrown up by dynamite blasts used to close caves where Japanese soldiers were hiding. This picture was made in the northern portion of Iwo Jima where the terrain consisted of many rocky outcroppings.

AP Wide World photo from U.S Marine Corps

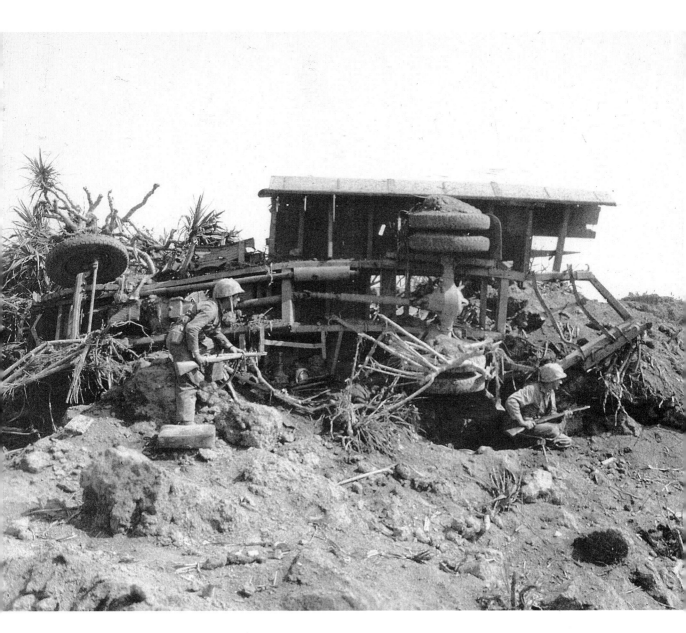

A blasted Japanese truck provides cover for Marines advancing in the northern areas of the island.

U.S. Marine Corps photo, National Archive, by Cooke

A wounded Marine is helped to safety from the front line.
U.S. Marine Corps photo

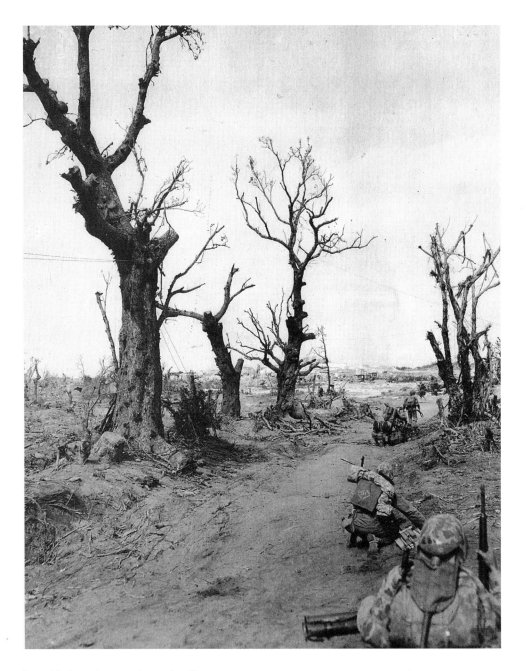

LEFT: Marines take cover from sniper fire.
U.S.Marine Corps photo, National Archive, by Mark Kauffman.

Though Mt. Suribachi was an inactive volcano, there were hot sulphur waters running through the island. In some cases these waters generated heat sufficient to warm up military rations and provide hot lunch in the field.

AP Wide World photo from U.S. Marine Corps

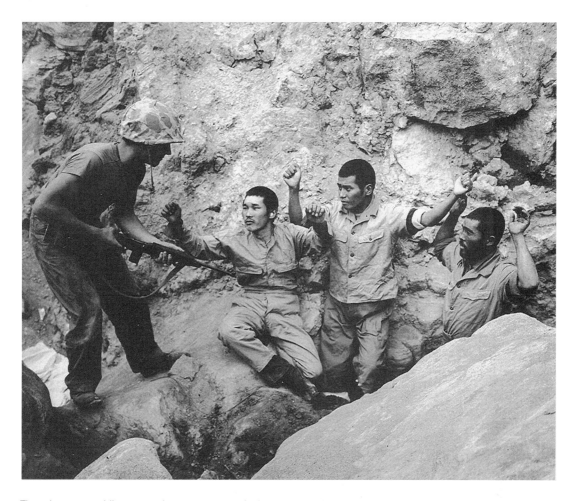

Three Japanese soldiers surrender near a cave at the bottom of a sulphur pit near a Marine command post. Surrenders were rare. Japanese either fought to the death or committed suicide; only 1,200 of a 22,000 man garrison survived the battle.

U.S. Marine Corp photo, National Archive, by Ferneyhough

OPPOSITE PAGE: An officer with Japanese language skills attempts to talk Japanese into surrendering. Sometimes it worked, but more frequently the caves were blown shut with dynamite.

U.S. Marince Corps photo, National Archive, by Pfc. J. B. Cochran

Marines Hew Out 500–Yard Gains In Hand-to-Hand Fighting on Iwo

By WARREN MOSCOW
By Wireless to *THE NEW YORK TIMES*

GUAM, THURSDAY, MARCH 8–The fighting on Iwo Island has reached the hand-to-hand stage as the tired marines battle desperately to bring the prolonged encounter to an end.

The Japanese, fighting equally furiously, continue to hang on to each acre of land, but are slowly being pushed back. Today's communique from Admiral Chester W. Nimitz showed the largest forward push by the marines in three days, but there was no claim that Japanese defenses had finally cracked.

On the northwest shoulder of the island the Fifth Marine Division fought its way down ridges sloping to the sea, gaining as much as 500 yards at one point on the extreme left of the American line, with smaller gains registered in the center and right.

The Third Marine Division, which entered the battle as reserves on D-day plus two, and has borne the brunt of the offensive since then, hacked out an equal 500-yard gain on its front between the Fifth and Fourth Marines in the center of the island.

Veterans of the Bougainville and Guam campaigns knocked out Japanese pillboxes with grenades wrestled and bayoneted the enemy as he was driven from caves.

The Fourth Division, holding the line to the east, made advances of 100 to 200 yards in local areas, but in other places gained not at all in the face of intense enemy small-arms and machine-gun fire that the Japanese are now using in place of mortar fire in the earlier stages of the campaign.

> "Miller was the pilot for our plane . . . he told us that when he looked down on the island he could see where the front lines were, because there were thousands of people moving around all over the surface of the ground behind our lines, and in front he never ever saw a living human being. All the Japanese were holed up in their caves and tunnels all over the entire island.

—MAJ. CARL W. HJERPE
CO, 2nd Battalion

I remember the time me and another Marine had to take this kid out on a stretcher. It really takes four guys to take a body out, but there were only two of us. Then out of nowhere comes a mortar, and the other guy was killed. The wounded guy got hit again, and he was dying. I didn't want to leave him. What got me was we talked a bit, and I found out we liked the same things. I liked the sunsets. When I was a little kid I used to sit on top of the hill in the summertime, and I would stay there until it started to turn dark. And he liked sunsets, too. He reached like this, and I grasped his hand with my left hand, and I held it. I squeezed it a few times and he responded. I knew he was alive. I waited a while and did it again. Then he stopped. He was dead.

And so now, whenever I write somebody a letter, I put on the envelope, "See you at sunset." That's about the time he died. He said what time is it . . . I said about sunset . . . he said, good. So he died sort of pleasantly. He was a guy from down Georgia. That's all I wanted to know about him.

—PVT. LIBERTO G. RICCIO
Rifleman

Americans Storm And Take Iwo Hill

Gen. Smith Predicts Isle Will Be Ours 'in Few More Days' --Gain on Central Airfield

By WARREN MOSCOW
By Wireless to *THE NEW YORK TIMES*

GUAM, TUESDAY, FEB. 27—The first use by American planes of an Iwo Island airfield was reported in a communique issued this morning by Admiral Chester W. Nimitz. Marine observation planes began operating yesterday from the bomber field in the southern part of the island known as Motoyama No. 1, which was captured a week ago.

These planes now can spot enemy positions for the direction of artillery and fleet gunfire.

As fierce fighting continued the Third Marine Division drove froward in the center of the island through most of the central airfield, Motoyama No. 2, right up to Hill 382 yesterday.

Gains of 400 yards were made in the face of heavy fire. The communique again mentioned that the Americans had encountered Japanese rockets.

By noon of yesterday after eight days of fighting our forces had counted 3,568 enemy dead and nine prisoners.

Carrier aircraft strafed targets in and around Chichi Island in the near-by Bonins, which had been subjected to neutralizing attacks all through the Iwo campaign. One enemy plane was burned on the ground, two medium-sized merchant vessels were left burning, a smaller one was destroyed and oil storage facilities were blown up.

Iwo's Volcanic Ash Hampers Marines

It Bogs Down Vehicles, Chokes Rifles and Clogs Men's Eyes, Returning Veterans Say

By CLINTON GREEN
By Telephone to THE NEW YORK TIMES

PEARL HARBOR, FEB. 28—The first fighting men to return to Pearl Harbor from the hell of Iwo Island said today that the greatest natural enemy encountered in the early days was the volcanic ash that succeeded in miring vehicles, covering the firing mechanisms of their guns and making nearly impossible their effort to dig foxholes.

Every time a Marine wanted to fire his carbine he found it necessary to first clean the firing bolt and the immediate area of the mechanism with a tooth brush. The time necessary to prepare for firing a rifle thus cut down on the firing power of groups of Marines and concentrated fire power was exceedingly difficult to accomplish.

With vehicles bogged own in the gripping volcanic ash the marines had to lug their ammunition to the men in the forward liens and because of the enemy gunfire - mortars, rockets, artillery, machine guns and small arms-the ammunition carriers were frequently unable to walk erect with their vital loads.

Instead, they were forced to crawl along the ground-with the volcanic ash getting in their eyes, their mouths and in their shoes-shoving and pushing the ammunition.

Second Lieut. Peter Zurlieden, 30 years old, a native of Cleveland, Ohio, and former Associated Press reporter in the Maryland Bureau, started for shore at 12:45 P.M., three and three-quarters hours after "H-hour" but because of their confused beach conditions he was not allowed to land with his party until 3:34 P.M.

Foe's Barrage "Murderous"

"There was hardly anything moving on the beach," he said. "The Japs were laying down a murderous barrage. They had position on Mount Surabachi and would go after anything that moved.

"That damn volcanic ash would not let the vehicles move. The only heavy equipment I saw moving were bulldozers, and it was a tug-of-war for them. They had to lug the stuff by hand. We were constantly being pinned down and when we dug our foxholes we did it by hand. Brother we dug.

"The Japs were shooting at anything moving. They were going after corpsmen who were helping wounded. The Japs would drop a mortar in back of a walking party and the men would just keep on walking. Then the Japs would drop a mortar in front of the men but those corpsmen just kept going. And often the Japs would drop one right on the walking party."

> We left on the twenty-sixth of March. We were already on the beach and getting ready to board the USS *Cape Johnson*. And then one more of our boys was hit by a sniper, right through the temple. By this time, of course, no one wanted to wear his helmet anymore, so we weren't wearing them. It happened right there on the beach. Guy Siler was his name. We didn't know where the sniper was hiding, but the island was honeycombed with caves.
>
> —STANLEY E. DABROWSKI
> Pharmacist's Mate Second Class

> We had a Jap dog, and a Jap goat, to get to the lighter side of things. And we had a replacement from Oklahoma who could cook goat, and he kept the goat and fattened him up. One day the goat got in and ate a bar of GI soap. Nobody would eat the goat.
>
> —CPL. DONALD DIXON
> Range Setter

MARINES FIGHT WAY TO IWO'S NORTH RIM

Reach Cliff Top Overlooking Northeast Shore as Others Stab Up Northwest Coast

By the ASSOCIATED PRESS.
GUAM, FRIDAY, MARCH 9— Frontline dispatches disclosed today that the Third Marine Division has reached the cliff top overlooking the northeast beaches of Iwo and the Fifth Marine Division has shot an enveloping arm 1,000 yards up the northwest shore.

The disclosures followed a Navy communiqué announcing only small gains Thursday on the third day of an all-out push so bitterly contested that the marines had to call on tanks to operate in unfavorable terrain as support.

continued on p.35

from page 2

The front-line dispatches amplified these gains, placing Maj. Gen. Graves B. Erskine's Third Division at the edge of cliffs only 300 yards from the beach. The cliffs are honeycombed with dugouts in which machine-guns and possibly heavier weapons bar the precipitous path down to the surf.

Stride 1,000 Yards in Two Days
The place where the Third has completed the drive across the plateau is 1,500 yards southeast-wardly down the coast from Kitano Point, northernmost part of Iwo.

Maj. Gen. Keller E. Rockey's hard fighting Fifth Marine Division thrust up the northwest coast 1,000 yards Wednesday and Thursday.

[The exact spot reached by General Rockey's men was not reported, but a few days ago the Fifth was in a straight line with the Third Division Marines, who captured a 362-foot hill. An advance of 1,000 yards on the coast opposite that promontory would put the Fifth less than 2,000 yards from the extreme north tip of Iwo.]

Woman's Plea to End Iwo Battle Revealed

WASHINGTON, MARCH 15 (AP)—The Navy released today an exchange of correspondence between Secretary of the Navy James V. Forrestal and an unidentified woman who protested the heavy toll of life in the taking of Iwo Island. Said the Secretary: "There is no short cut or easy way. I wish there were.

Navy spokesman said the letter it made public was typical of a number the department had received. It read: "Please for God's sake stop sending our finest youth to be murdered on places like Iwo Jima. It is too much for boys to stand, too much for mothers and homes to take. It is driving some mothers crazy. Why can't objectives be accomplished some other way. It is most inhuman and awful—stop, stop."

Secretary Forrestal replied:
"On Dec. 7, 1941, the Axis confronted us with a simple choice: Fight or be overrun. There was then, and is now, no other possibility.

"Having chosen to fight, we had then, and have now, no final means of winning battles except through the valor of the Marine or Army soldier who, with rifle and grenades, storms enemy positions, takes them and holds them. There is no short cut or easy way. I wish there were."

Navy officials said it had no information whether the writer of the letter had a son or other close relative at Iwo Island. They declined to divulge her identity.

"We used to see the planes come in damaged ... Big B-29s come in with holes in the wings that you could drive a car through, half the tail missing, one motor gone, and they still came in and landed. Or if they couldn't land, we'd count the guys as they bailed out, eleven guys per plane. Sometimes, they'd set the plane on automatic pilot, and then jump out and let the plane fly out to sea and crash. One time, one didn't crash, it just kept circling the island, and they had to send a fighter plane up to shoot it down."

—CPL. DONALD DIXON
Range Setter

"The Turkey Knob area, I think, I remember one thing. I think the officer was a little wacko. We had a machine gun on the top of a knoll, and a sniper got the machine gunner right in the head. And I was in line, which bothered me. So the officer called on another one of the men to go up and take the place of the machine gunner. The guy goes up, and he no sooner gets there and gets a bullet right between the eyes. Three times the officer sent someone up, three guys got killed. Finally someone talked to the officer, and someone crawled up and pulled the machine gun down to a different location. I was standing there, he could have pointed at me, you know. It's all luck. I could have been the one to get it."

—PFC. GEORGE G. GENTILE
Rifleman

"... one day I was going down to the Higgins boats and a friend of mine, from my hometown was there, a lieutenant in charge of the boats, and he had some eggs. Nobody had any eggs or anything else, so I came back and gave them to the fellas. Then I had go to the latrine, which was about forty yards on up closer to the airfield, and I heard the screaming demon, one of the Jap mortars that was almost as big as a man. It whistled over and landed in a foxhole in the area where I just was. Took everybody out. I'll never forget that. What is fate? What is timing? You don't know."

—PVT. JOSEPH H. KROPF
Rifleman

9 REALITY, MYTHS, And THE FOG OF WAR

*In the eighteenth century, Prussian general and military strategist
Karl von Clausewitz wrote that war exists in a realm of uncertainty that,
"like a fog or a moonshine gives to things exaggerated dimensions and
unnatural appearance." Reliable information is too often hard to come by,
he notes, and calls the resulting chaos "the fog of war."*

JOE ROSENTHAL RETURNED to Guam on March 4, (D+13) to make preparations
for coverage of the Okinawa invasion scheduled for April 1. March 4 was the day
Sgt. Bill Genaust died in a cave on Hill 362-A and the day *Dinah Might*, the first
crippled B-29 Superfort to land on Iwo Jima, slammed down on Airfield One.
There was mopping up going on at the Meat Grinder and Turkey Knob Hill, but
the rocky badlands of northern Iwo Jima still held thousands of Japanese troops
awaiting the Marines.

Rosenthal remembers arriving at the Guam press headquarters where corre-
spondents and photographers gathered to exchange notes, collect information,
file stories, etc.

"I knew most of the correspondents that were there . . . I would say maybe fif-
teen or so were around then . . . and they crowded around, telling me what a great
picture I made.

"Now, at this time I still didn't know for sure which flag-raising picture created
all the fuss . . . I had stopped at Saipan en route to Guam and saw clippings there
of D-Day, a lot of front pages from all over the country . . . showing the invasion
and the Marines landing . . . and I thought, 'Gee, the stuff I'm making is useful, it
looked great.' Remember, we hadn't seen anything on Iwo, just a few messages . . .

but we had no idea how the story was being displayed in U.S. newspapers and magazines . . . that stop in Saipan was my first look at the usage the pictures were getting . . . but there were no clips in Saipan showing the flag-raising photo.

"Like I say, I had not seen the flag-raising picture . . . and one of the guys in the crowd asked if I had set up the picture and I . . . because I didn't know which picture they were referring to . . . I said, 'Yeah.' . . . thinking they were talking about the group picture, the one I knew I had made for sure.

"While I was talking, someone came up with a copy of the flag-raising picture and I saw it, and I got a little surprised . . . I looked at it and said that is a good shot . . . in a way not disagreeing with the editors. And I said, 'Oh, I didn't set up this one.'

"I can only presume that there might have been a correspondent who heard the first part and who was no longer with the group when I talked about the flag-raising shot . . . they were coming and going, some were leaving to whatever it is that writers do. And he may have left, and I'm simply saying that that is a likely explanation."

Rosenthal is a painfully modest man. He is not confrontational. He is quiet, unassuming. He is sensitive to the feelings of others. His explanation for the events that followed and how his flag-raising photo was said to be posed and set up is understandable. But that is not what happened.

Throughout the war, there was an unspoken competition between military and civilian photographers. The military shooters believed civilians received special consideration in logistics and in the handling of their film and photos. The civilians believed that the military photographers would like to see more of their pictures—perhaps only their pictures—used to show the war to the home front. There were more military than civilian photographers at work covering the war, and many of them were excellent cameramen. But sometimes the handling of military pictures was slow, cautious, and careful whereas the civilian teams of photographers and editors moved the hot pictures quickly, gobbling up precious circuit time. Finite limitations on picture distribution because of jammed communication circuits favored the civilian photographers. Prints released later in the United States were often seen as too late for usage in daily newspapers and in weekly magazines. All these factors combined to create beliefs based, not always on fact, but on perceived sleights and disadvantages.

The flag-raising picture moved through the maze promptly. Lou Lowery's pictures of the first flag raising got lost in the shuffle and his film arrived in Guam a week after Rosenthal's, whereas Rosenthal's image, recognized as a dramatic,

compelling picture flashed through the system and into the public eye just eighteen hours after Rosenthal's Speed Graphic exposed the film.

The front pages of newspapers, sensing victory ever closer in Europe but caught up also in the gripping combat of the Pacific, were, like the war itself, a hodgepodge of stories from far-flung corners of the world. Stories from Iwo Jima since D-Day stressed the fierce battle the Marines waged and the staggering losses they suffered on the slopes of Suribachi and on the edges of the airfields to the north. The war in Europe was equally hot, as the Allies moved closer to Berlin. The day the flag picture was published, it shared front pages crowded with headlines about Yank gains on the plains of Cologne, Russian advances on the eastern front, and hordes of Nazis captured. One triple headline in Boston jumped from Germany to Iwo to bombers blasting Tokyo. Another story told of Japanese losses in Manila.

The nuance of a story about first flag and second flag was lost in the headlines of international warfare that competed for attention. Only the photo's riveting image stood out clear, understandable and easily embraced. The world saw the flag of victory flying proudly over Iwo Jima. It was perceived as not just a victory on a mountaintop, not just victory on another tiny island, not just a victory in Asia, but, surrounded as it was by world headlines, it suggested the final, lasting victory, the victory that would bring the world's greatest conflict to a close.

As the days passed, the image gathered strength and took on a life of its own.

Talk of the picture and its escalating popularity did not escape the attention of Lou Lowery, who was also in Guam. He knew that he was the only photographer on Suribachi when the first flag went up, and he knew he had pictures. He asked himself: "Where did this picture come from? Where were his pictures?" There had to be, in his mind, some chicanery involved in the making of the second flag raising, and on March 13, he told Robert Sherrod of *Time* that Rosenthal's photo was a setup, posed, a phony . . . it couldn't be anything else. Sherrod, who was in Guam at the time, but did not check with Rosenthal, messaged his office that he was planning to expose the AP photo as a phony and subsequently provided a story, a story not printed in the pages of *Time* or *Life*, but broadcast in its essentials March 14 on *Time*'s radio service, *Time Views the News*.

The *Time* story, broadcast on March 13, said, in part:

"Everyone remembers the picture that came from Iwo a week or so ago showing heroically-grouped Marines placing the Stars and Stripes on Mount Suribachi. Well, this afternoon a cable from the *Time* correspondent on Iwo Jima, Robert Sherrod, adds an historical footnote to that picture . . . AP lensman

Rosenthal's great picture was a whiz photographically but historically it was slightly phony. Rosenthal climbed Suribachi, after the flag had already been planted. It was still a dangerous place. The Japanese snipers lurked everywhere. Like most photographers, Rosenthal could not resist re-posing his characters in heroic fashion. He posed them and snapped the scene."

A day or two before the Lowery-Sherrod meeting, and the subsequent broadcast, word came from New York that Rosenthal should return to the United States immediately to participate in the Seventh War Bond Drive and to give lectures about the war in the Pacific. At this time, he was still unaware of the picture's widespread celebrity, though the message was beginning to come through. He appealed New York's request, saying he had completed preparations for Okinawa and would like to cover at least the initial phase of the battle. The New York reply was clear: Return to New York was not a request, it was an assignment. He left Guam for Honolulu on March 15 (D+24). The next day, on embattled Iwo, the now-famous flag came down, tattered and torn by Suribachi's persistent winds. A headquarters installation was constructed on the island flatland, a flag was raised signaling American occupation, and Iwo Jima was declared secured. Marines thought that ironic—casualties would total hundreds more before the island was completely conquered on March 26 (D+35).

In Honolulu, Rosenthal got his first taste of the questions about the picture(s), questions that he would answer over and over again for the rest of his life. The AP Chief of Bureau greeted him on arrival and delivered a message from New York that said a *Time* magazine news broadcast reported that his picture—now the most talked about photo of World War II—was historically a posed phony. Rosenthal was asked to provide a response, which he did. He said he did not direct the photo, did not select the Marines in the photo, did not tell anyone when to raise the flag. He said it was the second flag raised on Suribachi, but that he had nothing to do with its being raised. He only photographed what happened.

He left the next day for San Francisco bewildered by the flow of events that swirled around him and wondering whether he was in the doghouse with his New York bosses.

The fog of war settled in.

Life magazine, AP learned, was determined to run Sherrod's story in the belief that they had a legitimate scoop—the famous picture was a posed setup. *Life* did not print the picture when it first appeared on February 24. What prohibited publication was never clarified, but *Life* now believed it had a hot story. AP responded

with threat of a million-dollar suit if such a story appeared. A meeting of the contending parties was arranged in the offices of Gen. Arthur Vandegrift, Marine Corps Commandant, in Washington on March 17. By coincidence, Warrant Officer Norman Hatch, the military photo boss on Iwo, arrived in Washington the same day in the role of a film courier from Iwo Jima. Unshaven, haggard, and still in his travel uniform of combat fatigues, Hatch was dragged into the meeting as the man who could help clear up the controversy. By this time, Hatch knew of, but had not seen, Genaust's motion picture film and had seen Bob Campbell's picture of the two flags, one going up, the other coming down. He also produced a log of the day's events from his courier package. Together, the evidence showed that the photo was not posed. The *Life* editors were convinced, and Rosenthal's reputation was cleared.

On March 17 *Time* broadcast another story, an apology to Rosenthal and to the AP. It said, in part:

"This next item is in the nature of a correction. Last week, *Time Views the News* reported on that historic Associated Press photograph of the Marines raising the American flag on Mount Suribachi, on Iwo Jima. We said that photographer Joe Rosenthal had 're-posed' the Marines for the picture after they had raised the flag for the first time. 'Reposed' was our word, and not that of correspondent Robert Sherrod. We used the word through a misunderstanding of Sherrod's cable. What actually happened was this: A previous flag had been raised by Marines over Suribachi—a smaller flag on a piece of captured Japanese pipe. A photograph of that earlier flag raising had been taken by a Marine photographer, and it subsequently appeared in the soldier magazine *Yank*, and other publications. The Associated Press reported the raising of this flag.

"To the Associated Press and to AP's photographer Rosenthal, our apologies: Mr. Rosenthal's photograph is indeed moving and historic, and he snapped it under the threat of Japanese sniper fire."

Lowery's photos were released by *Leatherneck* on March 20, transmitted on the AP network, and distributed in print form. *Life* published the flag-raising picture along with the Lowery photo and ran a story about two flags on Suribachi, a first flag and a second flag, comparing the image to the painting of George Washington crossing the Delaware.

But the fog didn't drift away. Outlandish stories of what actually happened on Suribachi appeared out of the mist, some offered by uninformed commentators, but others written into the record (and never corrected) by researchers that should have known better.

These are just a few of the tales that emerged:

One story had it that Rosenthal picked up a film holder lost by a Marine photographer who was either wounded or slain, and that he, Rosenthal, passed the picture off as his own. That story was squelched when pool staff pointed out that Rosenthal's exposure was made on Ansco film, whereas the military photographers all used Kodak film, an arrangement designed to avoid just such mixups.

Another story was that Rosenthal carried the pole up Suribachi himself and provided it so that the flag could be raised. Six Marines had all they could do to raise the heavy pipe that served as a flagstaff, and one man could never have carried it up Suribachi.

And another said he climbed Suribachi, not with Campbell and Genaust, but with the Marines who carried the second flag to the top of the mountain at his direction.

Still another version was that the first flag was blown up in the firefight that took place after the raising of the first flag, and therefore a second flag had to be raised.

An art critic writing about picture manipulation, said the first flag was raised at night and pictures could not be made, so a second flag was arranged for the purpose of publicity for the Marine corps.

Then there was the story that had Joe Rosenthal seeing his picture for the first time in the form of a news clip sent to him by his mother. Rosenthal said it must have been a heavenly communication because his mother was dead.

Amongst the most absurd stories was the one where Rosenthal could not comment on the picture because he himself was dead.

On and on the stories rolled, each more ludicrous than the other, but all indicating that something wasn't quite right with the picture.

Two myths emerged:

The first was that the Marines battled Japanese troops to reach the top of the mountain. They faced rolling hand grenades and falling boulders as they battled their way inch by inch up the slopes of the volcano. Then, in one dramatic moment, they thrust the pole with flag attached into the ash of the mountaintop.

The second myth was that a publicity-hungry Marine corps and a conniving photographer conspired to make a magnificent photo, pose it, choreograph it, and pass it off as the real thing.

Like most myths, both were wrong.

Marines from D–Day to D+3 battled fiercely on the lower slopes and around the base of Suribachi to dislodge Japanese troops from the intricate, deadly Kurib-

ayahsi defense. But the climb to Suribachi on D+4 was quiet. There was no action until after the first flag was raised, and there were no Marine casualties.

Rosenthal himself put the lie to the second myth.

"If I had posed it," he said, "I would have ruined it. I would have fewer Marines in the picture, and I would make sure that their faces were seen, and I would have their identifications so that their hometown papers would have the information. I wish I could pose a picture that good, but I know that I never could."

Posed or not posed, phony or not phony—all this played out as the Seventh War Bond drive got underway. Suribachi survivors Gagnon, Bradley, and Hayes were treated as heroes. Gagnon, Hollywood handsome and a Robert Taylor look-alike, loved the attention. Bradley was more reserved and did his duty. Hayes, quiet, unassuming, even introverted, was the unhappy one. Keyes Beech, the Marine battlefield correspondent, was assigned to chaperone the trio through their paces, including a raising of the real Suribachi flag at various locations, including Times Square in New York and over the U.S. Capitol in Washington. Gold Star mothers appeared on the stage with the trio and touched the flag that now took on the aura of a Holy Grail. Rosenthal, who worked a different aspect of the Bond drive, made his appearances as the hero photographer who photographed the icon that captured America's heart.

Except for Gagnon, none of the participants were comfortable in their role because they did not see themselves as heroes. They repeated over and over again that Iwo Jima's heroes were buried in its gritty soil. Protests were to no avail however, and they were treated as heroes, like it or not. Before the Bond tour was over, Hayes, who had turned to drinking too much and who had ended up in jail on drunk charges, was sent back to his unit. The cover story was that he wanted to rejoin his fighting buddies on Okinawa. Bradley, ever the steady member of the trio, stuck with the tour to the end and returned to his rehabilitation. Gagnon, disappointed that the tour and its festive celebrations ended, returned to his hometown. Rosenthal long before had returned to San Francisco when the end of war put an end to the story of the picture and flag raisers—temporarily.

The fascination of the picture is that it would not disappear. Rosenthal, ten years later, wrote a story about the flag that was published in *Collier's* magazine under the title "The Picture That Will Never Die." With the help of writer W.C. Heinz, he told his story in full detail, hoping that it would once and for all put an end to the questions. He learned to his chagrin that, like the picture, the questions would never die, either. Movies, books and television documentaries would keep the story alive well into the twenty-first century.

Victory Flag Raised on Iwo;
Airfield is Used by Bombers

By ROBERT TRUMBULL
By Wireless to *THE NEW YORK TIMES*

GUAM, THURSDAY, MARCH 15— The United States flag was formally raised over Iwo at 9:30 A.M. yesterday, although fighting continued unabated in the northern sector and in a small pocket in the northeastern part of the island, Pacific Fleet headquarters announced today. The communique gave 20,000 as a "very close approximation" of the Japanese dead in the twenty-three days of the Iwo battle through yesterday. Marine casualties were not mentioned.

Army, Navy and Marine planes are now operating from Iwo, using No. 1 airfield, which is far behind the lines. The second airfield is being worked into condition meanwhile. This strip has a hump in the middle and from there runs uphill. Seabees and engineers are leveling that. No. 1 strip is already a very bus airport, taking all sizes of planes.

Army fighters based on Iwo bombed and strafed airfield installations on Chichi Island in the Bonin group yesterday. On the previous day Army Liberators of the Strategic Air Force of the Pacific Ocean areas bombed the Chichi airstrip.

Ceremony Held During Battle

Rifle fire in the embattled area of the north was faintly audible as Col. D. A. Stafford of Spokane, Wash., Fiftieth Amphibious Crops personnel officer, read Admiral Chester W. Nimitz's proclamation suspending Japanese rule in the Volcano Islands—an integral part of the Japanese Empire. Nearby Marine artillery pieces roared as Colonel Stafford read, drowning his voice.

The flag was raised on a Japanese anti-aircraft gun emplacement at the foot of Mount Suribachi and simultaneously the flag raised by the Marines during the firth day of the battle on top of Suribachi's 551-foot active cone was lowered. Marine Pfc. John Glynn, 21, of New Orleans sounded "Colors" as the Stars and Stripes were pulled to the top of the flagstaff by Pfc. Thomas J. Casale, 20 of Herkimer, N.Y., and Albert B. Bush, 24 of Cleveland. Sgt. Anthony Yusi, 25 of Port Chester, N.Y., was in charge of the color detail. They were chosen from the corps military police company for "general efficiency and military bearing."

High-ranking officers of the Army, Navy and Marine Crops were present at the ceremony.

THE NEW YORK

196 JAPANESE KILLED IN SNEAK IWO CHARGE

By Wireless to THE NEW YORK TIMES.

GUAM, WEDNESDAY, MARCH 28— The last of the Japanese on Iwo, where organized resistance ended twelve days ago, die hard, but fairly completely, word from Third Marine Division headquarters on the island, received here today, indicated.

Early Monday morning (Eastern Longitude time) some 200 Japanese emerged from caves and attacked Army aviation units. The attack was staged near the beach southeast of Airfield No. 2. When the Marines ceased firing they counted 196 dead Japanese. Some of the enemy were armed with marine guns, presumably taken from our dead in the fight for control of Iwo.

Some of the attacking force were officers and the onslaught seemed to have been well planned. The enemy struck at 5 A.M. in a battalion sector of the Fifth Marine Divisional Pioneers. The Japanese cut their way through a bivouac area occupied by fliers and aviation service troops.

Fighting well and quietly, the Japanese passed on and thirty minutes later they came upon the marine encampment. The leathernecks, led by Maj. Robert Riddell, were waiting for them and opened heavy fire. The few Japanese not killed took to their heels amid a shower of automatic-rifle fire.

Strong marine patrols still operate against enemy troops concealed in the innumerable caves on the island. The attack of Monday was believed to have been launched from the extreme north tip of the island.

FACING PAGE: The 1945 3-cent postage stamp carrying the Iwo Jima picture. It was the first time live persons were shown on a stamp. Some 135,000,000 were printed.

AP Wide World photo

A PICTURE FOR ALL TIME

"**H**ERE'S ONE FOR all time!"

That instant assessment by veteran picture editor Jack Bodkin, the first person to see the flag-raising picture after it emerged still wet from the processing tanks, has persisted from generation to generation. Time and critics, those who would trivialize the picture, those who would cast doubt on its credibility, and those who would distort it, failed to reduce or remove the photo's place in the hearts of Americans.

The Seventh War Bond drive raised some $250,000,000 (1945 dollars), thanks largely to the patriotism inspired by the picture and the flag raisers. It was far and away the most successful bond drive of World War II.

A loving public demanded that the U.S. Post Office create a stamp honoring the picture. The demand was initially rejected because Post Office policy forbids images of living persons on stamps. Congress applied pressure, and the Post Office relented, creating a 3-cent stamp that featured the picture. More than 135,000,000 were issued five months after the flag raising, making it among the biggest selling stamps in Post Office history. Long lines of people circled blocks around post office buildings, waiting patiently in the July heat to make their purchase.

An error was corrected in 1947, when it was announced that one of the flag raisers, Sgt. Henry O. Hansen, was misidentified. Hansen was among those who raised the first flag, and it was thought he was the only Marine involved with both flags. The Marine Corps, alerted months earlier of the possible error, conducted

A 50-foot statue of the Iwo Jima flag raising is unveiled in New York's Times Square on May 11, 1945, to mark the opening of the Seventh War Bond drive. The original flag from Mt. Suribachi is used with the statue, its ends tattered by the winds atop the volcano's summit where the flag flew for more than three weeks.

AP Wide World photo by John Rooney

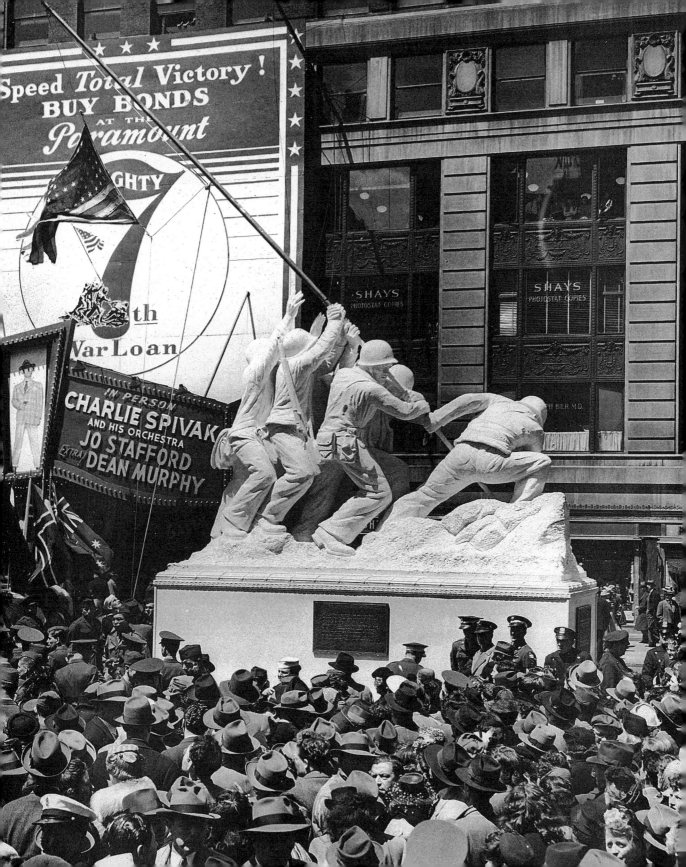

The flag-raising picture became the singular icon representing American victory in the Pacific War. It was seen everywhere throughout the United States and in Europe. In this picture Gen. George Patton waves to a cheering crowd in Los Angeles in June, 1945, after the war ended in Europe. The flag picture, in its role as the symbol of the Seventh War Bond drive, is in the background.

AP Wide World photo

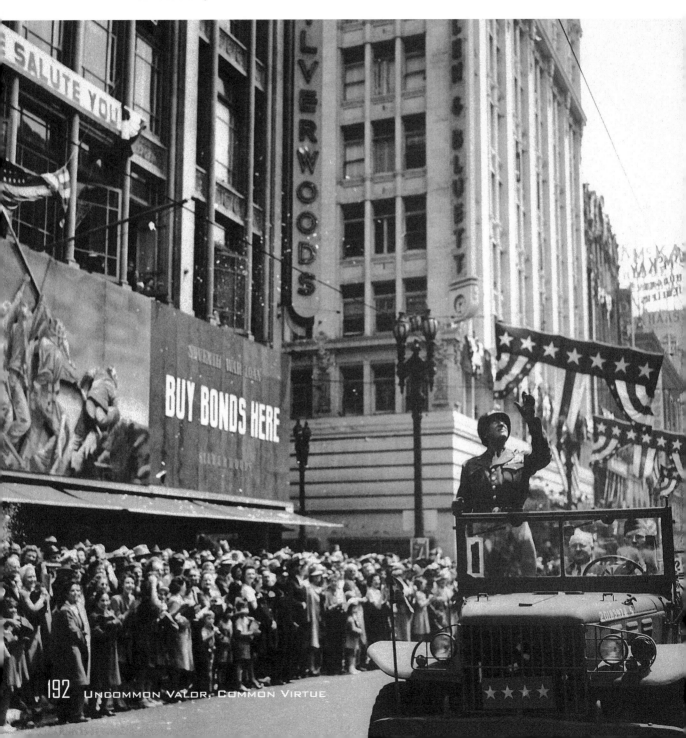

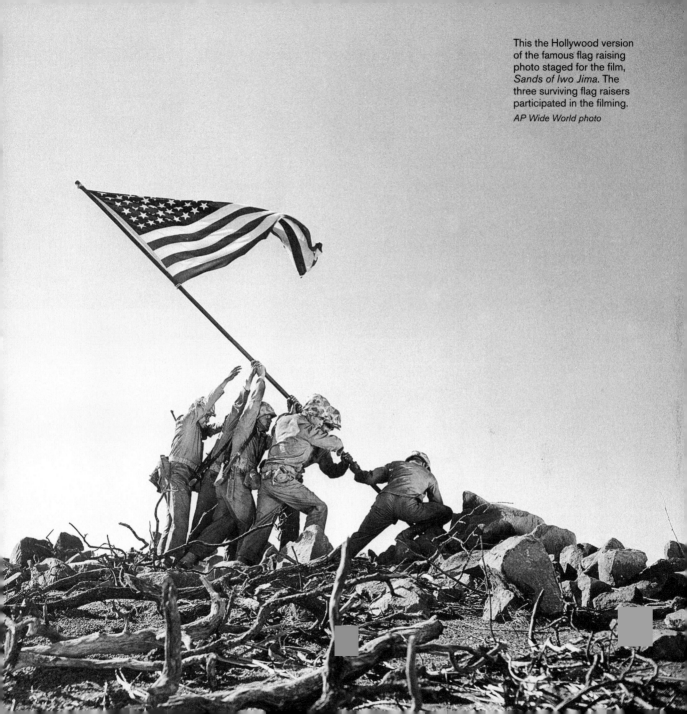

This the Hollywood version of the famous flag raising photo staged for the film, *Sands of Iwo Jima*. The three surviving flag raisers participated in the filming.

AP Wide World photo

The surviving flag raisers from Iwo Jima pose for a picture during the filming of *Sands of Iwo Jima* in California serveral years after the battle. The trio participated in the filming. From Left: Ira Hayes, John Bradley, and Rene Gagnon.

AP Wide World Photo by Frank Filan

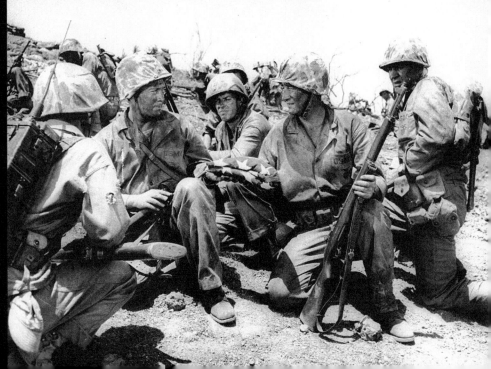

During the filming of *Sands of Iwo Jima* Capt. H.G. Schrier, left, who actually led the platoon that took the summit of Mt. Suribachi, hands a flag to actor John Wayne, who played the role of Sgt. Stryker, a fictional Marine. Later, Wayne is killed in the film though there were no actual Marine casualties during the taking of Suribachi.

AP Wide World Photo by Frank Filan

an investigation and concluded that the Marine thought to be Hansen was actually Harlon Block. Corrections were made, but another error clouded the picture. One family was devastated, another vindicated (the Block family had always thought it was their son in the picture) before the issue passed into history.

In 1949, Hollywood contributed its share of contradictions to the never-ending saga. John Wayne was chosen to star in the movie, *Sands of Iwo Jima*. It was a perfect role for the fast-rising Wayne, and the film eventually assured his future as an action hero. Wayne played the role of a tough Marine sergeant charged with training his men for the invasion of Iwo Jima. The story centered around the Wayne character, a loner struggling with the responsibilities of command. The movie blended actual war footage with Hollywood staged action so expertly that the film was nominated for several Academy Awards. Wayne was asked to put his imprint in concrete, which not so coincidentally contained black sand from the Iwo beaches.

The flag raising was re-created by the surviving flag raisers—Gagnon, Bradley, and Hayes—who played themselves in a brief scene at the end of the film. Lt. Harold Schrier, who led the patrol up Suribachi, also had a role.

But the scene of the flag raising was wrong, excused no doubt by the need for dramatic license, but wrong nevertheless and another source of confusion about the picture. The film showed Marines climbing Suribachi on D+4 behind tanks; that didn't happen. It showed Marines killed while climbing; that didn't happen. The film showed shooting during the ascent; that didn't happen. It showed flamethrowers used during the climb; that didn't happen, though flamethrowers were used during the firefight on top of Suribachi. Only one flag was involved in the film version; there were two. The flag was passed from one Marine to another on the mountain; no, the first flag was passed to Schrier before he climbed Suribachi. The Wayne character was shot on Suribachi; there were no Marine casualties in the Suribachi flag raisings on D+4.

It was good movie drama, but it was not accurate.

All this time, since D+4, Felix de Weldon worked steadily on his plan for a magnificent monument. He showed his models to President Truman, and he began the task—part art, part construction—to create a memorial that would be the largest bronze statue in the world. Ten years later, on November 10, 1954, a crisp, sunny autumn day in Arlington, Virgina, the monument was unveiled. It was described during its creation: 100 tons, rifles twelve-feet long, fingers the size of a man's arm, helmets the size of a small automobile. The Marines raised $850,000 from private sources to finance it.

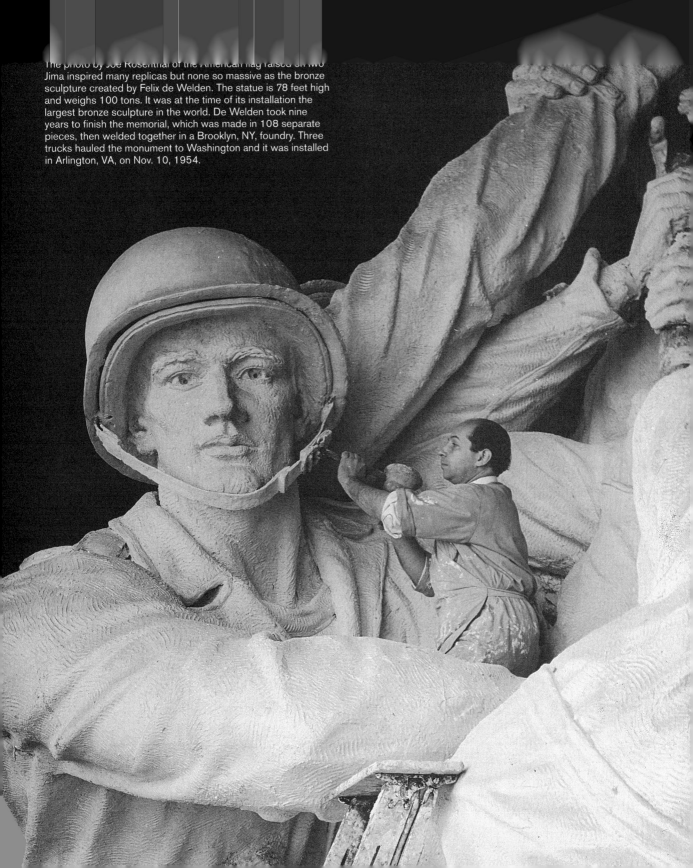

The photo by Joe Rosenthal of the American flag raised on Iwo Jima inspired many replicas but none so massive as the bronze sculpture created by Felix de Welden. The statue is 78 feet high and weighs 100 tons. It was at the time of its installation the largest bronze sculpture in the world. De Welden took nine years to finish the memorial, which was made in 108 separate pieces, then welded together in a Brooklyn, NY, foundry. Three trucks hauled the monument to Washington and it was installed in Arlington, VA, on Nov. 10, 1954.

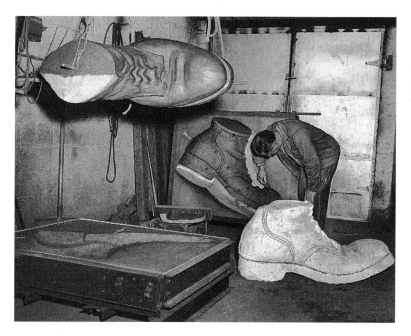

Felix de Welden
works on his
massive sculpture
in a Brooklyn, NY,
foundry.

*AP Wide World
photo*

The three surviving flag raisers meet with De Welden during the final stages of the monument's construction. From left: de Welden, Rene Gagnon, Ira Hayes, and John Bradley.

AP Wide World photo

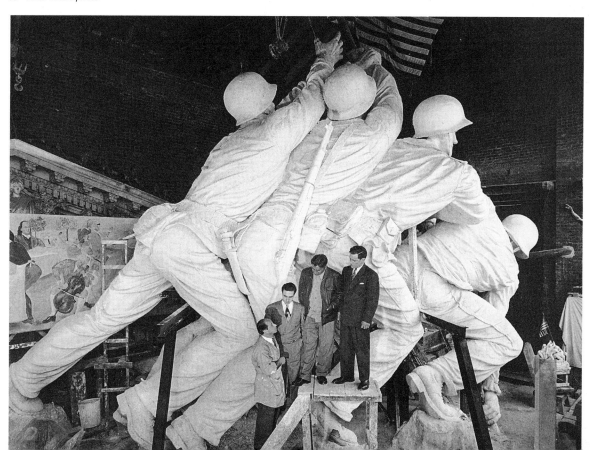

Three trucks carry the pieces of the de Welden sculpture across New York's George Washington Bridge enroute to Arlington, VA.

AP Wide World photo by Tony Camerano.

A crowd of thousands attend the dedication ceremonies of the Marine Memorial in Arlington, VA, Nov 10, 1954.

AP Wide World photo

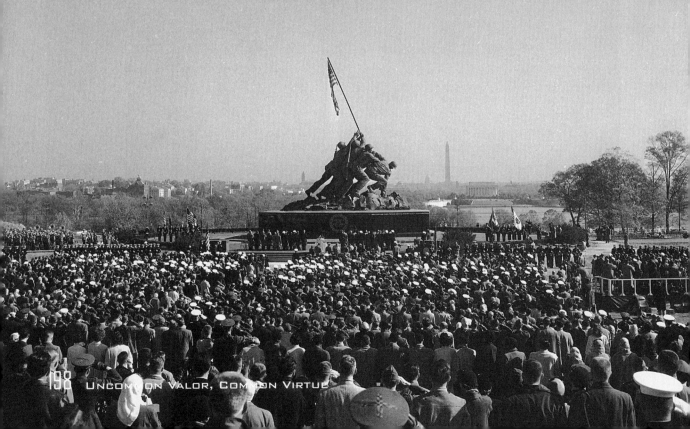

Joe Rosenthal was invited to the ceremony with his wife and two children. He planned to show the monument to his son, Joe Jr. and ask him to look for his name. Fortunately, Joe Sr. didn't do that and saved himself and his family embarrassment—nowhere in the area of the monument was there mention that his photo inspired the statue. It would take twenty-eight years and an executive order by President Ronald Reagan for a plaque to be attached to the monument recognizing the photo and the photographer.

The monument, like the photo, was not without controversy.

Washington insiders protested installation of the monument in the capital, saying it was neo-classic and in the European tradition. A committee, with the power to prevent the monument's appearance in the capital, was successful. Hence land was found for the statue's home in Arlington, Virginia. Presidents Truman and

The three surviving flag raisers sit on the stand during ceremonies to mark the unveiling of the Marine Memorial in Arlington, VA, on November 10, 1954. From left: John Bradley, with hat, Ira Hayes, and Rene Gagnon. *AP Wide World Photo*

Eisenhower were put off by the Marine Corps' aggressive publicity surrounding the building and location of the monument. Eisenhower disliked the statue itself thinking it too grand for the moment in time it represented. He attended the monument unveiling, arriving late and departing immediately to meet, among others, the ambassador from Japan. Speech making was delegated to his vice president, Richard Nixon.

President-elect Eisenhower looks at a plaque atop Mt. Suribachi marking the spot where the flag was put up.

AP Wire Photo

Surviving first-flag raisers were invited to the ceremony but were seated at the rear and were treated as they had been since D+4 on Suribachi, as a footnote to history. At the Washington monument celebration, they were not interviewed by reporters or others involved with the day's festivities. Charles Lindberg, one of the surviving first-flag raisers, expressed his disappointment with the treatment he and his surviving colleagues received. In several television documentaries Lindberg offered versions of this commentary from "Unsung Heroes," a History Channel program produced by Lou Reda Productions:

"It just did not seem that that could happen . . . we put the flag up, we took the enemy off the mountain, somebody comes two hours later and puts another flag up and they are national heroes."

Just weeks after the Arlington ceremony, Ira Hayes was found dead outside an adobe hut on his Arizona reservation. A medical examiner ruled cause of death to be acute alcoholism and exposure. He had drifted from job to job and

Actor Tony Curtis, in his role as Ira Hayes for the movie, *The Outsider.*
AP Wide World photo

was jailed several times, each incident leading to the same headlines—Iwo Hero Jailed as Drunk, etc. His battle with the bottle stayed in the headlines after the war's end until his death in January 1955. Hayes's story, however, survived his death. In 1960, two presentations—a movie and a TV docudrama—kept Hayes and the Iwo photograph in the news—and in the center of controversy.

Hollywood and the National Broadcasting Company each decided to dramatize the Hayes story. The 1962 Universal-International movie, *The Outsider,* starred a heavily made-up Tony Curtis as Hayes. The script was tweaked, noodled, and rewritten, finally ending up, not as a war movie, but as a social commentary on

discrimination and a muddled psychological treatment of Hayes's life. It bombed at the box office.

Two years earlier an NBC docudrama, called *The American*, starring former Marine Lee Marvin as Hayes, directly attacked the photo. Hayes was shown as a much misunderstood victim of his past, especially his flag-raising episode on Iwo. The photograph, while not explicitly indicted, was implicitly credited with creating Hayes's problems because it made Hayes a hero, a role he could not accept. Worse, the drama indicated the photo was a phony, that made it all the more responsible for Hayes's condition. One scene in the NBC program re-created the flag-raising scene of the earlier Wayne movie. Marvin, playing a drunken Hayes, talked to a buddy during the flag-raising recreation:

"They'd already took about ten thousand pictures that day. And you said, 'Ira, we might as well get in one of these.' So I went with you—everybody on the island knew it was a phony—didn't they, Nick?

"When that colonel flew all the way out from Washington, D.C., and said he was going to take us guys that were in the picture back to some war bond drive, I said 'no, colonel, I hadn't had anything to do with raising any flag, I was just in the picture that's all.' The colonel, he said, I know, it's just a picture, Chief—but to everybody back in the States you're a hero' and he said it didn't really mater. All that picture is is a symbol of all the guys that were on this island. He said, 'Chief, as far as I'm concerned, every guy on the island was a hero.'"

Later Marvin, still in the role of the war-haunted Hayes, says:

"I can't go around the rest of my life letting people believe I did something I didn't do. That flag-raising picture was a phony, I am a phony."

The script for the TV program, broadcast on March 27, 1960, was written by Merle Miller, directed by the then up-and-coming John Frankenheimer, and also starred Stephen Hill. A disclaimer at the end of the movie attempted to keep the record straight about the flag picture, but it was a weak, easily missed statement. The docudrama repeated yet again the story of the picture, now clouded not only by war but by the passage of time. Associated Press issued a sharp statement saying the NBC broadcast misrepresented the picture. Holland Smith, the Marine general from Iwo, said in his terse style: "The picture was no phony!" Lou Lowery, by then a friend of Rosenthal, chimed in to say that the picture was not a phony and was not posed. Rosenthal himself entered a suit that was settled out of court eighteen months later.

In 1991, another attack came in the form of *Iwo Jima: Monuments, Memories and the American Hero*, a book by Karal Ann Marling and John Wetenhall. A review of

the book in the *New York Times* was headlined: "Birth of a National Icon, but an Illegitimate One." The old songs were played again, with repetitious cracks and missed chords. "Hoax" was applied to describe the picture, and "staged" was used to describe the making of the picture. The review said the picture represented the ". . . mating of unvirtuous photojournalism with an insatiable desire on the part of the Marine officers to enhance a history that needed no enhancement." The reviewer wondered whether there should be reconsideration of the Pulitzer Prize. The *Times* subsequently printed letters from those Marines involved in the conquest of Suribachi that supported the picture, but in the fast lane of daily journalism, correction seldom catches up with error.

Two other books were subsequently published, carefully researched volumes that told the story: *Immortal Images* by Tedd (cq) Thomey and *Shadow of Suribachi*, by Parker Bishop Albee Jr., and Keller Cushing Freeman. Balance was provided, but myths—good and bad—die slow and hard.

A series of lesser stories that featured errors and misconceptions about the picture emerged from time to time, but in 1994, a column by syndicated columnist Jack Anderson once again brought the story to high-profile status. Jack Bradley, the Navy corpsman who was the last survivor of the six flag raisers, died in 1994. His postwar life, unlike his fellow survivors, had been steady and fruitful. He avoided involvement in public discourse about the picture, appearing only infrequently. He was a respected member of his Appleton, Wisconsin, community and raised a family.

Bradley's death, however, alerted Anderson to the picture, and his column of January 19, 1994, brought up all the old saws about the photo. He reported that old files revealed that the picture was restaged by the photographer, that the Marine Corps handpicked the flag raisers and then forced the survivors to lie about the picture. The column drew a vigorous response from Marines and others who knew the story, and Anderson apologized weeks later saying that he had been misled by faulty research. But the story was in the public eye once again.

Many references over time described the photo as an accident—a happy accident—but an accident nevertheless. Rosenthal himself inscribed a print he gave to Lowery "To Lou Lowery, who got there first,—a helluva Marine and a great guy, all the best from lucky Joe Rosenthal." He is quoted as saying that between Lowery and himself there may be a discussion of who was the better photographer, but there was no question about who was the luckiest. Rosenthal's modesty was sincere, but misleading.

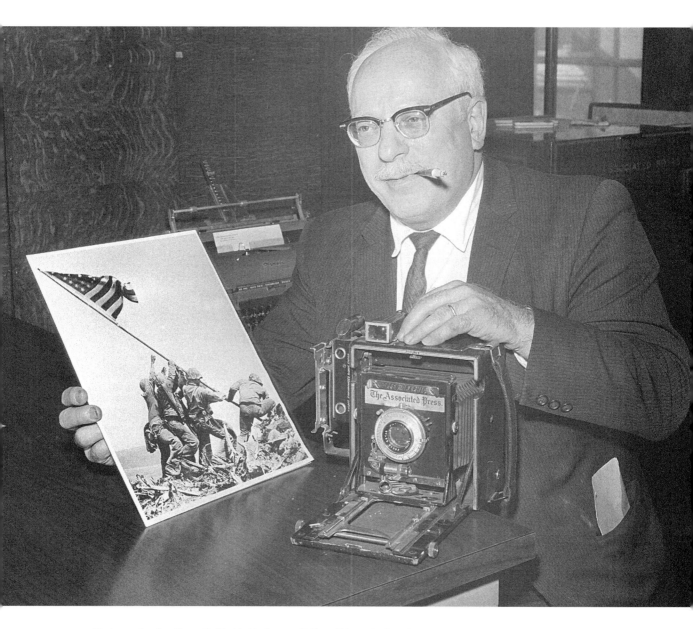

Photographer Joe Rosenthal holds his famous Pulitzer Prize–winning photo.

AP Wide World photo

Serendipity is part of photography, but it is not all of photography. Rosenthal chose to climb Suribachi after he learned that a flag was up; he decided to not shoot the picture of one flag going up and another coming down because it was too chancy; he constructed a small platform of boulders and sandbags to provide a better angle; he calculated the distance to make sure the upward arc of the rising would not swing the flag out of the frame; he made the picture at the peak of action, not too late, not too early. There were five other photographers on Suribachi when the flag went up. Only Rosenthal and Genaust made the picture.

Truth, error, fiction, and fact ebbed and flowed around the picture for more than half a century. Despite the furor, Americans held the photo close to their hearts. The message communicated through its visual power survived those who would belittle the photo, American patriotism, and American ideals. It said what Americans themselves could not articulate, and in a way understood by all.

Joe Rosenthal has often been asked whether it was worth it all—the fame (or notoriety), the challenges to his professionalism and his ethics, the distortions, the constant repetition of the word *phony*.

"I tried not to complain about it, but it has taken over half of my life. It has made a difference, but you must talk about the good side . . . sometimes I lapse into being annoyed . . . of wondering whether this will not ever pass But I know I did my job . . . the job turned out well . . . and I wonder, what if somebody else might have made the picture . . . but, no, I can't say I would like that, I can't go that far . . . no, there's a certain kind of inner happiness of my being able to say I had something to do with that. I can't regret doing it. And to feel that I'm even remotely part of that . . . there's something good about it that outweighs all the annoyance."

Joe Rosenthal revisits the beach of Iwo Jima several years after the war. Battle debris remains buried in the sand during his visit but in later years scrap metal dealers cleared away the materiel.

AP Wide World photo

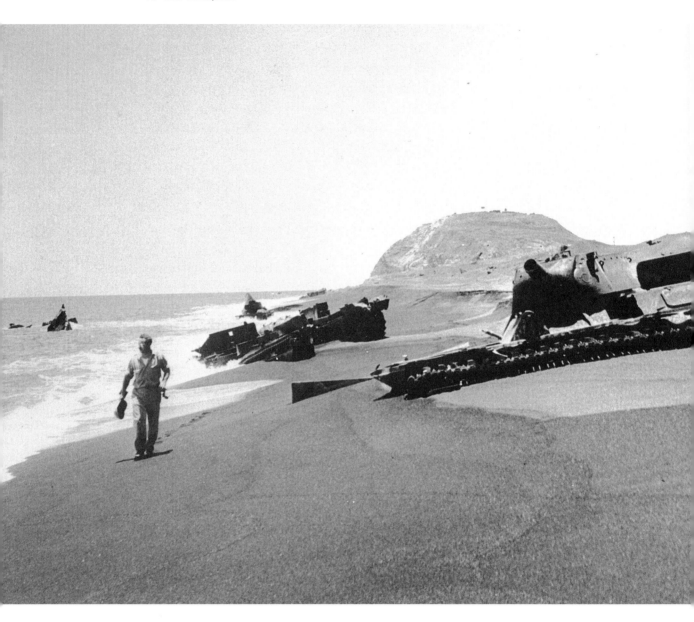

The flag-raising picture was replicated uncounted times but among the first reproductions was this bas relief carved into the side of a high boulder by a Seabee. This picture was made in 1965. The bas relief continued in place into the 21st century.

AP Wide World photo by Nobuyuki Masaki

In June 1989, using the Iwo Jima Memorial as a backdrop, President Bush delivers a speech in Arlington where he urged passage of a constiutional amendment to ban flag burning.

AP Wide World photo

Uncommon Valor, Common Virtue

Many U.S. Presidents seek patriotic backgrounds for speech making. In this photo President Bill Clinton offers remarks on February 19, 1995, in front of the Marine Memorial marking the anniversary of the Iwo Jima battle.

AP Wide World Photo

The three surviving flag raisers prepare to hoist the Stars and Stripes over the nation's capitol in Washington, DC. This was the actual flag that flew atop Mt. Suribachi.

AP Wide World photo

Joe Rosenthal, right, poses with movie stars James Cagney and Spencer Tracey to promote the opening of the Seventh War Bond drive in April, 1945.

AP Wide World photo from U.S. Treasury Dept.

A representation of the flag-raising picture was cut into a 15 acre corn field in LaSalle, Colorado, in September of 2004, an example of the enduring hold the picture continued to have on the American psyche.

Photo by John Epperson, Denver Post

University of Maryland gymnasts, their bodies coated with aluminum paint and mineral oil, re-create the flag raising of Iwo Jima during a show that toured military bases in 1972.

AP Wide World photo

> *I looked back at the little island, and I said, every day I live from now on will be a bonus.*
>
> —SGT. ALFRED CIALFI

Island Seemed Like Beachead on Hell

I WO JIMA CONVEYED a sullen sense of evil to all the Americans who saw it for the first time. The cold, wet winds loaded with fine volcanic dust. The blazing tropical sun, the shifting volcanic sand that slid back into foxholes and clotted firing mechanisms, the rotten egg smell of sulphur, the heaving steaming ground, the 20-foot surf, the bats called "slit faced" and "trumpet eared," all combined to make the Marines feel that at last they had established a beachead on hell. The 20,000 Japanese who died there, plus the few dozen who were taken prisoner, did their utmost to confirm this impression. The Air Force and Navy had tried by 74 days of bombing and three days of shelling to pulverize the Japs but they squatted relatively unscathed in their fortifications until the Marines came after them in person. The Japanese sometimes fought in the uniforms of dead Marines and sneaked out at night to booby trap the bodies of the American dead. The U.S. dead and wounded on Iwo were more mangled than usual because most casualties were mortar fire. Even doctors sustained heavy casualties because the whole island was continuously within range of both sides. Since a unit had no place to go when "relieved," it simply stayed in the foxholes and let another unit fight ahead through it. There were only two pleasant or useful things about Iwo. One was a red clay that made a good airstrip surface. The other was a creeping little purple flower. But the Japs begrudged losing this inhospitable fragment of land. Admission of utter defeat finally came in the Tokyo radio's agonized weasely "American Marines have gradually penetrated Japanese strongholds and consequently the communication more or less has the tendency to stop."

—*Life* magazine
APRIL 9, 1945

ANOTHER PICTURE

IT IS ARLINGTON, Virgina, 1995, half a century and half a world distant from 1945. Another picture is made. It shows Joe Rosenthal walking across a lush green lawn. At his left is the current Marine commandant, a generation younger than Joe. At Joe's right is the president of the National Press Photographer's Association, yet another generation younger. Behind this trio stands a Marine honor guard, a still younger generation, locked in rigid attention as ceremonies proceed honoring photographers who died in combat. The background to all is the Marine Corps War Memorial, a massive 64-foot bronze replica of a photograph that forever holds an endearing and enduring grip on the American experience.

IWO JIMA AND 9/11

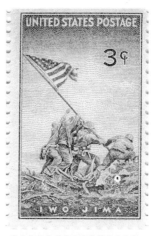

THE TWO MIGHTY towers of New York collapsed in a roar of dust, rubble, and smoke. Darkness created by the crash's debris soon cleared, and the light of a bright September morning revealed a pile of twisted metal standing starkly in dirt and stone. Fanatical terrorists had murdered more than 2,000 people and destroyed the World Trade Center.

That afternoon, photographer Tom Franklin of the Record in New Jersey completed his coverage of this deadliest attack in history on American soil. As he headed for his office, he saw three firemen on the far side of the destruction with an American flag obtained from a boat in the nearby Hudson River. Franklin made a photo as the firemen prepared to raise the flag over the scene.

Comparison with the picture from Iwo Jima was instantaneous. One photo reached across the generations to strengthen the message of another, each reminding Americans that in 2001, as in the Pacific battle of 1945, the nation, its ideals, and its values would prevail.

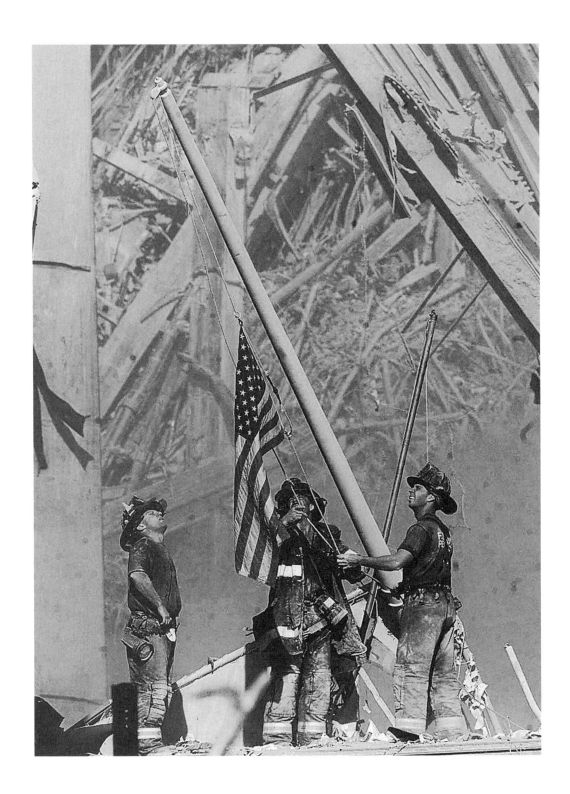

Uncommon Valor, Common Virtue

LOOSE ENDS

THE FINAL OFFICIAL word on casualties at the battle for Iwo Jima are:

	KILLED	WOUNDED	COMBAT FATIGUE	TOTAL
Marines	5,931	17,272	2,648	25,851
Navy				
Ships/Air	633	1,158		1,791
Corpsman	195	529		724
Seabees	51	218		269
Doctors	2	12		14
Army Units	9	28		27
Total	6,821	19,217	2,648	28,676

Estimated Japanese deaths were put at 21,000. Prisoners totaled 1,083.

⚓

Six of the twelve men that raised flags on Suribachi were killed before the battle was concluded. Of the forty-man platoon that took the flags to the top of Mt. Suribachi, four left Iwo Jima unhurt. The others were killed or wounded.

⚓

The Marines left Iwo Jima in late March and early April, and an Army force took over. In the following weeks, Army units accounted for 1,600 more Japanese casualties.

⊙═╌═⊙

The effectiveness of Tadamichi Kuribayashi's defense was confirmed: he was the only Japanese general who inflicted more casualties on Americans than Americans inflicted on Japanese in the Pacific war.

⊙═╌═⊙

Kuribayahsi's body was never found. Japanese prisoners had no information of his end. It is assumed he died either from American attacks or by ritual suicide near Kitano Point on the extreme northern point of Iwo Jima, the last of two areas of the island to fall to the Marines.

⊙═╌═⊙

Joe Rosenthal's camera was assigned to Europe after the war but returned to Asia in the hands of AP Rome photographer Jim Pringle who covered the Korean War. It crossed Korea's 38th parallel twice, once going north and once going south.

The most important picture taken with the camera after Suribachi became part of the Korean armistice talks when, in July 1951, a Communist infantry company marched through Kaesong, a flagrant violation of the agreement at the time. Objections were raised, and the Communists demanded proof of the incident. The only picture made was by Pringle and it became part of the official record. When Pringle returned to Rome the camera was put aside in Tokyo as a spare.

George Sweers, Tokyo photo editor at the time and the Kansas City wirephoto operator who saw Rosenthal's picture the morning it was transmitted to the world, located the camera in 1954. The camera, which took the photo symbolizing the defeat of Japan, performed its final service in the hands of a young Japanese photographer. The camera was placed in the Graflex company's historical exhibit and was eventually sent to the George Eastman House in Rochester, New York, where it is kept today.

⊙═╌═⊙

Many of the Marines and other U.S. personnel who died on Iwo Jima were buried immediately on the island, but virtually all were returned to their home soil in the

1950s. Most of the Japanese who died on Iwo Jima remain buried on the island, sealed in caves blown and bulldozed shut half a century ago.

⊶——⊷

Iwo Jima was returned to the Japanese in 1968 and the turnover left Marine Corps survivors of the battle upset. Iwo Jima is now used primarily as a navigational watch point. A number of modern buildings and storage tanks for water and fuel have been built. Some seven hundred Japanese personnel staff the island.

Iwo is difficult to get to and private visits require special permission from the Japanese government. The American flag is flown on four days a year. Iwo survivors, both Japanese and American, conduct combined memorial services on the island with some regularity. As one observer put it: white-haired grandfathers meet on black sand. Families of Japanese who died on Iwo visit the island regularly to pay homage to their ancestors. Many see Iwo Jima as a kind of shrine that still holds the bodies of Japanese who died honorably.

⊶——⊷

After the flag raising, Rene Gagnon remained on Iwo until the end of the battle, then participated in the Seventh War Bond Drive. He never truly adjusted to a routine life. He traveled to Japan at one time and presented a stone from Iwo to the widow and son of General Kuribayashi. After working at several different jobs, Gagnon turned to alcohol and died in 1979. He was fifty-three.

John Bradley, the wounded Navy corpsman, completed his rehabilitation and returned to his home state of Wisconsin. He became a prominent citizen of Appleton, Wisconsin, owned and directed a funeral home, married, and raised several children. He was perceived as not involved in Iwo affairs after the war, but he

Renee Gagnon, after attending a reunion of American and Japanese veterans of Iwo Jima, stopped in Japan to present a stone from the island to the widow of General Tadamichi Kuribayashi, commander of Japanese forces on Iwo.

AP Wide World photo

appeared in the John Wayne movie, attended the unveiling of the Marine Memorial in Arlington, Virginia. He turned down most requests for interviews but did sit for a couple. He died of natural causes early in 1994 at the age of seventy, the last of the flag raisers.

Vegetation covers the island, making it appear green and alive. Military hardware that littered the beaches was cut up for scrap. Some of the pillboxes and old Japanese fortifications remain, however, mute reminders of the bloody battle of 1945. A few tunnels have been declared safe and are sometimes visited by those who go to the island.

President Eisenhower stopped on Iwo Jima in 1952 en route to Korea, where he flew secretly to fulfill an election campaign promise to visit American troops. He took a quick tour of the island and stopped on top of Suribachi.

In 2005, the U.S. mint issued a one dollar coin honoring the anniversary of the Marine Corps. One side of the coin featured a replica of the flag raising. It was the first time a specific branch of the military was so honored.

AP Wide World Photo by Joseph Kazamarek

There is a plaque on Suribachi that features a relief of Joe Rosenthal's picture, but his name is not included. There is also a plaque remembering Sgt. Bill Genaust's film sequence and there are several Japanese memorials on top of the mountain.

Suribachi, young in geologic measurement, continues to rise and is now close to thirty feet higher than it was in 1945. Steam still hisses from its fissures, and the odor of sulphur is still in the air. Some scientists say the volcano could erupt in the future. In 2005, underwater eruptions sent a geyser of water into the air in nearby ocean waters.

Joe Rosenthal and Lou Lowery became friends after a long, night session with Marines and bourbon in a Washington, D.C., hotel room, where they got together after a reunion of Iwo veterans. Lowery, when asked, always responded that he was confident that Rosenthal's flag-raising picture was not posed. And Lowery's picture took on a life of its own in later years, though it never had the visual impact to overtake the emotional pull that Rosenthal's picture had. When Lowery died, Rosenthal attended his funeral.

Robert Sherrod in later years also apologized for the stir his early reports caused, and for the string of events that it set in motion. He said he should have checked with Rosenthal before indicating in his story that the picture was a phony.

Joe Rosenthal died on August 20, 2006, of natural causes, at the age of ninety-four. In his final years he suffered failing health and deteriorating eyesight but he remained alert and from time to time participated in photo conferences by telephone.

In July of 2007 a joint POW/MIA group from Hawaii spent more than a week on Iwo Jima searching for the remains of motion picture photographer Sergeant Bill Genaust. Several caves were examined as possible sites for excavation at a later date.

In the summer of 2007 descendents of those who lived on Iwo Jima successfully petitioned the Japanese government to restore the island's original name, which was Iwo To (pronounced *ee-wah-toe*). The Japanese administration agreed and maps published after September 2007 would use the Iwo To name. It means the same as Iwo Jima (Sulphur Island) but has a different sound when spoken. The name Iwo Jima was what Japanese military occupation called the island when they sent residents home before the battle in early 1945.

In 2006 and 2007 Hollywood star and motion picture director Clint Eastwood released two motion pictures about Iwo Jima—*Flags of Our Fathers*, based on the book by James Bradley, and *Letters from Iwo Jima*, a film that told the story of the battle from the Japanese perspective.

MEDAL OF HONOR CITATIONS

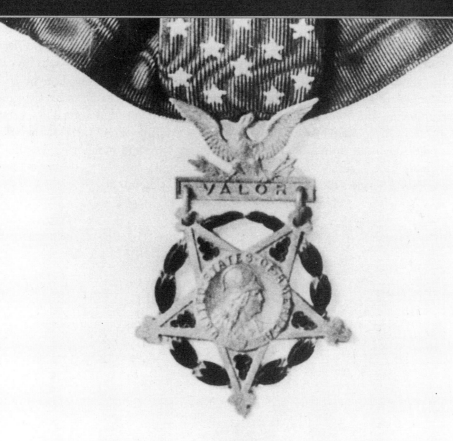

March 3, 1945

CORPORAL CHARLES J. BERRY

FOR CONSPICUOUS GALLANTRY and intrepidity at the risk of his life above and beyond the call of duty as a member of a Machine–gun crew, serving with the First Battalion, Twenty-sixth Marines, Fifth Marine Division, in action against enemy Japanese forces during the seizure of Iwo Jima in the Volcano Islands, on 3 March 1945.

Stationed in the front lines, Corporal Berry manned his weapon with alert readiness as he maintained a constant vigil with other members of his gun crew during the hazardous night hours. When infiltrating Japanese soldiers launched a surprise attack shortly after midnight in an attempt to overrun his position, he engaged in a pitched hand grenade duel, returning the dangerous weapons with prompt and deadly accuracy, until an enemy grenade landed in the foxhole. Determined to save his comrades, he unhesitatingly chose to sacrifice himself and immediately dived on the deadly missile, absorbing the shattering violence of the exploding charge in his own body and protecting the others from serious injury. Stouthearted and indomitable, Corporal Berry fearlessly yielded his own life that his fellow Marines might carry on the relentless battle against a ruthless enemy and his superb valor and unfaltering devotion to duty in the face of certain death reflect the highest credit upon himself and the United States Naval Service. He gallantly gave his life for his country.

Harry S. Truman
PRESIDENT OF THE UNITED STATES

Pfc William R. Caddy

For conspicuous gallantry and intrepidity at the risk of his life above and beyond the call of duty while serving as a Rifleman with Company I, Third Battalion, Twenty-sixth Marines, Fifth Marine Division, in action against enemy aggressor forces during the seizure of Iwo Jima in the Volcano Islands, 3 March 1945. Consistently aggressive, Private First Class Caddy boldly defied shattering Japanese machine gun and small–arms fire to move forward with his platoon leader and another Marine during a determined advance of his company through an isolated sector and, gaining the comparative safety of a shell hole, took temporary cover with his comrades. Immediately pinned down by deadly sniper fire from a well concealed position, he made several unsuccessful attempts to again move forward and then, joined by his platoon leader, engaged the enemy in a fierce exchange of hand grenades until a Japanese grenade fell in the shell hole. Fearlessly disregarding all personal danger, Private First Class Caddy instantly threw himself upon the deadly missile, absorbing the exploding charge in his own body and protecting the others from serious injury. Stouthearted and indomitable, he unhesitatingly yielded his own life that his fellow Marines might carry on the relentless battle against a fanatic enemy. His dauntless courage and valiant spirit of self-sacrifice in the face of certain death reflects the highest credit upon Private First Class Caddy and the United States Naval Service. He gallantly gave his life for his country.

Harry S. Truman
President of the United States

February 19–22, 1945

COLONEL JUSTICE M. CHAMBERS
UNITED STATES MARINE CORPS RESERVE

FOR CONSPICUOUS GALLANTRY and intrepidity at the risk of his life above and beyond the call of duty as Commanding Officer of the Third Assault Battalion Landing Team, Twenty-fifth Marines, Fourth Marine Division, in action against enemy Japanese forces on Iwo Jima from, 19 to 22 February 1945. Under a furious barrage of enemy machine gun and small-arms fire from the commanding cliffs on the right, Colonel Chambers, then Lieutenant Colonel, landed immediately after the initial assault waves of his Battalion on D-Day to find the momentum of the assault threatened by heavy casualties from withering Japanese artillery, mortar, rocket, machine gun and rifle fire. Exposed to relentless hostile fire, he coolly reorganized his battle-weary men, inspiring them to heroic efforts by his own valor and leading them in an attack on the critical, impregnable high ground from which the enemy was pouring an increasing volume of fire directly onto troops ashore as well as amphibious craft in succeeding waves. Constantly in the front lines encouraging his men to push forward against the enemy's savage resistance, Colonel Chambers led the 8-our battle to carry the flanking ridge top and reduce the enemy's fields of aimed fire, thus protecting the vital foothold gained. In constant defiance of hostile fire while reconnoitering the entire Regimental Combat Team zone of action, he maintained contact with adjacent units and forwarded vital information to the Regimental Commander. His zealous fighting spirit undiminished despite terrific casualties and the loss of most of his key officers, he again reorganized his troops for renewed attack against the enemy's main line of resistance and was directing the fire of the rocket platoon when he fell, critically wounded. Evacuated under heavy Japanese fire, Colonel Chambers, by forceful leadership, courage and fortitude in the face of staggering odds, was directly instrumental in insuring the success of subsequent operations of the First Amphibious Corps on Iwo Jima, thereby sustaining and enhancing the finest traditions of the United States Naval Service.

Harry S. Truman
PRESIDENT OF THE UNITED STATES

February 19, 1945

SERGEANT DARRELL S. COLE
UNITED STATES MARINE CORPS RESERVE

FOR CONSPICUOUS GALLANTRY and intrepidity at the risk of his life above and beyond the call of duty while serving as leader of a Machine Gun Section of Company B, First Battalion, Twenty-Third Marines, Fourth Marine Division, in action against enemy Japanese forces during the assault on Iwo Jima in the Volcano Island, on 19 February 1945. Assailed by a tremendous volume of smallarms, mortar, and artillery fire as he advanced with one squad of his section in the initial assault wave Sergeant Cole boldly led his men up the sloping beach toward Airfield No. 1 despite the blanketing curtain of flying shrapnel and, personally destroying with hand grenades, two hostile emplacements that menaced the progress of his unit, continued to move forward until a merciless barrage of fire emanating from three Japanese pillboxes halted the advance. Instantly placing his one remaining machine gun in action, he delivered a shattering fusillade and succeeded in silencing the nearest and most threatening emplacement before his weapon jammed and the enemy, reopening fire with knee mortars and grenades, pinned down his counterattack for the second time. Shrewdly gauging the tactical situation and evolving a daring plan of counterattack, Sergeant Cole, armed solely with a pistol and one grenade, coolly advanced alone to the hostile pillboxes. Hurling his one grenade at the enemy in a sudden, swift attack, he quickly returned to his own lines for additional grenades and again advanced, attacked, and withdrew. With enemy guns still active, he ran the gauntlet of slashing fire a third time to complete the total destruction of the Japanese strong point and the annihilation of the defending garrison in this final assault. Although instantly killed by an enemy grenade as he returned to his squad, Sergeant Cole had eliminated a formidable Japanese position, thereby enabling his company to storm the remaining fortifications, continue the advance, and seize the object. By his dauntless initiative, unfaltering courage and indomitable determination during a critical period of action, Sergeant Cole served as an inspiration to his comrades, and his stouthearted leadership in the face of almost certain death sustained and enhanced the highest tradition of the U.S. Naval Service. He gallantly gave his life for his country.

Harry S. Truman
PRESIDENT OF THE UNITED STATES

February 20–21, 1945

CAPTAIN ROBERT H. DUNLAP
UNITED STATES MARINE CORPS RESERVE

FOR CONSPICUOUS GALLANTRY and intrepidity at the risk of his life, above and beyond the call of duty as Commanding Officer of Company C, First Battalion, Twenty-Sixth Marines, Fifth Marine Division, in action against enemy Japanese forces during the seizure of Iwo Jima in the Volcano Islands, on 20 and 21 February 1945. Defying uninterrupted blasts of Japanese artillery, mortar, rifle, and machine gun fire, Captain Dunlap led his troops in a determined advance from low ground uphill toward the steep cliffs from which the enemy poured a devastating rain of shrapnel and bullets, steadily inching forward until the tremendous volume of enemy fire from the caves located high to his front temporarily halted his progress. Determined not to yield, he crawled alone approximately two hundred yards forward of his front lines, took observation at the base of the cliff fifty yards from Japanese lines, located the enemy gun position, and returned to his own lines, where he relayed the vital information to supporting artillery and naval gunfire units. Persistently disregarding his own personal safety, he placed himself in an exposed vantage point to direct more accurately his own supporting fire and, work without respite for two days and two nights under constant enemy fire, despite numerous obstacles and heavy Marine casualties. A brilliant leader, Captain Dunlop inspired his men to heroic efforts during this critical phase of the battle and by his cool decision, indomitable fighting spirit, and daring tactics in the face of fanatical opposition, greatly accelerated the final decisive defeat of Japanese countermeasures in his sector and materially furthered the continued advance of his company. His great personal valor and gallant spirit of self-sacrifice throughout the bitter hostilities reflect the highest credit upon Captain Dunlap and the United States Naval Service.

Harry S. Truman
PRESIDENT OF THE UNITED STATES

SERGEANT ROSS F. GRAY
UNITED STATES MARINE CORPS

FOR CONSPICUOUS GALLANTRY and intrepidity at the risk of his life above and beyond the call of duty as Acting Platoon Sergeant serving with Company A, First Battalion, Twenty-fifth Marines, Fourth Marine Division, in action against enemy Japanese forces on Iwo Jima, Volcano Islands, on 21 February 1945. Shrewdly gauging the tactical situation when his platoon was held up by a sudden barrage of hostile grenades while advancing toward the high ground northeast of Airfield Number One, Sergeant Gray promptly organized the withdrawal of his men from enemy grenade range, quickly moved forward alone to reconnoiter, and discovered a heavily mined area extending along the front of a strong network of emplacements joined by covered communication trenches. Although assailed by furious gunfire, he cleared a path leading through the minefield to one of the fortifications then returned to the platoon position and, informing his leader of the serious situation, volunteered to initiate an attack while being covered by three fellow Marines. Alone and unarmed but carrying a twenty-four pound satchel charge, he crept up on the Japanese emplacement, boldly hurled the short-fused explosive, and sealed the entrance. Instantly taken under machine gun fire from a second entrance to the same position, he unhesitatingly braved the increasingly vicious fusillades to crawl back for another charge, returned to his objective, and blasted the second opening, thereby demolishing the position. Repeatedly covering the ground between the savagely defended enemy fortifications and his platoon area, he systematically approached, attacked, and withdrew under blanketing fire to destroy a total of six Japanese positions, more than twenty-five of the enemy, and a quantity of vital ordnance gear and ammunitions. Stouthearted and indomitable, Sergeant Gray had single-handedly overcome a strong enemy garrison and had completely disarmed a large minefield before finally rejoining his unit and, by his great personal valor, daring tactics, and tenacious perseverance in the face of extreme peril, had contributed materially to the fulfillment of his company's mission. His gallant conduct throughput enhanced and sustained the highest traditions of the United States Naval Service.

Harry S. Truman
PRESIDENT OF THE UNITED STATES

March 3, 1945

Sergeant William G. Harrell
United States Marine Corps.

FOR CONSPICUOUS GALLANTRY and intrepidity at the risk of his life above and beyond the call of duty as leader of an Assault group, serving with the first Battalion, Twenty-Eighth Marines, Fifth Marine Division, during hand to hand combat with enemy Japanese at Iwo Jima, Volcano Islands, on 3 March 1945. Standing watch alternately with another Marine in a terrain studded with caves and ravines, Sergeant Harrell was holding a position in a perimeter defense around the company command post when Japanese troops infiltrated our lines in the early hours of dawn. Awakened by a sudden attack, he quickly opened fire with his carbine and killed two of the enemy as they emerged from a ravine in the light of a star-shell burst. Unmindful of his danger as hostile grenades fell closer, he waged a fierce lone battle until an exploding missile tore off his left hand and fractured his thigh; he was attempting to reload the carbine when his companion returned from the command post with another weapon. Wounded again by a Japanese who rushed the foxhole wielding a saber in the darkness, Sergeant Harrell succeeded in drawing his pistol and killing his opponent, and then ordered his wounded companion to place of safety. Exhausted by profuse bleeding but still unbeaten, he fearlessly met the challenge of two more enemy troops who charged his position and placed a grenade near his head. Killing one man with his pistol, he grasped the sputtering grenade and with his good right hand and, pushing it painfully toward the crouching soldier, saw his remaining assailant destroyed but his own hand severed in the explosion. At dawn, Sergeant Harrell was evacuated from a position hedged by the bodies of twelve dead Japanese, at least five of whom he had personally destroyed in his self-sacrificing defense of the command post. His grim fortitude, exceptional valor, and indomitable fighting spirit against almost insurmountable odds reflect in the highest credit upon himself and enhanced the finest traditions of the United States Naval Service.

Harry S. Truman
PRESIDENT OF THE UNITED STATES

LIEUTENANT JUNIOR GRADE RUFUS B. HERRING
UNITED STATES NAVY

FOR CONSPICUOUS GALLANTRY and intrepidity at the risk of his life above and beyond the call of duty as commanding officer of LCI (G) 449 operating as a unit of LCI (G) Group 8, during the preinvasion attack on Iwo Jima on 17 February 1945. Boldly closing the strongly fortified shores under the devastating fire of Japanese coastal defense guns, Lieutenant (then Lieutenant Junior Grade) Herring directed shattering barrages of 40mm, and 20mm gunfire against hostile beaches until struck down by the enemy's savage counterfire that blasted the 449's heavy guns and whipped its decks into sheets of flame. Regaining consciousness despite profuse bleeding, he was again critically wounded when a Japanese mortar crashed the conning station, instantly killing or fatally wounding most of the officers and leaving the ship wallowing without navigational control. Upon recovering the second time, Lieutenant Herring resolutely climbed down to the pilothouse and, fighting against his rapidly waning strength, took over the helm, established communication with the engine room, and carried on valiantly until relief could be obtained. When no longer able to stand, he propped himself against empty shell cases and rallied his men to the aid of the wounded; he maintained position in the firing line with his 20mm. guns in action in the face of sustained enemy fire, and conned his crippled ship to safety. His unwavering fortitude, aggressive perseverance, and indomitable spirit against terrific odds reflect the highest credit upon Lieutenant Herring and uphold the highest traditions of the United States Naval Service.

Harry S. Truman
PRESIDENT OF THE UNITED STATES

February 26, 1945

PRIVATE FIRST CLASS DOUGLAS T. JACOBSON
UNITED STATES MARINE CORPS RESERVE

FOR CONSPICUOUS GALLANTRY and intrepidity at the risk of his life above and beyond the call of duty while serving with the Third Battalion, Twenty-third Marines, Fourth Marine Division, in combat against enemy Japanese forces during the seizure of Iwo Jima in the Volcano Islands, on 26 February 1945. Promptly destroying a stubborn 20mm antiaircraft gun and its crew after assuming the duties of a bazooka man who had been killed, Private First Class Jacobson waged a relentless battle as his unit fought desperately toward the summit of Hill 382 in an effort to penetrate the heart of Japanese cross-island defenses. Employing his weapon with ready accuracy when the platoon was halted by overwhelming enemy fire on 26 February, he first destroyed two hostile machine gun positions, then attacked a large blockhouse, completely neutralizing the fortifications before dispatching the five-man crew of a pillbox and exploding the installation with a terrific demolitions blast. Moving steadily forward, he wiped out an earth-covered rifle emplacement and, confronted by a cluster of similar emplacements that constituted the perimeter of enemy defenses in his assigned sector, fearlessly advanced, quickly reduced all six positions to a shambles, killed ten of the enemy, and enabled our forces to occupy the strong point. Determined to widen the breach thus forced, he volunteered his services to an adjacent assault company, neutralized a pillbox holding up its advance, opened fire on a Japanese tank, pouring a steady stream of bullets on one or our supporting tanks and smashed the enemy tank turret in a brief but furious action, culminating in a single-handed assault against still another blockhouse and the subsequent neutralization of its firepower. By his dauntless skill and valor, Private First Class Jacobson destroyed a total of sixteen enemy positions and annihilated approximately seventy-five Japanese, thereby contributing essentially to the success of his division's operations against the fanatically defended outpost of the Japanese Empire. His gallant conduct in the face of tremendous odds enhanced and sustained the highest traditions of the United States Naval Service.

Harry S. Truman
PRESIDENT OF THE UNITED STATES

March 9, 1945

PLATOON SERGEANT JOSEPH R. JULIAN
UNITED STATES MARINE CORPS

 FOR CONSPICUOUS GALLANTRY and intrepidity at the risk of his life above and beyond the call of duty as a platoon sergeant serving with First Battalion, Twenty-seventh Marines, Fifth Marine Division, in action against Japanese forces during the seizure of Iwo Jima in the Volcano Islands, on 9 March 1945. Determined to force a breakthrough when Japanese troops occupying trenches and fortified positions on the left front laid down a terrific machine gun and mortar barrage in a desperate effort to halt his company's advance, Platoon Sergeant Julian quickly established his platoon's guns in strategic supporting positions and then, acting on his own initiative, fearlessly moved forward to execute a one-man assault on the nearest pillbox. Advancing alone, he hurled deadly demolitions and white phosphorus grenades into the emplacement, killing two of the enemy and driving the remaining five out into the adjoining trench system. Seizing a discarded, rifle, he jumped into the trench and dispatched the five before they could make an escape. Intent on wiping out all resistance, he obtained more explosives and, accompanied by another Marine, again charged the hostile fortifications and knocked out two more cave positions. Immediately thereafter, he launched a bazooka attack unassisted, firing four rounds into the one remaining pillbox and completely destroying it before he fell, mortally wounded by a vicious burst of enemy fire. Stouthearted and indomitable, Platoon Sergeant Julian consistently disregarded all personal danger and, by his bold decision, daring tactics, and relentless fighting spirit during a critical phase of the battle, contributed materially to the continued advance of his company and to the success of his division's operations in the sustained drive toward the conquest of this fiercely defended outpost of the Japanese Empire. His outstanding valor and unfaltering spirit of self-sacrifice throughout the bitter conflict sustained and enhanced the highest traditions of the United States Naval Service. He gallantly gave his life for his country.

Harry S. Truman
PRESIDENT OF THE UNITED STATES

PRIVATE FIRST CLASS JAMES D. LA BELLE
UNITED STATES MARINE CORPS RESERVE

FOR CONSPICUOUS GALLANTRY and intrepidity at the risk of his life above and beyond the call of duty while serving with the Weapons Company, Twenty-seventh Marines, Fifth Marine Division, in action against enemy Japanese forces during the seizure of Iwo Jima in the Volcano Islands, on March 8, 1945. Filling a gap in the front lines during a critical phase of the battle, Private First Class La Belle had dug into a foxhole with two other Marines and grimly aware of the enemy's persistent attempts to blast a way through our lines with hand grenades, applied himself with steady concentration to maintaining a sharply vigilant watch during the hazardous night hours. Suddenly, a hostile grenade landed beyond reach in the foxhole. Quickly estimating the situation, he determined to save the others if possible, shouted a warning, and instantly dived on the missile, absorbing the exploding charge in his own body and thereby protecting his comrades from serious injury. Stouthearted and indomitable, he had unhesitatingly relinquished his own chance of survival that his fellow Marines might carry on the relentless fight against a fanatical enemy, and his dauntless courage, cool decision, and valiant spirit of self-sacrifice in the face of certain death reflect the highest credit upon Private First Class La Belle and the United States Naval Service. He gallantly gave his life in the service of his country.

Harry S. Truman
PRESIDENT OF THE UNITED STATES

SECOND LIEUTENANT JOHN H. LEIMS
UNITED STATES MARINE CORPS RESERVES

FOR CONSPICUOUS GALLANTRY and intrepidity at the risk of his life above and beyond the call of duty as Commanding Officer of Company B, First Battalion, Ninth Marines, Third Marine Division, in action against enemy Japanese forces on Iwo Jima in the Volcano Islands, on 7 March 1945. Launching a surprise attack against the rock-embedded fortifications of a dominating Japanese hill position, Second Lieutenant Leims spurred his company forward with indomitable determination and, skillfully directing his assault platoons against the cave-emplaced enemy troops and heavily fortified pillboxes, succeeded in capturing the objective in the late afternoon. When it became apparent that his assault platoons were cut off in this newly won position, approximately four hundred yards forward of adjacent units and lack all communication with the command post, he personally advanced and laid telephone lines across an isolated expanse of open, fire-swept terrain. Ordered to withdraw his command after he joined his forward platoons, he immediately complied, adroitly effecting the withdrawal of his troops without incident. Upon arriving at the rear, he was informed that several casualties had been left at the abandoned ridge position beyond the front lines. Although suffering acutely from strain and exhaustion of battle, he instantly went forward despite darkness and the slashing fury of hostile machine gun fire, located and carried to safety one seriously wounded Marine and then, running the gauntlet of enemy fire for the third time that night, again made his tortuous way into the bullet-riddled death trap and evacuated another of his wounded men. A dauntless leader, concerned at all times for the welfare of his men, Second Lieutenant Leims soundly maintained the coordinated strength of his battle-wearied company under extremely difficult conditions and, by his bold tactics, sustained aggressiveness and heroic disregard of all personal danger, contributed essentially to the success of his division's operations against this vital Japanese base. His valiant conduct in the face of fanatic opposition sustained and enhanced the highest traditions of the United States Marine Corps.

Harry S. Truman
PRESIDENT OF THE UNITED STATES

PRIVATE FIRST CLASS JACKLYN H. LUCAS
UNITED STATES MARINE CORPS

FOR CONSPICUOUS GALLANTRY and intrepidity at the risk of his life above and beyond the call of duty while serving with the First Battalion, Twenty-Sixth Marines, Fifth Division, during action against enemy Japanese forces on Iwo Jima, Volcano Island, on 20 February 1945. While creeping through a treacherous, twisting ravine that ran in close proximity to a fluid and uncertain front line on D-Day plus 1, Private First Class Lucas and three other Marines were suddenly ambushed by a hostile patrol that savagely attacked with rifle fire and grenades. Quick to act when the lives of the small group were endangered by two grenades that landed directly in front of them, Private First Class Lucas unhesitatingly hurled himself over his comrades upon one grenade and pulled the other one under him, absorbing the whole blasting force of the explosions in his own body in order to shield his companions from the concussion and murderous flying fragments. By his inspiring action and valiant spirit of self-sacrifice, he not only protected his comrades from certain injury or possible death, but also enabled them to rout the Japanese patrol and continue the advance. His exceptionally courageous initiative and loyalty reflect the highest credit upon Private First Class Lucas and the United States Naval Service.

Harry S. Truman
PRESIDENT OF THE UNITED STATES

March 8, 1945

FIRST LIEUTENANT JACK LUMMUS
UNITED STATES MARINE CORPS RESERVE

FOR CONSPICUOUS GALLANTRY and intrepidity at the risk of his life above and beyond the call of duty as Leader of a Rifle Platoon, attached to Company E, Second Battalion, Twenty-seventh Marines, Fifth Marine Division, in action against enemy Japanese forces on Iwo JIma in the Volcano Islands, 8 March 1945. Resuming his assault tactics with bold decision after fighting without a respite for two days and nights, First Lieutenant Lummus slowly advanced his platoon against an enemy deeply entrenched in a network of mutually supporting positions. Suddenly halted by a terrific concentration of hostile fire, he unhesitatingly moved forward of his front lines in an effort to neutralize the Japanese position. Although knocked to the ground when an enemy grenade exploded close by, he immediately recovered himself and, again moving forward despite the intensified barrage, quickly located attacked and destroyed the occupied emplacement. Instantly taken under fire by the garrison of a supporting pillbox and further assailed by the slashing fury of hostile rifle fire, he fell under the impact of a second enemy grenade, but courageously disregarding painful shoulder wounds, staunchly continued his heroic one-man assault and charged the second pillbox annihilating all the occupants. Subsequently returning to his platoon position, he fearlessly traversed his lines under fire, encouraging his men to advance and directing the fire of supporting tanks against other stubbornly holding Japanese emplacements. Held up again by a devastating barrage, he again moved into the open, rushed a third heavily fortified installation and killed the defending enemy. Determined to crush all resistance he led his en men indomitably, personally, attacking foxholes and spider-traps with his carbine and systematically reducing the fanatic opposition until, stepping on a land mine, he sustained fatal wounds. By his outstanding valor, skilled tactics and tenacious perseverance in the face of overwhelming odds, First Lieutenant Lummus had inspired his stouthearted Marines to continue the relentless drive northward, thereby contributing materially to the success of his company's mission. His dauntless leadership and unwavering devotion to duty throughout enhanced and sustained the highest traditions of the United States Naval Service. He gallantly gave his life in the service of his country.

Harry S. Truman
PRESIDENT OF THE UNITED STATES

March 26, 1945

First Lieutenant Harry L. Martin
United States Marine Corps Reserve

FOR CONSPICUOUS GALLANTRY and intrepidity at the risk of his life above and beyond the call of duty as Platoon Leader attached to Company C, Fifth Pioneer Battalion, Fifth Marine Division, in action against enemy Japanese forces on Iwo Jima, Volcano Islands, on 26 March 1945. With his sector of the Fifth Pioneer Battalion bivouac area penetrated by a concentrated enemy attack launched a few minutes before dawn, First Lieutenant Martin instantly organized a firing line with the Marines nearest his foxhole and succeeded in checking, momentarily, the headlong rush of the Japanese. Determined to rescue several of his men trapped in positions overrun by the enemy, he defied intense hostile fire to work his way through the Japanese to the surrounded Marines. Although sustaining two severe wounds, he blasted the Japanese who attempted to intercept him, located his beleaguered men, and directed them to their own lines. When four of the infiltrating enemy took possession of an abandoned machine gun pit and subjected his sector to a barrage of hand grenades, First Lieutenant Martin alone and armed only with a pistol, boldly charged the hostile position and killed all its occupants. Realizing that his remaining comrades could not repulse another organized attack, he called this men to follow and then charged into the midst of the strong enemy force, firing his weapon and scattering them until he fell, mortally wounded by a grenade. By his outstanding valor, indomitable fighting spirit, and tenacious determination in the face of overwhelming odds, First Lieutenant Martin permanently disrupted a coordinated Japanese attack and prevented a greater loss of life in his own and adjacent platoons, and his inspiring leadership and unswerving devotion to duty reflect the highest credit upon himself and the United States Naval Service. He gallantly gave his life in then service of his country.

Harry S. Truman
PRESIDENT OF THE UNITED STATES

February 21, 1945

CAPTAIN JOSEPH J. McCARTHY
UNITED STATES MARINE CORPS RESERVE

FOR CONSPICUOUS GALLANTRY and intrepidity at the risk of his life above and beyond the call of duty as Commanding Officer of Company G, Second Battalion, Twenty-Fourth Marines, Fourth Marine Division, in action against enemy Japanese forces during the seizure of Iwo Jima, Volcano Island, on 21 February 1945. Determined to break through the enemy's cross-island defenses, Captain McCarthy acted on his own initiative when his company advance was held up by uninterrupted Japanese rifle, machine gun, and high-velocity 47mm fire during the approach to Motoyama Airfield Number Two. Quickly organizing a demolitions and flamethrower team to accompany his picked rifle squad, he fearlessly led the way across seventy-five yards of fire-swept ground, charged a heavily fortified pillbox on the ridge to the front and, personally hurling hand grenades into the emplacement as he directed the combined operations of his small assault group, completely destroyed the hostile installation. Spotting two Japanese soldiers attempting an escape from the shattered pillbox, he boldly stood upright in full view of the enemy and dispatched both troops before advancing to a second emplacement under greatly intensified fire and blasted the strong fortification with a well-planned demolitions attack. Subsequently entering the ruins, he found a Japanese taking aim at one of his men, and with alert presence of mind jumped the enemy, disarmed, and shot him with his own weapon. Then intent on smashing through the narrow breach, he rallied the remainder of his company and pressed a full attack with furious aggressiveness until he had neutralized all resistance and captured the ridge. An inspiring leader and indomitable fighter, Captain McCarthy consistently disregarded all personal danger during the fierce conflict, and by his brilliant professional skill, daring tactics, and tenacious perseverance in the face of overwhelming odds, contributed materially to the success of his division's operations against this savagely defended outpost of the Japanese Empire. His cool decision and outstanding valor reflect the highest credit upon Captain McCarthy and enhance the finest traditions of the Untied States Naval Service.

Harry S. Truman
PRESIDENT OF THE UNITED STATES

PRIVATE GEORGE PHILLIPS
UNITED STATES MARINE CORPS RESERVE

FOR CONSPICUOUS GALLANTRY and intrepidity at the risk of his life above and beyond the call of duty while serving with Second Battalion, Twenty-Eight Marines, Fiftieth Marine Division, in action against enemy Japanese forces during the seizure of Iwo Jima in the Volcano Islands, on 14 March 1945. Standing the foxhole watch while other members of his squad rested after a night of bitter hand-grenade fighting against infiltrating Japanese troops, Private Phillips was the only member of his unit alerted when an enemy hand grenade was tossed into their midst. Instantly shouting a warning, he unhesitatingly threw himself on the deadly missile, absorbing the shattering violence of the exploding charge in his own body and protecting his comrades from serious injury. Stouthearted and indomitable, Private Philips willingly yielded his own life that his fellow Marines might carry on the relentless battle against a fanatic enemy, and his superb valor and unfaltering spirit of self-sacrifice in the face of certain death reflect the highest credit upon himself and upon the United States Naval Service. He gallantly gave his life for his country.

Harry S. Truman
PRESIDENT OF THE UNITED STATES

PHARMACIST'S MATE FIRST CLASS FRANCIS J. PIERCE
UNITED STATES NAVY

FOR CONSPICUOUS GALLANTRY and intrepidity at the risk of his life above and beyond the call of duty while attached to the Second Battalion, Twenty-Four Marines, Fourth Marine Division, during the Iwo Jima campaign, on 15 and 16 March 1945. Almost continuously under fire while carrying out the most dangerous volunteer assignment, Petty Officer Pierce gained valuable knowledge of the terrain and disposition of troops. Caught in heavy enemy rifle and machine gun fire that wounded a corpsman and two of the eight stretcher bearers who were carrying two wounded Marines to a forward aid station on 15 March, Petty Officer Pierce quickly took charge of the party, carried the newly wounded men to a sheltered position, and rendered first aid.

After directing the evacuation of three of the casualties, he stood in the open to draw the enemy's fire and, with his weapon blasting, enabled the litter bearers to reach cover. Turning his attention to the other casualties, he was attempting to stop the profuse bleeding of one man when a Japanese fired from a cave less than twenty yards away and wounded his patient again. Risking his own life to save his patient, Petty Officer Pierce deliberately exposed himself to draw the attacker from the cave and destroyed him with the last of his ammunition. Then, lifting the wounded man to his back, he advanced unarmed through deadly rifle fire across two hundred feet of open terrain. Despite exhaustion and in the face of warnings against such a suicidal mission, he again traversed the same fire-swept path to rescue the remaining Marine. On the following morning, he led a combat patrol to the snipers nest and, while aiding a stricken Marine, was seriously wounded. Refusing aid for himself, he directed treatment for the casualty, at the same time maintaining protective fire for his comrades. Completely fearless and devoted to the care of his patients, Petty Officer Pierce inspired the entire battalion. His valor in the face of extreme peril sustains the finest traditions of the United States Naval Service.

Harry S. Truman
PRESIDENT OF THE UNITED STATES

PRIVATE FIRST CLASS DONALD J. RUHL
UNITED STATES MARINE CORPS

FOR CONSPICUOUS GALLANTRY and intrepidity at the risk of his life above and beyond the call of duty while serving as a Rifleman in an Assault Platoon of Company E, Twenty-Eight Marines, Fifth Marine Division, in action against enemy Japanese Forces on Iwo Jima, Volcano Islands, from 19 to 21 February 1945. Quick to press the advantage after eight Japanese had been driven from a blockhouse on D-Day, Private First Class Ruhl single-handedly attacked the group, killing one of the enemy with his bayonet and another by rifle fire in his determined attempt to annihilate the escaping troops. Cool and undaunted as the fury of the hostile resistance steadily increased throughout the night, he voluntarily left the shelter of his tank trap early in the morning of D-Day plus 1 and moved out under a tremendous volume of mortar and machine gun fire to rescue a wounded Marine lying in an exposed position approximately forty yards forward of the line. Half pulling and half carrying the wounded man, he removed him to a defoliated position, called for an assistant and a stretcher and, again running the gauntlet of hostile fire, carried the casualty to an aid station some three hundred yards distant on the beach. Returning to his platoon, he continued his valiant efforts, volunteering to investigate an apparently abandoned Japanese gun emplacement seventy-five yards forward of the flank during consolidation of the front lines, and subsequently occupying the position through the night to prevent the enemy from repossessing the valuable weapon. Pushing forward in the assault against the vast network of fortifications surrounding Mt. Suribachi the following morning, he crawled with his platoon guide to the top of a Japanese bunker to bring fire to bear on enemy troops located on the far side of the bunker, when suddenly a hostile grenade landed between the two Marines. Instantly, Private First Class Ruhl called a warning to his fellow Marine and dived on the deadly missile, absorbing the full impact of the shattering explosion in his own body and protecting all within range from danger of flying fragments, although he might easily have dropped from his position on the edge of the bunker to the ground below. An indomitable fighter, Private First Class Ruhl rendered heroic service toward the defeat of a ruthless enemy, and his valor, initiative, and unfaltering spirit of self-sacrifice in the face of almost certain death sustained and enhanced the highest traditions of the United States Naval Service. He gallantly gave his life for his country.

Harry S. Truman
PRESIDENT OF THE UNITED STATES

PRIVATE FRANKLIN E. SIGLER
UNITED STATES MARINE CORPS RESERVE

FOR CONSPICUOUS GALLANTRY and intrepidity at the risk of his life above and beyond the call of duty while serving with the Second Battalion, Twenty-Sixth Marines, Fifth Marine Division, in action against enemy Japanese forces during the seizure of Iwo Jima in the Volcano Islands, on 14 March 1945. Voluntarily taking command of his rifle squad when the leader became a casualty, Private Sigler fearlessly led a bold charge against an enemy gun installation that had held up the advance of his company for several days and, reaching the position in advance of the others, assailed the emplacement with hand grenades and personally annihilated the entire crew. As additional Japanese troops opened fire from concealed tunnels and caves above, he quickly scaled the rocks leading to the attacking guns, surprised the enemy with a furious one-man assault and, although severely wounded in the encounter, deliberately crawled back to his squad position where he steadfastly refused evacuation, persistently directing heavy-gun and rocket barrages on the Japanese cave entrances. Undaunted by the merciless rain of hostile fire during the intensified action, he gallantly disregarded his known painful wounds to aid casualties, carrying three wounded squad members to safety behind the lines and returning to continue the battle with renewed determination until ordered to retire for medical treatment. Stouthearted and indomitable in the face of extreme peril, Private Sigler, by his alert initiative, unfaltering leadership, and daring tactics in a critical situation, effected the release of his besieged company from enemy fire and contributed essentially to its further advance against a savagely fighting enemy, His superb valor, resolute fortitude, and heroic spirit of self-sacrifice throughout reflect the highest credit upon Private Sigler and the United States Naval Service.

Harry S. Truman
PRESIDENT OF THE UNITED STATES

CPL. TONY STEIN
UNITED STATES MARINE CORPS RESERVE

FOR CONSPICUOUS GALLANTRY and intrepidity at the risk of his life above and beyond the call of duty while serving with Company A, First Battalion, Twenty-Eighth Marines, Fifth Marine Division, in action against enemy Japanese forces on Iwo Jima, in the Volcano Island on 19 February 1945. The first man of his unit to be on station after hitting the beach in the initial assault, Corporal Stein, armed with a personally improvised aircraft-type weapon, provided rapid covering fire as the remainder of his platoon attempted to move into position and, when his comrades were stalled by a concentrated machine gun and mortar barrage, gallantly stood upright and exposed himself to the enemy's view, thereby drawing the hostile fire to his own person and enabling him to observe the location of the furiously blazing hostile guns. Determined to neutralize the strategically placed weapons, he boldly charged the enemy pillboxes one by one and succeeded in killing twenty of the enemy during the furious single-handed assault. Cool and courageous under the merciless hail of exploding shells and bullets that fell on all sides, he continued to deliver the fire of his skillfully improvised weapon at a tremendous rate of speed that rapidly exhausted his ammunition. Undaunted, he removed his helmet and shoes to expedite his movements and ran back to the beach for additional ammunition, making a total of eight trips under intense fire and carrying or assisting a wounded man back each time. Despite the unrelenting savagery and confusion of battle, he rendered prompt assistance to his platoon whenever the unit was in position, directing the fire of a half-track against a stubborn pillbox until he had effected the ultimate destruction of the Japanese fortification, Later in the day, although his weapon was twice shot from his hands, he personally covered the withdrawal of his platoon to the company position. Stouthearted and indomitable, Corporal Stein, by his aggressive initiative, sound judgment, and unwavering devotion to duty in the face of terrific odds, contributed materially to the fulfillment of his mission, and his outstanding valor throughout the bitter hours of conflict sustained and enhanced the highest traditions of the United States Naval Service.

Harry S. Truman
PRESIDENT OF THE UNITED STATES

PHARMACIST'S MATE SECOND CLASS GEORGE E. WAHLEN
UNITED STATES NAVY

FOR CONSPICUOUS GALLANTRY and intrepidity at the risk of his life above and beyond the call of duty while serving with the Second Battalion, Twenty-Sixth Marines, Fifth Marine Division, during action against enemy Japanese forces on Iwo Jima in the Volcano Group, on 3 March 1945. Painfully wounded in the bitter action on 26 February, Wahlen remained on the battlefield, advancing well forward of the front lines to aid a wounded Marine and carrying him back to safety despite a terrific concentration of fire. Tireless in his ministrations, he consistently disregarded all danger to attend his fighting comrades as they fell under the devastating rain of shrapnel and bullets, and rendered prompt assistance to various elements of his combat group as required. When an adjacent platoon suffered heavy casualties, he defied the continuous pounding of heavy mortars and deadly fire of enemy rifles to care for the wounded, working rapidly in an area swept by constant fire and treating fourteen casualties before returning to his own platoon. Wounded again on 2 March, he gallantly refused evacuation, moving out with his company the following day in a furious assault across six hundred yards of open terrain, repeatedly rendering medical aid while exposed to the blasting fury of powerful Japanese guns. Stouthearted and indomitable, he persevered in his determined efforts as his unit waged fierce battle and, unable to walk after sustaining a third agonizing wound, resolutely crawled fifty yards to administer first aid to still another fallen fighter. By his dauntless fortitude and valor, Wahlen served as a constant inspiration and contributed vitally to the high morale of his company during critical phases of this strategically important engagement. His heroic spirit of self-sacrifice in the face of overwhelming enemy fire upheld the highest traditions of the United States Naval Service.

Harry S. Truman
PRESIDENT OF THE UNITED STATES

February 27, 1945

SGT. WILLIAM G. WALSH
UNITED STATES MARINE CORPS

FOR CONSPICUOUS GALLANTRY and intrepidity at the risk of his life above and beyond the call of duty as leader of an assault platoon, attached to Company G, Third Battalion, Twenty-Seventh Marines, Fifth Marine Division, in action against enemy Japanese forces at Iwo Jima, Volcano Islands, on 27 February 1945. With the advance of his company toward Hill 362 disrupted by vicious machine gun fire from a forward position that guarded the approaches to this key enemy stronghold, Sergeant Walsh fearlessly charged at the head of his platoon against the Japanese entrenched on the ridge above him, utterly oblivious to the unrelenting fury of hostile automatic weapons fire and hand grenades employed with fanatic desperation to smash his daring assault. Thrown back by the enemy's savage resistance, he once again led his men in a seemingly impossible attack up the steep, rocky slope, boldly defiant of the annihilating streams of bullets that saturated the area. Despite his own casualty losses and the overwhelming advantage held by the Japanese in superior numbers and dominant position, he gained the ridge's top only to be subjected to an intense barrage of hand grenades thrown by the remaining Japanese staging a suicidal last stand on the reverse slope. When one of the grenades fell in the midst of his surviving men, huddled together in a small trench, Sergeant Walsh, in a final valiant act of complete self-sacrifice instantly threw himself upon the deadly bomb, absorbing with his own body the full and terrific force of the explosion. Through his extraordinary initiative and inspiring valor in the face of almost certain death, he saved his comrades from injury and possible loss of life and enabled his company to seize and hold this vital enemy position. He gallantly gave his life for country.

Harry S. Truman
PRESIDENT OF THE UNITED STATES

February 26 and 27, 1945

PRIVATE WILSON D. WATSON
UNITED STATES MARINE CORPS RESERVE

FOR CONSPICUOUS GALLANTRY and intrepidity at the risk of his life above and beyond the call of duty as Automatic Rifleman serving with the Second Battalion, Ninth Marines, Third Marine Division, during action against enemy Japanese forces on Iwo Jima, Volcano Islands, 26 and 27 February 1945. With his squad abruptly halted by intense fire from the enemy fortifications in the high rocky ridges and crags commanding the line of advance, Private Watson boldly rushed one pillbox and fired into the embrasure with his weapon, keeping the enemy pinned down single-handedly until he was in a position to hurl in a grenade and running to the r ear of the emplacement to destroy the retreating Japanese and enable his platoon to take its objective. Again pinned down at the foot of a small hill, he dauntlessly scaled the jagged incline under fierce mortar and machine-gun barrages and with his assistant automatic rifleman charged the crest of the hill, firing from the hip. Fighting furiously against Japanese troops attacking with grenades and knee-mortars from the reverse slope, he stood fearlessly erect in his exposed position to cover the hostile entrenchments and held the hill under savage fire for fifteen minutes, killing sixty Japanese before his ammunition was exhausted and his platoon was able to join him. His courageous initiative and valiant fighting spirit against devastating odds were directly responsible for the continued advance of his platoon and his inspiring leadership throughout this bitterly fought action reflects the highest credit upon Private Watson and the United States Naval Service.

Harry S. Truman
PRESIDENT OF THE UNITED STATES

CORPORAL HERSHEL W. WILLIAMS
UNITED STATES MARINE CORPS

FOR CONSPICUOUS GALLANTRY and intrepidity at the risk of his life above and beyond the call of duty as Demolition Sergeant serving with the First Battalion, Twenty-First Marines, Third Marine Division, in action against Japanese forces on Iwo Jima, Volcano Islands on 23 February 1945. Quick to volunteer his services when our tanks were maneuvering vainly to open a lane for the infantry though the network of reinforced concrete pillboxes, buried mines, and black, volcanic sands, Corporal Williams daringly went forward alone to attempt the reduction of devastating machine-gun fire from the unyielding positions. Covered only by four riflemen, he fought desperately for four hours under terrific enemy small arms fire and repeatedly returned to his own lines to prepare demolition charges and obtain serviced flamethrowers, struggling back, frequently to the rear of hostile emplacements, to wipe out one position after another. On one occasion he daringly mounted a pillbox to insert the nozzle of his flamethrower through the air vent, kill the occupants, and silence the guns; on another, he grimly charged enemy riflemen who attempted to stop him with bayonets and destroyed them with a burst of flame from his weapon. His unyielding determination and extraordinary heroism in the face of ruthless enemy resistance were directly instrumental in neutralizing one of the most fanatically defended Japanese strong points encountered by his regiment, and aided in enabling his company to reach its objective. Corporal Williams aggressive fighting spirit and valiant devotion to duty throughout this fiercely contested action sustain and enhanced the highest traditions of the United States Naval Service.

Harry S. Truman
PRESIDENT OF THE UNITED STATES

March 3, 1945

Pharmacist's Mate Third Class Jack Williams
United States Naval Reserve

FOR CONSPICUOUS GALLANTRY and intrepidity at the risk of his life above and beyond the call of duty while serving with the Third Battalion, Twenty-Eighth Marines, Fifth Marine Division during the occupation of Iwo Jima, Volcano Islands, on 3 March 1945. Gallantly going forward on the front lines under intense enemy smallarms fire to assist a Marine wounded in a fierce grenade battle, Petty Officer Williams dragged the man to a shallow depression and was kneeling, using his own body as a screen from the sustained fire as he administered first aid when struck in the abdomen and groin three times by hostile rifle fire. Momentarily stunned, he quickly recovered and completed his ministrations before applying battle dressings to his own multiple wounds. Unmindful of his own urgent need for medical attention, Petty Office Williams remained in the perilous fire-swept area to care for another Marine casualty. Heroically completing his task despite pain and profuse bleeding, he then endeavored to make his way to the rear in search of adequate aid for himself when struck down by a Japanese sniper bullet that caused his collapse, succumbing later as a result of his self-sacrificing service to others. By his courageous determination, unwavering fortitude, and valiant devotion to duty, Petty Office Williams served as an inspiring example of heroism: thereby reflecting great credit upon himself and upholding the highest traditions of the United States Naval Service. He gallantly gave his life for his country.

Harry S. Truman
PRESIDENT OF THE UNITED STATES

PHARMACIST'S MATE FIRST CLASS JOHN H. WILLIS
UNITED STATES NAVY

FOR CONSPICUOUS GALLANTRY and intrepidity at the risk of his life above and beyond the call of duty as Platoon Corpsman serving with the Third Battalion, Twenty-Seventh Marines, Fifth Marine Division, during operations against enemy Japanese forces on Iwo Jima, Volcano Island, on 28 February 1945. Constantly imperiled by artillery and mortar fire from strong and mutually supporting pillboxes and caves studding Hill 362 in the enemy's cross-island defenses, Petty Officer Willis resolutely administered first aid to the many Marines wounded during the furious close-in fighting until he himself was struck by shrapnel and was ordered back to the battle aid station. Without waiting for official medical release, he quickly returned to his company and, during a savage hand-to-hand enemy counterattack, daringly advanced to the extreme front lines under mortar and sniper fire to aid a Marine lying wounded in a shell hole. Completely unmindful of his own danger as the Japanese intensified their attack, Petty Officer Willis calmly continued to administer blood plasma to his patient, promptly returning the first hostile grenade that landed in the shell hole while he was working and hurling back seven more in quick succession before the ninth one exploded in his hand and instantly killed him. Through his great personal valor in saving others at the sacrifice of his own life, he inspired his companions, although terrifically outnumbered, to launch a fiercely determined attack and repulse the enemy force. By his exceptional fortitude, remarkable courage, and inspiring dedication to duty, Petty Officer Wilis reflected great credit upon himself and upheld the highest traditions of the United States Naval Service. He gallantly gave his life for his country.

Harry S. Truman
PRESIDENT OF THE UNITED STATES

INDEX

Airfield no. 1
 B-29 lands safely on, 161–62
 as first objective, 93
 fortifications near, 75
 Marines approaching, 74
 Marines battle enemy at, 84
 Marines occupying, 102
 Marines pray near, 137
 U.S. aircraft using, 187
Albee, Parker Bishop Jr., 203
The American docudrama, 202
American flag
 exchanging, 107
 Iwo Jima with, 182, 187
 Iwo Jima's first, 101, 104, 155, 156
 Marines battle under, 114, 115
 Marines raising first, 100, 109
 Marines steadying, 107
 Mt. Suribachi with, 5, 6, 101, 113
 proudest moment raising, 101
Americans
 flag raising photograph influencing, 158, 204
 Iwo Jima battle mentality for, 56
 Iwo Jima needed by, 8
 Iwo Jima stormed by, 175
 photograph symbolizing ideals of, 5, 204

two lines held by, 72–73
The Amphitheater, 160
Anderson, Jack, 203
Anti-aircraft fire, 145
Army units, 220
Artillery spotter, 90
Associated Press
 defense coverage by, 15
 photographer's pool including, 17–18, 128
 Rosenthal photographer for, 11

B-29 bomber, 161, 162, 177
Banzai charges, 35
 Marines attacked by, 78
 Marines decimating, 46
Barges, 132, 133
Bas relief carving, 207
Battlefield
 illuminating shells fired over, 72
 map of, 154
 medical teams on, 58
 weather bad on, 74
Battles
 Airfield no.1, 84
 Japanese mentality toward, 32, 56
 Japanese troops and, 93
 Marines returning to, 114, 115

mosaic of, 6
pillbox's separate, 74
Beaches
 blockhouse view of, 35
 death violent on, 54–56
 heavy equipment disabled by, 88
 invasion progress slowed by, 59
 Iwo Jima's volcanic sand, 23, 51
 landing craft invading, 51, 52
 Marines dig in, 53
 Marines invading, 54, 55, 60, 61, 62
 Marines slain on, 157
 Marines under fire on, 63, 64, 67
 Rosenthal revisits, 206
 ruined vehicles littering, 56, 57, 86
 supplies hand carried on, 79
 vehicle wreckage on, 92
Beech, Keyes, 186
Berry, Charles J., 252
Bismarck Sea, 34, 75–78
Block, Harlon, 104, 105
 enemy fire killing, 166
 as flag raiser, 165
Blockhouse
 beach view from, 35
 Marine guarding, 150, 151
 Navy shells destroying, 136

Turkey Knob Hill with, 160
U.S. forces blasting, *131*
Bodkin, Jack, 130, 190
Boyle, James, 152
Bradley, John, *105,* 164, *194*
 ceremonies attended by, *199*
 death of, 221–22
 as flag raiser, 165
 leg injury for, 166
Burmeister, Louis, 111
Burnes, George, 111
Bush, George H.W., *208*

Caddy, William R., 251
Cagney, James, *211*
Cameras, 11, 220
Campbell, Bob, *103,* 104, 111,
 184
Catholic Mass, *116*
Caves
 Japanese soldiers emerging
 from, *37*
 Marines dynamiting, *167*
 Marines investigating, *158*
Censorship, 128
Ceremony, *198, 199*
Chambers, Justice M., 250
Charlo, Louis, 99, 100
Christian, David, *151*
Cialfi, Alfred, 214
Civilian companies, 128
Clinton, Bill, *209*
Cole, Darrell S., 249
Collier's magazine, 186
Command ship, 96
Communications equipment, *82*
Company E, 166
Cook, William, 3
Corn field, *212*
Curtis, Tony, *201*

da Vinci, Leonardo, 159
Dabrowski, Stanley E., 176
D'Amico, Albert, 70
Dart, Willard, *122*
D-Day
 bombing begins on, 42
 Iwo Jima and, 44
 Marines on, 30, 47, *60*
 surviving, 53–54
Defense systems
 Japanese with, 43
 Kuribayashi with, 46–47
Delaplane, Stan, 15

de Weldon, Felix
 monument begun by, 132
 monument sculpted by, *196,
 197*
 monument unveiled by, 195
Dixon, Donald, 176, 177
Doctor, 69
Dunlap, Robert H., 248

Eisenhower, Dwight, 199–200,
 222
Eldorado, 112, 129
 as command ship, 96
 Rosenthal embarking from,
 102
Enemy fire, 7, 166
Engstrom, Rudolph E., 85
Erskine, Graves B., 152
Essex, 20
Explosions, 52

Faron, Hamilton, 112
Filan, Frank, 18, 44, 46
Flag. *See* American flag
Flag raisers
 Block, Harlon, as, 165
 Bradley, John, as, 165
 ceremonies attended by, *199*
 de Weldon meeting with, *197*
 enemy fire killing, 7
 Gagnon, Rene, as, 165
 Hayes, Ira, as, 166
 minted dollar honoring, *222*
 movie scene for, 195
 roles of, 186
 Sands of Iwo Jima film for, *194*
 Sousely, Franklin, as, 166
 Strank, Michael, as, 165
 Washington DC flag raising by,
 210
Flag raisers photograph, *105,
 205*
Flag raising monument
 anniversary picture of, *215,
 216*
 Bush speaking at, *208*
 Clinton speaking at, *209*
 controversy about, 199–200
 dedication ceremonies for, *198*
 de Weldon beginning, 132
 de Weldon sculpting, *196, 197*
 de Weldon unveiling, 195
 Seventh War bond Drive with,
 190, *191*

Flag raising photograph
 American ideals symbolized by,
 5, 204
 American mind-set changed
 by, 158
 artistic qualities of, 159
 bas relief of, *207*
 celebrations for, 163
 controversy of, 183–84
 corn field cut into, *212*
 details of, 110–11
 front pages for, 132
 gymnasts recreating, *213*
 Hollywood's version of,
 193–94, 195
 journey of, 128–31
 Lowery first for, 182
 9/11 photo compared to, 217,
 218
 outlandish stories about, 184–86
 as posed photo, 165, 182–83
 postage stamp using, 188, *189*
 Rosenthal first sees, 181
 Rosenthal preparing, 106–7
 Rosenthal with, *205*
 Seventh War bond Drive using,
 163, *192*
 visual force of, 156
Flamethrowers
 Marines using, *91, 147, 161*
 tanks with, *160*
"Fog of war," 180
Forrestal, James, 96, *97,* 157
Fox hole, *135*
Frankenheimer, John, 202
Franklin, Tom, 217
Freeman, Keller Cushing, 203
Front lines, 174

Gagnon, Rene, 104, *105, 194*
 ceremonies attended by, *199*
 as flag raiser, 165
 stone presented by, *221*
Genaust, Bill, 104, *110*
 film sequence by, *108*
 Hill 382 and, *163*
 Japanese gunfire killing, 111,
 162, 166
 Tracy with, *164*
Gentile, George G., 93, 178
Graflex camera, 11
Grave marker, *143*
Gray, Ross F., 247
Grenade

Berry throwing himself on, 252

Caddy throwing himself on, 251

La Belle throwing himself on, 241

Lucas throwing himself on, 238

mortally wounded by, 237, 249

Phillips throwing himself on, 235

Ruhl throwing himself on, 233

Walsh throwing himself on, 229

Guam, *17*

film processed in, 129

Marines recapturing, 18

picture transmitter in, *130*

Rosenthal arriving in, 180

Gung Ho picture, *109, 110*

Hansen, Henry O., *100*

Harrell, William G., 246

Hatch, Norman, 104, 184

Hayes, Ira, 104, *105, 194*

attitude of, 202

ceremonies attended by, *199*

death of, 201

as flag raiser, 166

Heavy equipment, *88*

Heinz, W.C., 186

Hell's horror, 59

Herring, Rufus B., 245

Hill 362

Genaust killed on, *163*

Marines mounting summit or, 161

Hill, Stephen, 202

Hipple, Bill, 98, 102

Hjerpe, Carl W., 174

Hollywood, *193–94, 195*

Immortal Images (Thomey), 203

Islands

Iwo Jima and, 1, 22

Japanese defending, 25, 72

Nanpo Shoto as, 1

Iwo Jima

aerial view of, *21*

as aesthetically ugly, 39, 69

American battle mentality on, 56

American flag raised on, 101, *104, 155,* 156

Americans storm, 175

battle plan map for, *154*

beaches of, 23, 51

blockhouse view on, *35*

casualties on, 219

as costliest battle, 8

D-Day on, 44

death sentence on, 31

Eisenhower visiting, 222

hand-to-hand fighting on, 174

Japanese aircraft based on, 8

Japanese aircraft destroyed on, *24, 28*

as Japanese shrine, 221

Japanese soldiers hidden on, 30

Kuribayashi defending, *32*

landing craft heading for, *41, 48*

Liberator bomber flying over, *25*

Marine slain on, *66*

Marines buried on, 220–21

Marines dig in on, *53*

Marines hampered on, 175

Marines invading, 5, *54, 55, 61, 62,* 68

Marines under fire on, *63, 64, 65*

Mt. Suribachi descriptive feature of, 49

9/11 picture compared to, 217, *218*

as Pacific war center stage, 26

planes bombing, *73*

rocky terrain of, *141*

Rosenthal pictures of, *6–7*

Rosenthal revisiting, *206*

sense of evil from, 214

as Sulphur Island, 3

supplies handcarried on, *79*

twisted foliage on, *89*

U.S. aircraft lands on, 161–62

U.S. forces briefed about, 23

U.S. ships blasting, *36*

U.S. ships offshore of, *43, 44, 47*

victory far off for, 132

victory flag flying over, 182, 187

Volcano Islands with, 1, 22

Iwo Jima: Monuments, Memories and the American Hero (Marling, Wetenhall), 202–3

Jacobson, Douglas T., 243

Japan

Iwo Jima stepping stone to, 68

Nanpo Shoto claimed by, 3

Japanese

American aircraft drawn by, 34

battle mentality of, 32, 56

defense systems of, 43

island defense by, 25, 72

Iwo Jima shrine for, 221

livelihood of, 3

Japanese aircraft

anti-aircraft fire repelling, *145*

bombing of, *24*

Iwo Jima base for, 8

phosphorus bombs dropped by, *27*

smoke coming from, *28*

Japanese coastal defense, 245

Japanese defense systems, 43

Japanese emplacements

artillery spotting, *90*

Gray destroying, 247

Leims capturing, 239

Lummus attacking, 240

Marines occupying, *120, 121*

Marines searching for, *141*

mortar fire directed at, *144*

U.S. forces attacking, *139*

U.S. ships firing back at, 73

Williams, Hershal, neutralizing, 227

Japanese language, 31–32

Japanese memorials, 223

Japanese territory, 101

Japanese troops, *135*

battles bitter with, 93

causalities of, 219

death honorable for, 35

Dunlap relaying information about, 248

emerging from caves, *37*

flamethrowers effective against, *91, 147, 160, 161*

Genaust killed by, 111, 162, 166

Harrell attacking, 246

as hidden on Iwo Jima, 30

Jacobson annihilating, 243

Kuribayashi commanding, 30

Marines banzai attacked by, 78

Marines charged by, 78, 102

Marines helping, *29*

Marines seeking, 100

McCarthy neutralizing, 236

U.S. forces attacked by, 188
U.S. forces prevailing over, *172, 173*
U.S. forces questioning, *38*
Wahlen dauntless fortitude against, 228
Watson, Wilson, furiously fighting, 230
Johnson, Chandler, 99
Julian, Joseph R., 242

Kamikazes
 as any combatant, 34
 Keokuk hit by, 92
 U.S. ships attacked by, 75–78
Keokuk, 92
Kiely, Arthur J. Jr, 69
Kropf, Joseph H., 178
Kuribayashi, Tadamichi, 152
 construction project by, 35
 defense effectiveness of, 220
 defense system of, 46–47
 initial strategy by, 58–59
 instructions by, 32–33
 Iwo Jima defense by, *32*
 as Japanese troop commander, 30, *31*
 kamikaze spirit supported by, 34
 widow of, *221*

La Belle, James D., 241
Landing craft
 beaches invaded by, 51, *52*
 Marines in, *41, 48*
Leims, John H., 239
Liberator bomber. *See also* Planes, fighter; U.S. aircraft
 Iwo Jima flown over by, *25*
 runways bombed by, *26*
Life magazine, 183–84, 214
Lindberg, Charles, 100, 201
Liversedge, Harry B., 124
Lowery, Lou, 99, 129
 as first flag photographer, 182
 pictures lost in shuffle for, 181–82
 Rosenthal friends with, 223
Lucas, Jacklyn H., 238
Lummus, Jack, 240

MacArthur, Douglas, 19–20
Machine gunners l, 178
Marine memorial, *198, 208, 209*
Marines. *See* U.S. Marines

Marlin, Karal Ann, 202–3
Marquand, John P., 39, 69
Marshall, Gene, *100*
Martin, Harry L., 237
Marvin, Lee, 202
McCarthy, Joseph J., 236
The Meat Grinder, 159, 161
Medal of Honor, 7
 Berry, Charles J., for, 252
 Caddy, William R., for, 251
 Chambers, Justice M., for, 250
 Cole, Darrell S., for, 249
 Dunlap, Robert H., fo, 248
 Gray, Ross F., for, 247
 Harrell, William G., for, 246
 Herring, Rufus B., for, 245
 Jacobson, Douglas T., for, 243
 Julian, Joseph R., for, 242
 La Belle, James D., for, 241
 Leims, John H., for, 239
 Lucas, Jacklyn H., for, 238
 Lummus, Jack, for, 240
 Martin, Harry L., for, 237
 McCarthy, Joseph J., for, 236
 Phillips, George, for, 235
 Pierce, Francis J., for, 234
 Ruhl, Donald J., for, 233
 Sigler, Franklin E., for, 232
 Stein, Tony, for, 231
 Wahlen, George E., for, 228
 Walsh, William G., for, 229
 Watson, Wilson D., for, 230
 Williams, Hershal W., for, 227
 Williams, Jack, for, 244
 Willis, John H., for, 226
Medical teams, *58*
Mercer, George, 99
Merchant Marines, 15–16
Michels, James, *100*
Miller, Merle, 202
Mortar fire
 Japanese emplacements target for, *144*
 Japanese troops using, 57, 178
 Strank killed by, 166
Mt. Suribachi
 American flag on, 5, 6, 101, *113*
 causalities of, 219
 climbing decision made for, 96
 defensive action ideal from, 24–25
 as descriptive feature, 49
 flag exchange on, *107*

highest point on, 22–23
hot sulphur springs on, *171*
Japanese memorials on, 223
Marines bomb near, *83*
Marines capturing, 7, 124
Marines watching on, *117*
Rosenthal heading for, 103–4
Rosenthal stands on, *118*
strategic purpose of, 36
U.S. forces approaching, 75
U.S. forces patrolling, 99
U.S. forces using, *117*

Nanpo Shoto
 as group of islands, 1
 Japan claiming, 3
Navy fire fighters, 77
New York Times Square, 191
Newspaper Enterprise Association (NEA), 10
Newspapers, 132, 182
Nimitz, Chester W., 68, 124, 125, 175, 177
9/11, 217, *218*
Nixon, Richard, 200

O'Mahoney, Joseph, 158
Ouellette, Albert J., 39, 69, 70
The Outsider, 201–2

Pacific war
 Iwo Jima center stage of, 26
 Rosenthal headed for, 18
Parents, 9
Patton, George, *192*
Pearl Harbor, 14
Peleliu, 18–20
Perry, Mathew, 1
Philippines, 19–20
Phillips, George, 235
Phosphorus bombs, 27
Photographer(s). *See also* Christian, David; Filan, Frank; Lowery, Lou; Rosenthal, Joe
 arrival time for, 50–51
 competition between, 181
 Lowery first flag, 182
 Rosenthal as, 5
 wounded, *151*
 youngsters encouraged by, 10
Photographer's pool
 Associated Press with, 17–18, 128
 Rosenthal heading for, 112

wounded, *151*
youngsters encouraged by, 10
Photographer's pool
 Associated Press with, 17–18, 128
 Rosenthal heading for, 112
Photography
 camera systems for, 11
 substance required for, 53
Picture transmitter, *130*
Pierce, Francis J., 234
Pillboxes
 demolition of, *123*
 fortifications with, 75
 Julian attacking, 242
 as separate battles, 74
 Stein attacking, 231
 tanks attacking, *138*
Planes, fighter
 deck littered by, 77
 Iwo Jima bombed by, *73*
Post office, 190
Postage stamp, 188, *189*
Prayer, 45, *137*
Press camp, 126, *127*
Pringle, Jim, 220

The Quarry, 159

Rations, *171*
Riccio, Liberto G., 175
Rockey, Keller E., 177
Rosenthal, Joe
 as Associated Press photographer, 11
 bond drive promoted by, *211*
 camera exhibited for, 220
 congratulations sent to, 159
 Eldorado exited by, 102
 falling into water, 98
 first camera of, 9, 11
 first two pictures by, 51
 flag raising anniversary for, 215, *216*
 with flag raising photo, *205*
 flag raising photo by, *105*
 flag raising photo celebrations for, 163
 flag raising photo controversy for, 183–84
 flag raising photo details of, 110–11
 flag raising photo first seen by, 181

flag raising photo journey for, 128–31
flag raising photo preparation by, 106–7
flag raising with, *104*
Graflex first camera for, 11
Guam press headquarters for, 180
Iwo Jima pictures by, 6–7
Iwo Jima revisited by, *206*
Lowery friends with, 223
luck of, 203–4
Marines/flag photographed by, *109*
as Merchant Marine, 15–16
mortar fire encountered by, 57
Mt. Suribachi reached by, *103,* 104
Mt. Suribachi with, *118*
Pacific war destination for, 18
Peleliu assignment for, 19
pool headquarters headed for by, 112
poor eye sight of, 15
San Francisco moved to by, 10
slain Marines photographed by, *56*
stories about, photo, 184–86
Time apologizing to, 184
as war photographer, 5
Rosiers, Edwin P., 153
Ruhl, Donald J., 233
Runways, *26*
Ruskin, Julium A., 92

San Francisco, 10
Sands of Iwo Jima (film), *193*
 surviving flag raisers in, *194*
 Wayne starring in, 195
Schrier, Harold, 99, 100, *194*
Screaming demon, 178
Scripps Howard, 11
Secretary of Navy, 96–99, *97*
Seventh War bond Drive, 167
 Cagney, Tracey, Rosenthal promoting, *211*
 flag raising monument for, 190, *191*
 flag raising photo symbol for, 163, *192*
 monies raised by, 190
 start of, 186
Shadow of Suribachi (Albee, Freeman), 203

Sherrod, Robert, 223
Shibasaki, Keiji, 46
Ships. *See* U.S. ships
Sigler, Franklin E., 232
Smith, Holland, 96–99, *97*
Snowden, Lawrence, 153
Sousely, Franklin, 104, *105*
 enemy fire killing, 166
 as flag raiser, 166
The Spirit of '76, 159
Stein, Tony, 231
Strank, Michael
 flag raiser as, 165
 mortar fire killing, 166
Strank, Mike, 104, *105*
Strategy, 58–59
Sulphur Island, 3
Sulphur springs, 24, *171*
Supplies, *79, 80–81*
Sweers, George, 131, 132

Tanks, *160*
Tarawa, 46
Terrain, *141*
Third Marine Division, 177
Thomas, Ernest, 100, 125
Thomey, Tedd, 203
Tighe, Larry, 93
Time
 Rosenthal apologized to by, 184
 story broadcast by, 182–83
Time Views the News, 182, 184
Tokyo Rose, 39
Tracey, Spencer, *211*
Tracy, Atlee, *164*
Transportation, 128
Truman, Harry, 199–200
Tunnels, 35
Turkey Knob Hill
 assault on, 161
 blockhouse on, 160
 machine gunners killed on, 178

University of Maryland gymnasts, *213*
"Unsung Hero," 201
U.S. aircraft. *See also* Liberator bomber; Planes, fighter
 Airfield no. 1 used by, 187
 Iwo Jima landing, 161–62
 Japanese drawings of, 34
 Japanese troops attacked by, *33*

phosphorus bombs close to, *27*
U.S. forces
 blockhouse blasted by, *131*
 firepower of, 44
 Iwo Jima preparations by, *23*
 Japanese defense systems targets for, 43
 Japanese emplacements attacked by, *139*
 Japanese soldiers questioned by, *38*
 Japanese surrendering to, *172, 173*
 Japanese troops attacking, 188
 Mt. Suribachi approached by, 75
 Mt. Suribachi patrolled by, 99
 Mt. Suribachi used by, 117
 pillboxes demolished by, *123, 138*
 prayers by, 45
 sulphur springs assisting, *171*
 vehicles recued by, 87
U.S. Marine(s), *19*
 airfield approached by, 74
 Airfield no. 1 battle with, *84*
 Airfield no. 1 occupied by, *102*
 Banzai attack against, 78
 Banzai charges decimated by, 46
 barges carrying wounded, 132, *133*
 battle returned to by, *114, 115*
 beach invasion by, *54, 55, 59, 60, 61, 62*
 blockhouse guarded by, *150, 151*
 bombing by, *83*
 buried on island, 220–21
 cart pulled by, *65*
 Catholic Mass celebrated by, *116*
 caves dynamited by, *167*
 caves investigated by, *158*
 communications equipment carried by, *82*
 cover sought by, *136, 168, 170*
 on D-Day, 30, 47, *60*
 digging in, *53*
 direct hit on, 70
 enemy's defense pushed by, 152
 under fire, *63, 64, 67*
 first flag raised by, *100*
 flag prepared by, *101*

flag raising by, *109*
flag saluted by, *155,* 156
flag steadied by, *107*
flamethrowers used by, *91, 147, 161*
fox hole protecting, *135*
frontal assault by, *146*
grave marker for, *143*
Guam battle for, 17
Guam recaptured by, 18
gung ho picture of, *109, 110*
hell's horror reigned on, 59
Hill 382 mounted by, 161
humor, sense of, *49*
Iwo Jimo invaded by, 5, 68
Japanese emplacements sought by, *141*
Japanese opposition sought by, 100
Japanese sniper post occupied by, *120, 121*
with Japanese soldier, *29, 38*
Japanese soldiers charging, 78, 102
as kids going to battle, 50
in landing craft, *41, 48*
landing craft invasion by, 51, *52*
Mt. Suribachi captured by, *7,* 124
Mt. Suribachi watchtower for, *117*
Peleliu battled for by, 20
photograph conspiracy alleged against, 185
praying, *137*
protection for, 23
resting, *149*
slain, *56, 66, 86, 142, 148, 157*
terrain tough obstacle for, *141*
twisted foliage hindering, *89*
U.S. mint saluting, 223
volcanic ash hampering, 175
volcano cone reached by, 99
Willis administering aid to, 226
wounded carried by, *119, 134, 140,* 141, *169*
U.S. mint, *222,* 223
U.S. Navy
 blockhouse destroyed by, *136*
 kamikaze attacking, 75–78
 news report plane waiting by, *129*
 wounded soldier aided by, 18

U.S. ships
 illuminating shells fired by, *72*
 invasion preparations by, 42
 Iwo Jima invaded by, *43, 44,* 47
 Japanese emplacements attacked by, 73
 Kamikazes attacking, 75–78
 rockets fired by, *36*
 Rosenthal with, *118*
 sinking of, 16
USS *Cape Johnson,* 176
USS *Saratoga,* 34, 75, *76*

Vandegrift, Arthur, 184
Vehicles
 beaches littered with, 56, *57, 86, 92, 206*
 U.S. forces rescuing, *86*
Volcano
 Americans seizing, 124
 patrol reaching cone of, 99
Volcano Islands, 1, 22
von Clausewitz, Karl, 180

Wahlen, George E., 228
Walsh, William G., 229
Washington DC, *210*
Watson, Sherman, 99
Watson, Wilson D., 230
Wayne, John, 195
Wetenhall, John, 202–3
White, Theodore, 99
Williams, Hershal W., 227
Williams, Jack, 244
Willis, John H., 226
World War II
 censorship in, 128
 Pearl Harbor and, 14
Wounded
 barges for, 132, *133*
 grenade causing, 237, 249
 Marines, *119, 134, 140,* 141, *169*
 photographer being, *151*
 U.S. Navy aiding, *18*

Zegarski, Stanley, 94